JANGARH SINGH SHYAM
A CONJUROR'S ARCHIVE

The Museum of Art & Photography and the MAP Foundation, Inc. are
not-for-profit charitable organisations supported by private philanthropy.
The Trustees would like to thank MAP's Founding Patrons: Citi, Puneet
and Avantika Dalmia, Manipal Foundation, Kiran Mazumdar-Shaw, Sunil
Munjal, Sasken Technologies and Tata Trusts, its Founding Circle members
and all other donors.

Museum of Art & Photography (MAP)
22 Kasturba Road
Bangalore 560001
www.map-india.org

MAP Foundation, Inc.
84 State Street
Boston, Massachusetts 02109
www.map-foundation.org

International Distribution:
Worldwide (except North America and South Asia)
Prestel Publishing Ltd.
14-17 Wells Street
London W1T 3PD
T: +44 (0)20 7323 5004, F: +44 (0)20 7323 0271
E: sales@prestel-uk.co.uk
www.prestelpublishing.randomhouse.de

North America
Antique Collectors' Club
East Works, 116 Pleasant Street
Suite 18, Easthampton, MA 01027
T: +1 800 252 5231, F: +1 413 529 0862
E: ussales@accpublishinggroup.com
www.accpublishinggroup.com/us/

South Asia
Mapin Publishing Pvt. Ltd.
706 Kaivanna, Near Panchvati, Ellisbridge
Ahmedabad 380006
T: +91 79 40 228 228, F: +91 79 40 228 201
E: mapin@mapinpub.com
www.mapinpub.com

JANGARH SINGH SHYAM
A CONJUROR'S ARCHIVE

Jyotindra Jain

CONTENTS

PROLOGUE

In the usually sleepy Pardhan quarter of the village of Patangarh in the Dindori district of the then undivided state of Madhya Pradesh, an unusual commotion shot through the freshly mud-and-cow-dung plastered courtyards on the morning of June 12, 1961, when officials from the Census Authority of India came to prepare statistical data on the tribal population of the region. Their job that day was to update the numbers concerning the district's Pardhan and Gond communities.

For the Pardhans, it made little difference whether they were designated tribals or Hindus, Pardhans or Pardhan Gonds or just Gonds, as their identity had been shifting from census to census. Being classified as tribals did grant them certain advantages, such as reservations for government jobs, land rights or admission in schools and colleges under the so-called 'tribal quota,' though they knew only too well that these benefits were mostly of the chimerical kind and required endless navigation within the labyrinth of bureaucratic procedures. Still, a small crowd gathered around the makeshift desk of the census officials embarking on their task of collecting the data of the village's residents.

Suddenly, a second confusion seized the crowd. This time it was a group of women who hurried past the census officials, skirting their desk and disappearing into the narrow, winding pathway between two rows of huts. Moments later, the silence of the hamlet was broken by a newborn baby's shrill cry. Some women whispered, 'It's a boy.' The census officials, making a mental note to include the new arrival in their records, deputed the driver of their jeep to buy sweets to celebrate the occasion.

• • • •

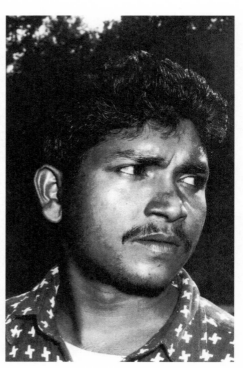

Fig. 1

Some 37 years after his birth, presided over by the officials of the Census of India Authority, Jangarh Singh Shyam, by then a renowned artist, was staying at the Crafts Museum in New Delhi, where I was curating and installing the exhibition *Other Masters: Five Contemporary Folk and Tribal Artists of India*. Jangarh was one of the five. While chatting over tea, I asked him about his unusual name and he told me the story of the *janaganana adhikaris* (officials of the Census Authority): "It was they who advised my parents to name me Janagana, as I was born on the auspicious day of *janaganana*, the Census of my community. Since most of my folk were not educated, they did not know the meaning of *janagana* nor could they pronounce it correctly, so eventually it just became Jangarh."

The shift of the Sanskrit formulation *janagana*, which also constitutes the opening word of India's national anthem referring to the entire populace of the unified nation, to the vernacular (Prakrit) "Jangarh" ironically turned out to be symptomatic: in the art historical classificatory mechanisms, Jangarh always remained bracketed — 'vernacular.'

• • • •

For the catalogue of the *Other Masters* exhibition, I needed a photograph of Jangarh to accompany the article on him, so I asked him to come to my office at the Crafts Museum. He appeared, dressed in a smart cotton shirt and blue jeans — his usual attire over the nearly 20 years of having lived in Bhopal, and while travelling in India and abroad to participate in exhibitions of his work.

Fig. 1 Portrait of Jangarh at Crafts Museum, New Delhi, 1998. Photo courtesy: Crafts Museum, New Delhi

I explained to him that the museum's photographer was waiting outside to take his photograph, which was to be published in the catalogue. He looked at me and asked very matter-of-factly, "*Sahab, kapde khol dun*?" (Sir, should I take off my clothes?) Perplexed, I asked him to clarify the strange question. He told me that an art gallery in Delhi, which had held a solo exhibition of his works the previous year, had asked him to remove his Western clothes and pose for their blurb photo bare-bodied, with just a loincloth and a kerchief turbaned around his head, because, so the argument went, his urban image would damage the authenticity of his art among the gallery's clients, echoing a Parisian dealer who is quoted to have said, "If the artist is known, the art is not primitive."[1]

The subtext is evident: to safeguard the authenticity of the tribal and his art, they must remain anchored in the past, and therefore the tribal cannot have a contemporary face — regardless of his nearly two decades of living in Bhopal and working in a modern, multi-arts complex in the city. As pointed out by James Clifford: "The concrete, inventive existence of tribal cultures and artists is suppressed in the process of either constituting authentic, "traditional" worlds or appreciating their products in the timeless category of "art.""[2]

Jangarh spent most of his life in Bhopal. His children grew up in this urban environment. Yet, he remained an outsider to the city and its art worlds. Neither could he have gone back to his village after so many years, where he would have been as much of an outsider. Territories are neatly divided. Crossing borders can be hazardous. More on this, in the following pages.

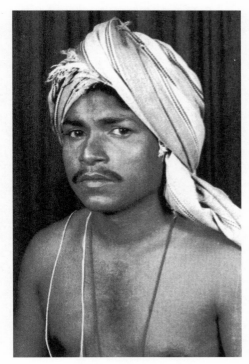

Fig. 2

1 Price 1989: 67
2 Clifford 1988: 200

Fig. 2 Portrait of Jangarh dressed as a tribal. Photo courtesy: Shajahan Art Gallery, New Delhi, 1997

THE MOULDING OF THE MUSE

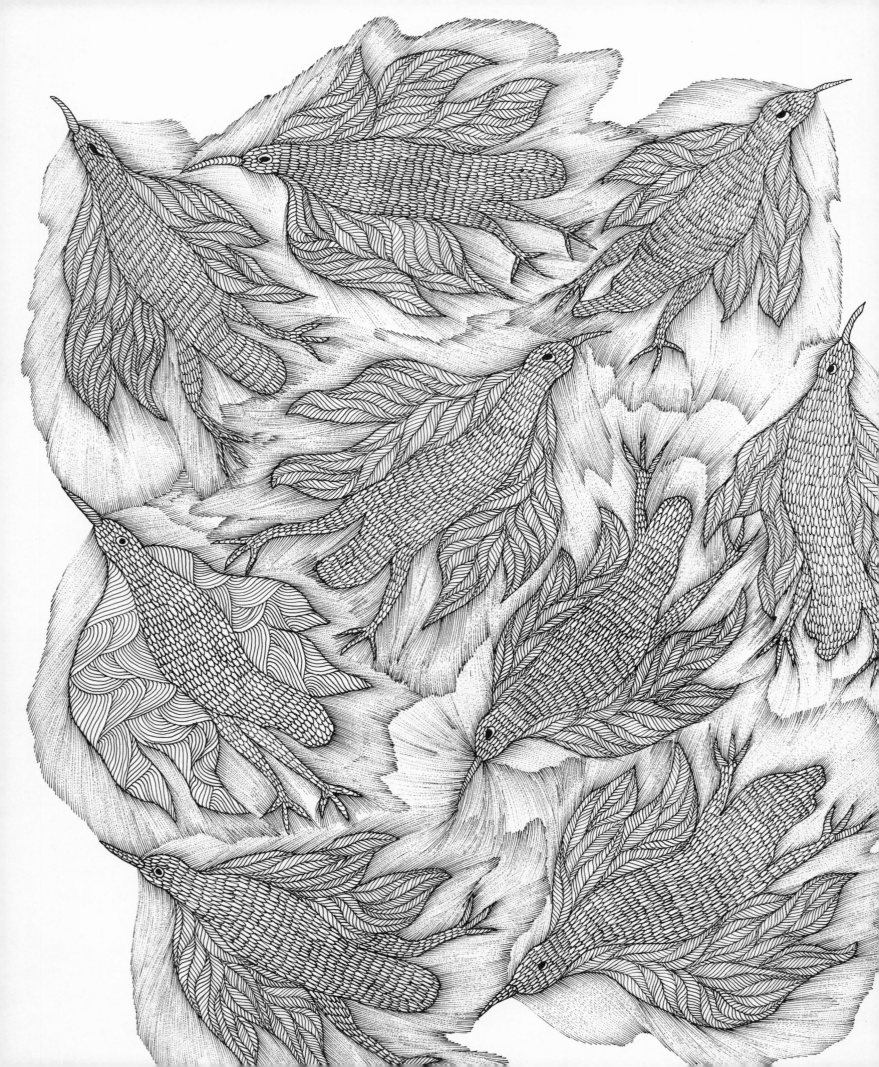

Regrettably, before a sound critical framework could be evolved around the phenomenon of Jangarh Singh Shyam as the progenitor of an exceptionally innovative artistic idiom of art now erroneously dubbed 'Gond School' or 'Gond Painting,' indiscriminate and ruthless market forces came to dominate this genre of art, and Jangarh himself became its first casualty. The sensationalism surrounding Jangarh's tragic suicide at the age of 40, under perplexing circumstances, and in a foreign country, further led to the consolidation of his legendary status. This spurred the large-scale collecting, museumising and fierce marketing of his paintings, and sadly only promoted an even more intense looking "at" his work rather than "into" it — as "[l]ooking beyond surfaces also means looking into contexts."[3] And the contexts need not always be ethnographic.

There is a whole range of circumstances, contexts, events and mediations associated with Jangarh's life and his art practice that needs to be critically examined and put into perspective, in order to construct an equitable account of the formation of his prodigious artistic idiom that founded his legacy and developed into a movement.

Part I of this book probes the efficacy of extra-cultural interventions into an individual artist's operative and relatively well-grounded indigenous cultural tradition, and asks how the latter interacted with the new, while intentionally reinventing itself not "on the basis of its conformity to the cultural tradition, but, rather, with respect to its relationship to extra-cultural reality."[4] From this perspective, I shall on the one hand examine aspects of Jangarh Singh Shyam's cultural inheritance rooted in art and mythology: the adornment of the walls of his community's homes with ritual clay relief work; the visualisation of gods in the images of their priests into whom they descend; the belief that the sacred musical instrument *bana* is the home of their highest deity; and the peculiar hierarchical relationship of the Pardhans (Jangarh's community) with the Gonds, for whom the Pardhans served as bards, singing them stanzas of their glorifying epics, which fuse together partly imaginary histories of the lost Gond kingdoms. On the other, I will trace Jangarh's individual journey to Bhopal, his interactions with modernist cultural

3 Thomas 1991: 9: Introduction
4 Groys 2014: 14

institutions, and his exposure to new materials and techniques of painting and printmaking; his participation in art camps with other Indian tribal as well as modern artists; his exposure to Australian aboriginal art; his establishment as a major artist, exhibiting works at national and international art fora, bringing him fame and fortune; and the resistance he frequently encountered from the Indian art establishment, which often opposed his co-sharing their privileged and well-guarded institutional spaces of art practice, on conceptual grounds.

Briefly, Part I focuses on how extraneous mediations expanded the boundaries of an individual artist's self-expression from within and outside a fixed and founded collective tradition to premise that "cultures do not impose uniform cognitive and reflective equipment on individuals."[5]

Let me first elucidate the ambiguity around such labels as 'Gond School' and 'Gond Painting,' which are applied undiscerningly to the genre of painting under discussion. These designations are flawed and inaccurate, as they are based on the name of a broad and largely loose conglomerate of several culturally heterogeneous tribal groups, cumulatively described as Gond by certain anthropologists. The Pardhans of Dindori and Mandla, the practitioners of the particular genres of painting associated with Jangarh Singh Shyam, considerably differ from the Gonds. In fact, the Census of India has categorised the Gonds and the Pardhans as separate tribal groups since 1911. The social, religious and economic relationship between the Gonds and Pardhans is rather complex. The Gonds and the Pardhans of the Dindori-Mandla regions often describe the Pardhans as *Chhota Bhai* or 'younger brother' of the Gonds, and some anthropologists have referred to the Pardhans as a branch of the great Gond tribe. Even so, in practice, no Pardhan refers to himself as Gond and vice versa. In fact, both groups are endogamous and traditionally have followed strictly hierarchised rules regarding the sharing of food and living spaces with each other. However, some of their clan names are common to both communities and the clans themselves are exogamous.

Shamrao Hivale, the longtime companion of the anthropologist Verrier Elwin, both of whom spent around fifteen years of their lives among the Pardhans and Gonds of Patangarh, published an in-depth study of the Pardhans of the Dindori and Mandla regions entitled *The Pardhans of the Upper Narbada Valley*.[6] Hivale's account, though based on his fieldwork of the 1930s and 40s, is nonetheless highly pertinent to our present context, as it is the only exclusive and formidable monograph on the Pardhans of the region, and Patangarh specifically, where Jangarh was born. According to Hivale, the Gonds and the Pardhans are two separate tribes, but there remains a close connection between the two:

> Gonds and Pardhans have the same mythologies; indeed a majority of the Gonds owe what little they know about the legendary origin of the world and the genesis of their own tribe to the Pardhans. The two tribes have the same religious practices. They observe the same festivals. They share each other's magicians. The Pardhans often act as genealogists to the Gonds. … They mix together entirely naturally and address one another as Mother, Aunt, Father, or Uncle, just as the Gonds do among themselves.[7]

Yet Hivale notes that there is a distinct limit to these commonalities: "But they [the Gonds] will not marry with them [the Pardhans] and although the Pardhan will take cooked food from the Gond, the Gond does not return the compliment. The Gond considers the Pardhan to belong to a lower social order than himself."[8] Hivale highlights the artistic impulse of the Pardhans — the inheritance of Jangarh Singh Shyam: "The Pardhan is a romantic. The Gond is a businessman. The Pardhan's devotion to his *bana* (the sacred fiddle, which is the home of Bara Pen) fills his life with poetry and the stolid steady Gond looks dry and arid beside him."[9]

An extremely strong social and economic bond between the Pardhans and the Gonds is defined by the old custom of *mangteri*. The latter is a triennial socioreligious tour by a Pardhan (usually accompanied by his wife) to his Gond host of the same clan to collect his rightful hereditary dues in terms of cash and perks. During their two or three-day stay in their respective Gond host's house, the Pardhans sing at night "one or other of the famous Gondwani or Pandawani stories about the ancestors of the Gond race or the great Hindu heroes of old."[10]

Jangarh Singh Shyam and the other artists working within the broad aesthetic parameters of the idiom that is now erroneously labelled as 'Gond Painting' are all from the Pardhan community of Patangarh and the nearby villages. It appears that the idiom evolved by Jangarh and adapted by several of his associates (all Pardhans and not one a Gond) was casually and mistakenly defined as 'Gond Painting' as a result of fallacies regarding the social complexity of the tribal groups of the area, and because the Gonds vaguely constitute a large, well-known and powerful conglomerate of diverse tribes. The nomenclature also seems to have stemmed from the earlier convention of historians of folk and tribal art to name a particular genre of art after a community — as is the case with Warli Painting, Santhal Painting and Bhil Painting — or after a geographical region — Madhubani Painting and Bastar bronzes, for example.

Regrettably, as mentioned above, the misnomer 'Gond Painting' took root as an artistic genre before any critical discourse developed around the work of Jangarh and the other artists working from within that broad aesthetic configuration. With the commercial side of the art world comprising investors and collectors, galleries and auction houses taking over the scene, the term 'Gond Painting' has become a universal brand name and the error will need to be perpetuated in order to sustain the powerful network of the art market.

My brief detour probing the community-based and inaccurate designation of 'Gond School' or 'Gond Painting' is not so much intended to argue in favour of replacing the label 'Gond' by 'Pardhan' — though the latter would be factually more accurate, if one were looking for a collective designation for a broad genre

5 Baxandall 1989: 107
6 Hivale 1946
7 Ibid.: 10-11

8 Ibid.: 12
9 Ibid.: 11
10 Ibid.: 57

of painting evolved by the Pardhan Jangarh, who left behind a rich aesthetic legacy, which was then explored by several other individual Pardhan artists, some of whom even charted their own distinctive paths.

Yet, in my view, a community-based designation, such as 'Pardhan' or 'Gond' for Jangarh's personal visual language, is simply not precise. Beyond creatively interpreting, transforming and abstracting his community's myths and legends, rituals and symbols, music and painted domestic clay relief work, as well as the various cultural and social practices in his painting, he evolved a highly expressive, individualistic, aesthetic idiom, which resulted from the extraordinary trajectory of his life, and particularly his conscious and discerning engagement with the various mediatory processes he encountered and openly responded to, in his work. The visual vocabulary that he originated and continuously improvised on was his own, in the sense that there was no precedent for it in his community's collective visual tradition, as was the case with the renowned Madhubani artist Ganga Devi or the Warli artist Jivya Soma Mashe, who largely used the inherited collective visual idiom to express their individual subjectivities, and invented narrative strategies that did not previously exist in their respective traditions. Similarly, there was no other Pardhan artist before Jangarh who had even remotely cultivated a pictorial style for him to draw from. In this respect, the designation 'Jangarh idiom' would aptly describe his full body of work. However, I would hesitate to subsume the entire wave of painting that occurred around and after Jangarh under the collective label of the 'Jangarh School.'[11] This would discredit the entire spectrum of work of the new generation of Pardhan artists. While many of them might have begun their practice within the larger ambit of influence of the Jangarh idiom, and some might even have contributed significantly to the creation of some of Jangarh's larger works while working as his assistants, they have also now charted out their own individual paths, too distinct to be absorbed under such a generic locus. Moreover, the post-Jangarh generation has branched out into other areas, reflecting in their work their own contemporary aesthetic, social and political predicaments, and signalling a definite departure from the Jangarh idiom.

I. Bharat Bhavan and the Art vs. Ethnography Discourse

At its core, J. Swaminathan's project of finding creative affinities between the works of the folk and tribal artists at Bharat Bhavan in Bhopal and the Indian modernists of the 1970s and 80s, on one level, and his emphatic dissociation of the "art" content of the tribal works from the "ethnographic" while prioritising the former, at another, was a modernist/formalist one. This somewhat simplistic dichotomy at the heart of the endeavour to collect indigenous art at Bharat Bhavan forms the subtext of several of Swaminathan's statements, such as, "You know, we were the first people to collect the work of the tribals as art, not as folkcraft"[12] or "… we are running an art exhibition, not an exercise in ethnography or anthropology."[13] When I visited Bharat Bhavan sometime in the mid-80s, I happened to stray into an exhibition of tribal terracottas.[14] As there were no captions on the works, I enquired about the reason for this. A curator told me that this was

because the pieces were to be appreciated for their artistic appeal rather than for their ethnographic context. Similarly, Swami's (as he was affectionately known) modernist stance vis-à-vis tribal art is further highlighted in his revealing comment about participants at an anthropological conference at the Indian Institute of Advanced Study, Shimla, presumably sometime in the 1980s: "The speakers there said that, as all tribal art was based on superstition, to attach any abiding importance to it is to perpetuate superstition. ... The stupid fools don't know what effect Picasso's discovery of tribal art had on Europe. ... Our intellectuals don't even have pride in their own country."[15] Swami's formalist reference to Picasso and tribal art also reminds me of a spontaneous response of another modern Indian artist to a tribal bronze from Bastar: "What a great piece of art, nothing less than a Brancusi or a Giacometti."[16]

This issue of the tendentious severing of art from ethnography in the context of folk and tribal art in the modernist framework has a formidable critical history. James Clifford, commenting on the exhibition *"Primitivism" in 20th Century Art: Affinity of the Tribal and the Modern*, held at MoMA in December 1984, offers a judicious appraisal of the issue:

> At MoMA treating tribal objects as art means excluding the original cultural context. Consideration of context, we are firmly told at the exhibition's entrance, is the business of anthropologists. Cultural background is not essential to correct aesthetic appreciation and analysis: good art, the masterpiece, is universally recognizable. ... What was good enough for Picasso is good enough for MoMA.[17]

In fact, it is noteworthy that from the very beginning, the collection-building exercise at Bharat Bhavan involved "art students from the state-run art institutions [who] were asked to volunteer for participation in the collection drive organised by the Museum."[18] They had little knowledge of the cultural or artistic significance of the objects they collected. As pointed out by Ashok Vajpeyi:

> But he [Swaminathan] organised orientation courses which ran into three to four weeks, prepared lectures and invited other experts to speak to them about anthropology, sociology, folk art, etc, to give them a sense of direction, an eye to discern, what and how to look for. He felt that as far as possible the material collected should be non-ritualistic, so that keeping it in the museum would not look sacrilegious. He then divided them into five or six groups and sent them off with proformas [sic] that he had devised himself, to collect art objects and information.[19]

11 For an alternative view on the issue, see Vajpeyi and Vivek 2008
12 Quoted in Tully 1991: 271
13 Quoted in ibid.
14 It must be clarified here that in the Indian context the term 'tribal terracotta' has a twofold meaning and could refer either to terracottas made by tribals or terracottas made by Hindu potters for tribals. This would equally apply to such terms as 'tribal bronzes,' 'tribal ornaments,' etc
15 Quoted in Tully 1991: 271. The identification of the Indian nation with the rural and pastoral has a long history and would require a separate discussion
16 In my 35-year engagement with tribal art, I have repeatedly come across such formalist observations by artists and art critics
17 Clifford 1988: 200
18 Swaminathan 1987: Preface
19 Vajpeyi 1994: 40

Interestingly, however, the book *The Perceiving Fingers: Catalogue of Roopankar Collection of Folk and Adivasi Art from Madhya Pradesh*, with an introduction by Swaminathan and published by Bharat Bhavan, lists over 3,500 objects of folk and *adivasi* art in the Roopankar collection (1981-86), where almost all works are classified either as 'religious' or 'decorative' with a few exceptions labelled 'toy,' 'utilitarian' or 'marital.'[20]

During the initial phase of curating the art galleries at Bharat Bhavan in the early 1980s, Swaminathan was keen on placing the works of the Indian modernists side by side with those of the tribal artists. "Then to give them [the folk and tribal artists] a sense of dignity that they are as good as anybody else, that there is a Pema Fatya and a Bhuribai along with a Manjit Bawa, Ram Kumar and Husain — this comraderie [sic] Swami alone could think of."[21] Apparently, the modernists were not pleased with the idea and a separate wing was created at Bharat Bhavan to house the folk and tribal art collections. This forms part of a much longer trajectory of Indian modernists resisting the inclusion of folk and tribal art in exhibitions and exhibition spaces where their own works are shown, which I will outline in more detail below.

During the selection process of artworks for the Indian section of the Fourth Triennale-India, the three authorised Commissioners had selected the Madhubani folk artist Ganga Devi and the Warli tribal artist Jivya Soma Mashe, along with more than a dozen younger modern artists. After a huge uproar by a number of modern artists about the inclusion of folk and tribal artists, the latters' names were removed "on the ground that such art does not have anything in common with contemporary art."[22]

Similarly, in an interview, Swaminathan once mentioned that "[w]hen Jangarh had his exhibition in Delhi, most of them [the modern artists] kept away. Most of them felt threatened, I reckon."[23] When the exhibition *Other Masters: Five Contemporary Folk and Tribal Artists of India*, which I curated, received an appreciative review in the international edition of Newsweek,[24] I was accused by a celebrated Indian modernist of perpetuating the orientalist image of India abroad — not realising that the *Other Masters* who were included in the exhibition were questioning, through their work, the relegation of their identity to an orientalist past, as reflected in most of the art critical writing in India.

While the credit for doing pioneering work in recognising the innate creativity of the folk and tribal artists of India and providing them with an institutional platform undeniably goes to Swaminathan to a large extent, there remained a need for a coherent and critical articulation of the "camaraderie" that Swaminathan sought to establish between the works of the Indian modernists, on the one hand, and the contemporary tribal artists, on the other.

Swaminathan's tenacious segregation of the ethnographic background of tribal art to better appreciate the latter's aesthetic qualities is inexplicable and remained largely unarticulated by him.

What was happening at Bharat Bhavan at that juncture was a fervent hunt for a "modernist aesthetic" within the tribal visual expressions but isolated from the artists' ethnographic background, thus missing the crux in how the tribal artist was not merely a mute observer in a fast changing and modernising India, but was, in fact, ready to reflect their immediate social and political predicament in their work — a sign of true contemporaneity.

The tribal artists Bhuribai, Ladobai and Pema Fatya are cases in point. Among the earliest tribal arrivals at Bharat Bhavan, they came from the tradition of Pithora ritual wall paintings, which already had a long history of incorporating in their works relating to their songs of creation, images of gun-racks and gun-toting policemen, clocks (as a new measure of time), of a Rathwa/Bhilala tribal shooting an arrow at an airplane, or of the billowing clouds of smoke of a locomotive, identified with ghostly spirits, or of Pithoro sporting sunglasses and wearing a watch, or references to the establishment of modern institutions of governance, such as the collector of revenue in the tribal areas. The early works of Bhuribai, Ladobai or Pema Fatya done on paper or canvas at Bharat Bhavan and using some of these modern motifs, were celebrated as "contemporary." Yet what eluded the curators there was that the guns, airplanes and trains indeed formed part of the Rathwa/Bhilala myth of creation, in which the modern world continues to constitute the ongoing process of creation, thus making it an inherently contemporary narrative. By shunning this ethnographic context, the particular route to their own contemporaneity chosen by the tribal or folk artists — arising out of their changing social predicament and not the modernist aesthetic contemporaneity extracted from the art-ethnography divide — was overlooked.

This brings us to the other important issue of how folk and tribal artists, who often hail from fairly isolated communities, have responded in their art to new mediatory processes. This, in fact, is the core theme of this book.

II. Jangarh's 'Discovery'

> Jangarh Singh, a young Pardhan artist with an inborn genius for drawing and painting and modelling... was "discovered" when the walls of his hut were found to be covered with paintings done by him.
> J. Swaminathan[25]

The term 'discovery' as applied to encountering works by indigenous or vernacular artists by ethnographers, art historians and what Jangarh would call *she-heri* (urban) artists further stresses the hierarchised binary between the two and,

20 Swaminathan 1987: 65-164
21 Vajpeyi 1994: 40
22 Sen 1978
23 Tully 1991: 272. This is a reference to Jangarh's

exhibition held at the Dhoomimal Gallery in Delhi in 1984
24 Clifton 1998 in Newsweek
25 Swaminathan 1987: 47

Fig. 3

concomitantly, the power relation inherent to the dynamic between the invasive 'discoverer' and the passive 'discovered,' more explicitly visible in the histories of colonial voyages and geographical discoveries. As pointed out by Sally Price in the context of the so-called discovery of America through Columbus: "Obviously, for those who were already living there [the indigenous], the 'New World' was not so new as it was for the Europeans of that time."[26]

Before the arrival of the museum team from Bharat Bhavan in Patangarh, Jangarh was already recognised for his painterly talent within his village and community. For them, there was no discovery. Signs of his early creative innovation were apparent in the visual conceptualisations of his gods, from their conventional geometric renderings to semi-anthropomorphic forms. As he once himself said: "I used to see people when the gods took possession of them, and that was how I got the idea of what the gods looked like."[27]

Jangarh has said about the time before his 'discovery' in 1980-81 by a team of artists from Bhopal: "I carried baskets of mud on my head and dug mud to fill other people's baskets, … we used to work in gangs and be away from the village for months."[28] In the context of his 'discovery,' the following conversation between Iyer (a modern artist from Bharat Bhavan) and Jangarh, quoted by Mark Tully, acquires significance:

[Iyer:] Well, what exactly did happen when the team of artists came? Where were you at the time?

[Jangarh:] I was working in another village in the fields, when I was sent for. I found these

Fig. 3 Jangarh's house in Patangarh, 2018. Photo courtesy: Harchandan Singh Bhatty, Bhopal

Fig. 4 Jangarh and his wife Nankushiya with the artist J. Swaminathan, Jangarh's mentor. Photo: Jyoti Bhatt, 1987. Courtesy: Asia Art Archive, and the photographer

Fig. 5 Jangarh's bust in his village Patangarh, 2018. Photo courtesy: Harchandan Singh Bhatty, Bhopal

people from the city in my village. They had seen a painting I had done on the walls of someone's house and had been told I had done it. They seemed to like it. Eventually I met Swami and told him I would like to go to Bhopal, and he agreed. At first I just went for a bit, but then Swami gave me a permanent job and I stayed in the city.[29]

Initially, Jangarh would visit Bhopal intermittently to participate in the periodic artists' camps there. In every camp workshop, Jangarh would stand out on account of his distinct and innovative creations, and around 1983 or 84 he was given a position at Bharat Bhavan's graphics studio, where he eventually mastered the technique of printmaking.

During his initial sporadic visits to Bhopal, Jangarh was occasionally accompanied by his friend Tirath, who had stood by him in his days of struggle in the village, back when they collected wood from the forest to earn a living. Another one of Jangarh's early companions was the late artist Chhattarpal, Jangarh's uncle, who joined him in Bhopal at least twice. Chhattarpal was adept at making clay images and architectural clay relief work, in addition to being a painter of merit. Ram Singh Urveti was another friend from his youth, about whom Jangarh spoke with great affection, recollecting how in their village days they played the characters of Ram and Sita in the local Ramleela performances — with Jangarh playing Ram.

Before I discuss the issue of the "blossoming" of Jangarh's art in Bhopal[30] through a range of complex mediatory processes that he underwent in the creative and open atmosphere of Bharat Bhavan, and which led to his evolving, percipiently and reflectively, into an exceptionally fine artist who pioneered a movement, let me take a brief detour to his personal recollections of his arrival and early years

Fig. 4

Fig. 5

26 Price 1989: 65
27 Quoted in Tully 1998: 278
28 Quoted in ibid.: 276

29 Quoted in ibid.: 277
30 As put by J. Swaminathan and quoted in Tully 1998: 278

in the city, which he related to me in numerous conversations, over many years. Undoubtedly, Jangarh received ample warmth and patronage from Swaminathan and much admiration for his talent and work by the modern as well as indigenous artists, and even by the theatre fraternity and from writers-in-residence at Bharat Bhavan. However, as Jangarh attained a measure of fame as an artist and as his market value increased, he began to face a growing resentment from some of his colleagues. In fact, Jangarh once told me that he was often abused by some of the artists at Bharat Bhavan. He said that when he was initially appointed as an attendant at Bharat Bhavan, he was rudely asked by some of his modern art colleagues to serve them tea or clear away empty cups and plates, often with a sarcastic comment that "you have now become a big artist." Jangarh found these insults difficult to bear and often complained to Swaminathan, who was the Director. Eventually, Jangarh was given the position of 'artist' at Bharat Bhavan, a special designation created for him.[31]

Jangarh often complained to me that some of his *sheheri* artist colleagues kept a stock of his paintings with them under the pretext of negotiating their sale to foreigners, as Jangarh could not speak English. The money received from such deals never reached Jangarh. He also told me that he had made several complaints about this to the government. Unfortunately, his death came faster than justice.

Another revealing account that I was given by one of Jangarh's artist friends is that Jangarh was in the habit of sipping his tea with a loud slurp, which did not go down well with one of the Delhi-based patrons and collectors of Jangarh's paintings. The collector asked Jangarh's friend to tell Jangarh to give up this 'uncouth' habit. Jangarh felt perplexed, as he not only relished drinking his tea in that manner, but it also saved his tongue from getting burnt.

I was also told by several eyewitnesses about an incident that occurred during the celebration of Bharat Bhavan's anniversary on February 13, 1986 (probably at Swaminathan's residence), for which a party was organised featuring a camp fire as well as food and drinks. Several *sheheri* and tribal artists had gathered together. Certain levels of inebriation ended up leading to a brawl. Some of the *sheheris* accused Swaminathan of favouring the tribal artists, even though the former had spent years toiling in art schools. Jangarh, in particular, was being indirectly targeted on this account. Also under the influence, he is said to have taken off his clothes in an attempt to throw them into the fire, while saying: "I will go back to my village in the same condition as I came to Bhopal." Swaminathan pacified everyone, and the matter ended there. Though versions of this story are circulating among the Pardhan artists in Bhopal, they are hesitant to go on record with it.

III. Multiple Mediations and the 'Secularising' Processes in Jangarh's Work

Let me briefly dwell on the various mediatory processes and multiple modernities[32] in India's vernacular arts, and interrogate the nature and role of extraneous transgressions into relatively well-anchored vernacular cultures. Contrary to the

earlier anthropological and art historical position that tribal cultures are static and frozen in the 'past' (itself a problematic category, based on the notion that it is a known, sterile and singular entity), I shall elucidate how vernacular traditions have always imaginatively reinvented themselves as they responded to the new and the 'extra-cultural.' A key aspect will be to examine how traditional practices of ritual art forms (which themselves have not been static) underwent a creative transformation, with the introduction of paper and bright, modern pigments for painting, and how their encounter with formal art spaces such as the museum, the art gallery and the art market played a pivotal role in widening their scope of visual expression. Besides these material factors, another important element to keep in mind is the vernacular communities' self-reflection in their art, in the wake of shifting power relations emanating from new economic forces and forms of governance. One of the critical outcomes of the now more enhanced mediatory processes is the growing tendency towards the narrative in vernacular painting. The desire to tell stories of the new economic, ecological or other societal challenges faced by their communities or their own individual perceptions of the changing world around them formerly almost never featured in the tradition-bound and ritually rooted painting, though it has now entered their pictorial space.

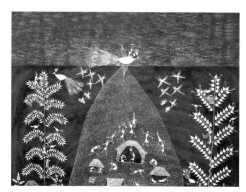

Fig. 6

The shift from static iconographies to fluid narrative in the folk and tribal arts must be looked at from several critical angles. Besides the new and enabling technical facility to articulate greater detail on paper or canvas with a pen or brush, compared to the grainy and uneven surface of a wall, a more momentous change that occurred was each individual artist's invention of devices to depict the passage of narrative time within the new pictorial space of the paper sheet or the canvas. Moreover, the artists now began more consciously to engage with the conceptual transformation that became possible with the demands of this new white space, which opened up potentialities of individual expression both in terms of locution and personal subjectivity. This shift also generated a new process of secularisation, not in the narrow dichotomous sense of 'religious' vs. 'secular' but in terms of responding to the traditional from today's perspective. This secularising process not only engendered contemporary interpretations of the traditional myths and legends, but the new secular space of the paper and the canvas also paved the way for the vernacular artists' reflection on their coeval world.

It was this shift that led the Warli artist Jivya Soma Mashe to give visual form to his inherited legends (Fig. 6) or to recall on his canvas, his community's collective memory of the new railway tracks ruthlessly cutting through his village (Fig. 7). It inspired the Madhubani artist Ganga Devi to construct the saga of the rites of passage among her Kayastha caste in her epic work 'The Cycle of Life' and gave rise to her 'Cancer Series' of paintings depicting the memory of her agonising hospitalisation and treatment (Fig. 8).[33] The painted scrolls of the Santhal tribe's

Fig. 6 Visual narrativisation of a Warli legend. A large bird covers the village with sand, to prevent the inhabitants from envisioning a boy picking fruits from a tree, which was a condition of a girl's father, before he gave his daughter in marriage to the boy. Jivya Soma Mashe, 2003, pigment on paper, 71 x 92 cm. Collection and image courtesy: Jyotindra Jain, New Delhi

31 Interestingly, after Jangarh's demise, his wife Nankushi-ya, too, was initially offered a job as attendant. I wrote a letter of protest to the Government of Madhya Pradesh, after which she, too, was given the post of 'artist'

32 Ruth Phillips and Norman Vorano are in the process of developing these concepts in a forthcoming publication
33 For a detailed account, see Jain 1997

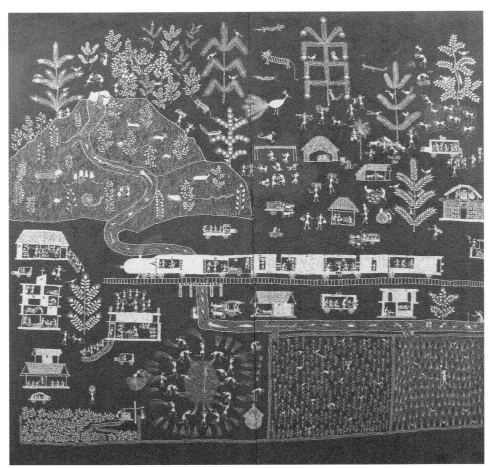

Fig. 7

Fig. 7 My Life (detail). Collective memory of the railway line cutting across the Warli villages. Jivya Soma Mashe, 1998, pigment on board, 185 x 185 cm. Collection and image courtesy: Crafts Museum, New Delhi

creation myths showing Yama, the God of Death, as a policeman flaunting his bullet belt, or the god Mahadev being escorted by rifle-wielding security guards (Fig. 9), or Jangarh Singh Shyam repeatedly recounting the memory of the waning forest myths are all examples of this enhanced shift towards the narrative resulting from interventions of extrinsic cultural agency into well-grounded indigenous traditions and reveal how the latter percipiently responded to their "evolving context" and to situations of "conflict and change"[34] while continuously reinventing itself.

• • • •

In his twenty-year career — from the time of his arrival at Bharat Bhavan in 1982-83 and until his death in 2001, Jangarh produced a formidable body of work, and in the process, evolved an individual language of pictorial expression. Throughout his artistic practice, Jangarh remained explorative and largely experimental. Unlike many other folk and tribal artists who also entered the contemporary art space through various mediatory transactions, Jangarh's case was different in that he worked at an art institution to which he remained attached until the end of his life, and mostly worked amidst its aesthetic and ideological parameters.

He was surrounded by staunch modernists. Jangarh often told me that some of them continuously nagged him to continue to be "authentic" by drawing inspiration from his tribal heritage rather than from his urban milieu, while others encouraged him to open up to his immediate urban environment. Jangarh often faced hostile criticism from both camps and had to navigate these aesthetic-ideological positions at Bharat Bhavan. This is where his muse was moulded or, as Swaminathan put it, Jangarh's art had "blossomed" and "his genius had burst forth here."[35]

Fig. 8

It was also there that he was first exposed to the magic of bright poster and acrylic colours, and their smooth and sensuous recipient surface of the white paper and canvas offered new possibilities for limitless expression. It was at Bharat Bhavan that he was introduced to the debate around the 'mainstream' and the 'marginal,' and the experience of becoming the celebrated Other. Having spent almost his entire life away from his native land, memory and nostalgia began to play an important role in his perception of it. The distance to the world left behind, opened up a whole new realm of 'imaginary homelands' from which he re-cast the gods and legends in his paintings. His ability to impulsively transform the real and the memory world into the intuitive lay at the core of his work.

Over the course of the various artists' camps and workshops held at Bharat Bhavan in the early 1980s, Jangarh began to acquaint himself with paper, poster colours and printmaking. He was so thrilled by the *chatak* (bright) pigments[36] that he once famously said: "The first time I dipped my brush in bright poster colours in Bhopal, tremors went through my body."[37]

Fig. 9

These new materials charged his imagination to no end. The white expanse of the paper gripped and animated him in an almost sensual manner. In an interview with Seema Sathyu, Jangarh discerningly articulated his experience of these new, dazzling colours. He spoke of *mara* vs. *zinda rang*, i.e. dead vs. living colour as an allegory for dull or bright pigments.[38] Sathyu recalls that when Jangarh first received sheets of paper and colours "which he had never used before, in one day, he poured out all his creative energy on the new space he was given."[39] Jangarh described his response to this new colour palette by saying that *tilmilati hain aankhen*, i.e. his eyes watered while working with them.[40] In the same conversation Jangarh has stated that his use of coloured dots "bears inspiration from the *parsa jhad* [a tree], which has flowers with spotted patterns."[41]

The prominent dotted patterns as seen in the works of Jangarh and other Pardhan artists may have been inspired by various sources. Kalavati, Anand Shyam's wife and an artist in her own right, feels that one of the influences for this pattern might have been the traditional clay relief work (Fig. 10). The continuous dotted

Fig. 8 Memory of the agonising days spent in a cancer ward at a hospital in Delhi. Ganga Devi, 1986, ink on paper, 55 x 76 cm. Collection: Crafts Museum, New Delhi. Image courtesy: Jyotindra Jain, New Delhi

Fig. 9 Mahadev being escorted by armed guards. Detail from a Santhal scroll of creation myth. Artist unknown, ca. 1950s, pigment on paper, 510 x 21 cm. Collection and image courtesy: Jyotindra Jain, New Delhi

34 Clifford 1991: 215, 218
35 As quoted in Tully 1998: 278
36 Sathyu 1989: 2

37 In a conversation with the author in Delhi in the 1990s
38 Sathyu 1989: 4
39 Ibid.: 1

40 Ibid.: 4
41 Ibid.

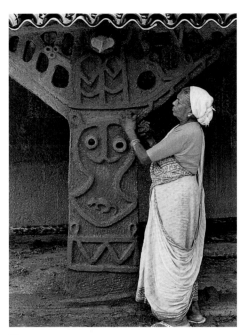

Fig. 10

clay relief borders running along the edge of all four walls of the house are created as part of the worship of Ravan on the occasion of his death anniversary, which falls in the month of *chaitra* (March). According to Kalavati, another possible impulse for the dotted pattern in Pardhan painting could be the dotted chintz attire of the *panda-pujari*, the master of religious ceremonies, who often went into a trance. It is pertinent to note here that Jangarh had once told me that he envisioned his gods in the image of the shamans through whom they descended during the invocation ceremonies.

Besides other forms of patterning, Jangarh employed a variety of dotted patterns in his work, from scattered dotting to dotted stripes. Strikingly, his profuse use of the fragmented wave pattern consisting of individual rainbows — designating single waves — that as a whole, radiate outwards, evokes the depiction of water in traditional Japanese and Chinese painting as well as in certain Indian miniature paintings, such as those of the Malwa School. Some Australian aboriginal artists, too, have used it in their works. However, Jangarh expanded the use of this pattern beyond depicting water to symbolise all kinds of undulating surfaces, be it the skin of a crocodile or a snake, the bark of a tree or the muscular structures of animals, the bodies of his deities, or the plumage of birds. This use of the pattern also evokes a sense of vestigial chiaroscuro.

When Jangarh began to come to Bhopal in the early 1980s, he met Pema Fatya, Bhuribai and Ladobai, the Bhil artists working at Bharat Bhavan.[42] The Bhilalas of Badwani, Jhabua and Alirajpur, and their Rathwa counterparts just across the border in Gujarat, had an old tradition of making painted installations of their myth of creation centring around their god, Pithoro, and comprising of equestrian figures of deities, elephants and other elements. These images were rendered with richly dotted patterns. The Bhil/Bhilala artists working at Bharat Bhavan employed this aesthetic mode as they began to work on paper, and this, too, may have served as an inspiration for Jangarh. On the other hand, it is remarkable that the later works of some of the Bhil artists show clear signs of being influenced by the Pardhan idiom that was developing in Bhopal. It would be a simplification to try and identify a singular source of inspiration for any artist's idiom and language. Artists tap into an ocean of visual memory and personal subjectivities, which converge in their work in multiple and unfathomable ways. Much of it may not be preplanned and what is later hailed as a defining element in their art may even have emerged on the canvas accidentally or spontaneously, in the very act of painting.

It is noteworthy here, that the range of dotted patterns, which has become a hallmark of Pardhan painting, also served as markers for individual stylistic idioms that arose from a minor altercation between Jangarh and Anand Shyam. After working as an artistic assistant for Jangarh for some time, Anand began to produce his own paintings, albeit initially using the characteristic dotted patterns pioneered by Jangarh, the latter's dots being minute opaque or hollow dots or circles. Jangarh apparently objected to Anand's use of his dotting style. The two men reached a compromise, with Anand evolving his own individual idiom consisting of crescent-shaped dots, which, combined with a template comprising short

parallel lines arranged in compartments, became Anand's personal idiom.[43] Somewhere along the line, each artist evolved a signature style based on their individual manner of creating patterns using dots, strokes and lines. Bhajju Shyam's parallel lines and running chains, and Ram Singh's chevron or arrowhead patterns, for example, became the hallmarks of these two artists' works.

This informal mutual understanding between the artists of developing one's own individual idioms, was consolidated by J. Swaminathan's advice that all artists should put their signatures on their works.[44] This finally led to the emergence of the 'Gond School' and 'Bhil School' signature artists, who in that very mode then entered the modernist art infrastructure of art galleries, museums, collections and art auctions.

IV. Visualising his Gods

> The deities become real by the truth of imagination.
> J. Swaminathan[45]

Rather than conforming to a certain 'school,' Swaminathan saw in Jangarh's work a great sense of originality and innovation. He has said about Jangarh's inventive portrayal of his community's deities in the new urban environment of Bhopal: "One thing readily noticeable in all of them is their conceptual character: they are not naturalistically rendered. The deities become real by the truth of imagination."[46] He goes on to elucidate that "[t]here is no doubt that he is an exception and herein lies our point: he is giving pictorial form to many of the Pardhan Gond deities. … [I]t is the individual artist who gives visual, tactile expression to commonly held beliefs and it is only then that such expressions become communal property."[47]

There is hardly any evidence of the nature of the painting or clay relief work that Jangarh did on the walls of his village house before he came to Bhopal. He once confirmed to me that his people represented gods through geometric renderings. Several sketches of such representations are reproduced by Shamrao Hivale in his book.[48] It was only after his exposure to paper and modern pigments in Bhopal that Jangarh produced a series of paintings depicting his gods. This may very well have been the first step from his inherited tradition to individual expression in response to the mediation through paper and luminous pigments.

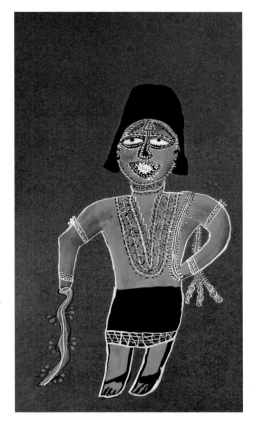

Fig. 11

Fig. 10 Jangarh's mother, Adharabai, creating traditional clay relief ornamentations at Manav Sangrahalaya, depicting a cat having ingested a mouse, Bhopal, 1992-93. Photo courtesy: Nankushiya Shyam

Fig. 11 A Pardhan shaman possessed by Baba Dev, holding a scourge in his right hand. Jangarh Singh Shyam, early 1980s, pigment on paper, 60 x 40 cm. Collection and image courtesy: Bharat Bhavan, Bhopal

42 It must be clarified here that the blanket term 'Bhil' has been loosely applied to a large conglomerate of tribes spanning the Bhils, Bhilalas, Kolis, Meenas, Rathwas and dozens of others inhabiting regions of Western Madhya Pradesh and parts of Rajasthan, Gujarat and Maharashtra. Several of these social groups have independent and complex sub-identities based on the rules of endogamy and exogamy, which often function within regional configurations. According to Christoph von Fürer-Haimendorf "…

[either] all groups of Bhils are the offshoots of a single tribe and their present diversity is the result of political pressure and historical development… [or] it may be, that when more advanced populations established their rule over the aboriginal peoples of Western India, a number of different tribes were classed together under a generic term Bhil." Several features of their cultural life, such as the habitat, the dress and ornaments, the language, the deities and their mythologies and even the clan names in the given regions,

are often shared by several social groups known as 'Bhil'
43 Anand Shyam in conversation with the author in New Delhi on June 9, 2017
44 Anand Shyam in conversation with the author in New Delhi on June 9, 2017
45 Swaminathan 1987: 47
46 Ibid.
47 Ibid.: 48
48 Hivale 1946

As observed by Swaminathan:

> There is no tradition among the Gond and the Pardhan of portraying their deities in painting. While simple geometric *chowk* are drawn for the various deities on various occasions, the deities themselves are not graphically represented. Taking his leap from the *chowk*, Jangarh displays an extraordinary versatility in giving the deities their physical form… [H]e has given them all individual characteristics and pictorial visages.[49]

Jangarh created iconographies of his deities from his imagination as well as through his encounters with them in the ceremony of invocation: "But then I used to see people when the gods took possession of them and that's how I got the idea of what the gods looked like."[50] It was these visions of gods that led Jangarh to iconise them holding spikes, tridents and scourges, or squatting on a seat of nails, as the priests in trance would do. In Fig. 11 we see the shaman possessed by Baba Dev wearing the priest's cap and holding in his right hand a scourge with which he would self-flagellate when in trance. In some images, he portrayed the gods near their shrines surrounded by flags, tridents, oil-lamps, a seat of thorns and *jamara*, young sprouts planted in earthen pots, their growth predicting next season's crop. Besides depicting his gods in human form in his early works, Jangarh also attempted to paint pairs of birds, fish or reptiles in the form of simple individual representations or in dialogue with each other. Here, the surrounding forested landscape had not yet emerged as in the later narrations of legends (Figs. 12, 13, 14).

A whole range of Jangarh's early renderings of gods include images of Baba Dev, Phulwari Devi, Narayan Dev, Khairagadhia Dev, Thahi Dev, Mashvasi Dev, Hanuman, Maha Dev, Mehralin Devi, Budha Dev, etc. (Figs. 15 to 19).[51]

Fig. 12

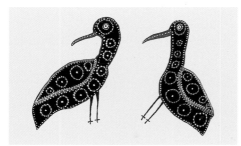

Fig. 13

Fig. 14

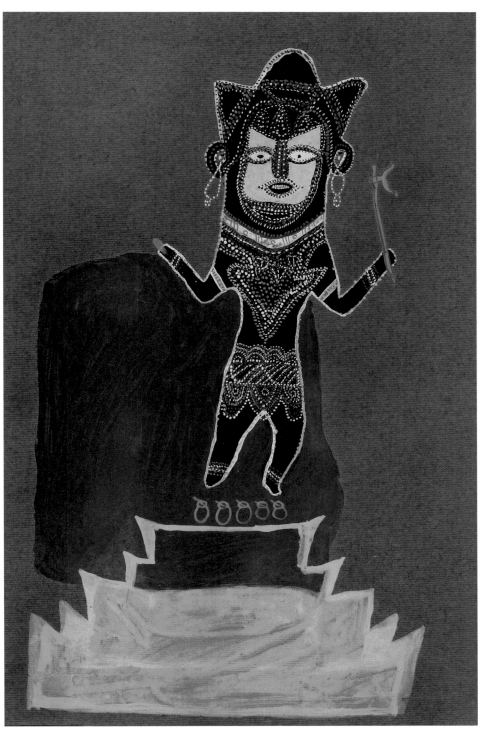

Fig. 15

Fig. 12 The depiction of a pair of birds is among the early works of the artist marked by a degree of spontaneity, created during the days of his initial introduction to paper and pigments. Jangarh Singh Shyam, early 1980s, pigment on paper, 35 x 65 cm. Collection and image courtesy: Bharat Bhavan, Bhopal

Fig. 13 A Pair of Birds. Jangarh Singh Shyam, early 1980s, pigment on paper, 30 x 60 cm. Collection: Bharat Bhavan, Bhopal. Image courtesy: Seema Sathyu, Bangalore

Fig. 14 A Pair of Fish. Jangarh Singh Shyam, early 1980s, pigment on paper, 50 x 71 cm. Collection: Bharat Bhavan, Bhopal. Image courtesy: Seema Sathyu, Bangalore

Fig. 15 Bara Dev or Baba Dev. An early painting, where the influence of *dhigna*, traditional wall and floor painting of the Pardhan households, is visible, especially in the rendering of the pedestal. Jangarh Singh Shyam, early 1980s, pigment on paper, 80 x 45 cm. Collection and image courtesy: Bharat Bhavan, Bhopal

49 Swaminathan 1987: 47
50 As quoted in Tully 1998: 278
51 Swaminathan 1987: 47

Fig. 16 Ratmai; 'Night Mother,' or the goddess who protects her devotees at night and resides in the hearth. Jangarh Singh Shyam, early 1980s, pigment on paper, 60 x 35 cm. Collection: Bharat Bhavan, Bhopal. Image courtesy: Seema Sathyu, Bangalore

Fig. 17 Mehralin Devi, a Pardhan deity. Jangarh Singh Shyam, early 1980s, pigment on paper, 65 x 40 cm. Collection: Bharat Bhavan, Bhopal. Image courtesy: Seema Sathyu, Bangalore

Fig. 18 Narayan Dev, a Pardhan deity. Jangarh Singh Shyam, early 1980s, pigment on paper, 35 x 75 cm. Collection: Bharat Bhavan, Bhopal. Image courtesy: Seema Sathyu, Bangalore

Fig. 16 Fig. 17

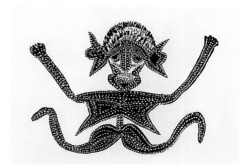

Fig. 18

Interestingly, the portrayal of Thahi Dev reveals a direct affinity to the Pardhan tradition of clay-relief representations of gods (Fig. 20). The visual conceptualisation of several of the deities mentioned above was also derived from their images in the local shrines in Patangarh and around. Using the stories and incidents related to these deities that circulated in his village, Jangarh portrayed them as fierce, evil or benevolent. These attributes were conveyed by him via certain patterns and textures in order to, as he put it himself, "help to give a frightening form (*bhayanak roop*)."[52] A more detailed description of Jangarh's iconisation of some of the Pardhan deities of the Patangarh region can be found in the section 'A Conjuror's Archive.'

Over the centuries, the Gonds and Pardhans, among other tribal groups of the region, have come under the predominant influence of local Hindu beliefs and practices, which have partly been absorbed by the religion of these communities. Contrary to common belief, most of the so-called tribal populations of India have lived in proximity with their rural Hindu and other neighbours, thereby undergoing cultural diffusion. In many ways, the economically and technologically advanced Hindu neighbours exercised authority over the autochthonous tribals. The tribals, in turn, often took the former's cultural values as a model for their own upward social mobility. However, as pointed out by Stella Kramrisch: "The liberating function of art is shared by the tribal non-Hindus, the peasant and the Hindu elite in one tribal-village-urban continuum where the currents of art from tribe and village to the elite and from the elite to tribe and village flow both ways."[53] For decades now, in most tribal pockets of India, Hindu artisan castes have been working for the tribals, engaged in making cultic and votive objects for their tribal clients. In doing so, they have regularly interposed their own symbols and iconographies

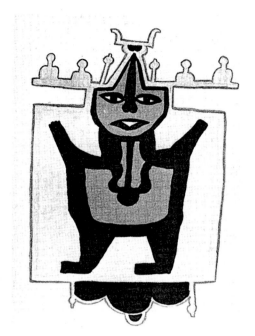

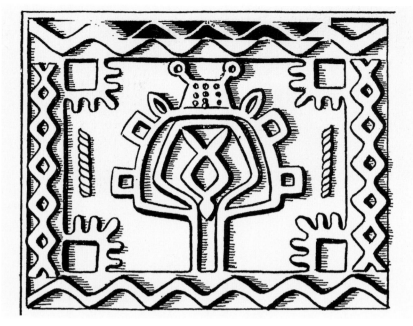

Fig. 19 Fig. 20

in the tribal ritual objects, thereby augmenting the tribal pantheon and often turning the aniconic into the anthropomorphic or even narrative. The absorption of deities such as Hanuman into the pantheon of gods by Jangarh, or the presence of several Hindu iconographic features in his images of various goddesses is a result of this diffusion. Jangarh described himself as a *shiv-bhakt* (devotee of Shiva) and in one of the rooms of his house in Bhopal he had installed an elaborate shrine of the goddess Durga (Fig. 21). Similarly, several tribal communities inhabiting the central Indian tribal belt never had a tradition of rearing horses. Yet, equestrian figures now have a central place in the tribal and peasant cultic iconography and rituals of this region, on account of similar processes of dissemination.

One afternoon at the Crafts Museum in New Delhi in late 1997, during a chat about the traditional religion of the Pardhans, Jangarh began to talk about Bara Dev, the Supreme Deity of his community. He mentioned that Bara Dev resides in the *bana,* the most important musical instrument, which the Pardhan bards played while singing about the glory of the Gond Rajas and their mythology, to their traditionally allotted Gond host families. Shamrao Hivale describes the *bana* as the Pardhan's "portable temple"[54] and "the very birthplace and seat of Bara Pen [Bara Dev]. He only appeared among men when it was made."[55] It is worth noting that several of Jangarh's portrayals of deities in his paintings appear to be inspired by the outer contours of the *bana.*[56]

Fig. 19 Thahi Dev, a Pardhan deity. This depiction has an obvious affinity with the traditional Pardhan *dhigna* wall and floor painting. Jangarh Singh Shyam, early 1980s, pigment on paper, 55 x 35 cm. Collection: Bharat Bhavan, Bhopal. Image reproduced from J. Swaminathan, *The Perceiving Fingers*, Fig. 17 on p. 6

Fig. 20 Detail of traditional clay relief work of Pardhan houses. Image reproduced from Shamrao Hivale, *The Pardhans of the Upper Narbada Valley*, p. 45

52 Sathyu 1998: 5
53 Kramrisch 1968: 52
54 Hivale 1946: 66

55 Ibid.: 66-67
56 Sathyu 1998: 5

Fig. 21

During his first encounter with paper and modern pigments, Jangarh mostly limited himself to the depiction of a lone image at the centre of the sheet, as can be seen in the early renderings of his deities, or in his portrayal of single or pairs of birds or other animals. The background was always left untouched. At this initial stage of his working with paper in Bhopal in the early 1980s, the images of his gods were more spontaneous and expressive. The deities and animals were painted in relatively flat and subdued colours, and adorned with simple and scattered dots (see Figs. 13 to 18).

Another example of Jangarh's initial perception of this new pictorial space are his early 1980s murals of birds, crocodiles and stags that he painted on the domes of Bharat Bhavan (see Figs. 60 and 61). They are in unrestrained motion and occupy their own spaces. The undulating, rippling body of the giant crocodile slithering across two fields appears autonomous, as in its natural habitat. The white expanse of the dome allows his images to move freely around the undivided spherical space, unlike that of the rectangular sheet of paper, where they had to be contained within its boundaries and were conceptualised accordingly — more like a framed portrait, centralised within its given space.

His exuberant and radiating rippled dotting in glistening bright colours, most of it as a fragmented wave motif, and the lustrous zigzag patterning as well as the intricate structuring used to portray the deities in his 1990s ink drawings had yet to appear. These works will be discussed in the following sections.

V. Printmaking

Jangarh's main job at Bharat Bhavan was as an attendant in its graphics studio, where some of the modernist artists produced signed limited editions of their works known as 'artist's prints.' Jangarh quickly mastered the medium and learnt to handle the technical aspects of the job, such as assisting the preparation of the screens, mounting them on the frame, exposing them to light and printing them. This expertise of the craft coupled with his own imaginative faculties led Jangarh to produce brilliant prints for the artists who worked there as his superiors, and later (ca. 1990-95) he began not only to screen-print his own line drawings (Fig. 22) but also his multichromatic paintings. In fact, he did not merely screen-print his ready works but often re-created them during the very process of serigraphy. He boldly began to explore the innovative possibilities of the medium through the very process of printing. He would experiment with multiple impressions, textures, stencilling, splashing inks and scraping, and scratching the silkscreen itself (see Figs. 23, 24, 25). In a sense, each such result was a 'mono-print' — a unique and original work, of which there were hardly two of the same. Generally, Jangarh's multichrome prints were not made using separate screens for each colour, but by blocking certain colour areas on the same screen while printing each colour. These mediations of tone, texture, volume and precision may have partially come from the modernist environment of Bharat Bhavan, but he fearlessly crossed the academic boundaries of the discipline of printmaking compared

Fig. 21 A shrine dedicated to the goddess Durga and to Shiva, at Jangarh's residence in Bhopal. Photo courtesy: Jyotindra Jain, New Delhi

Fig. 22 A serigraph of a line-drawing depicting a bullock, a peacock, an owl and *sanphadki*, the latter being a mythical snake/bird whose shadow is believed to cause the instant death of its receiver, followed by its own demise. Jangarh Singh Shyam, 1994, serigraph, 50 x 65 cm. Collection and image courtesy: Ashish Swami

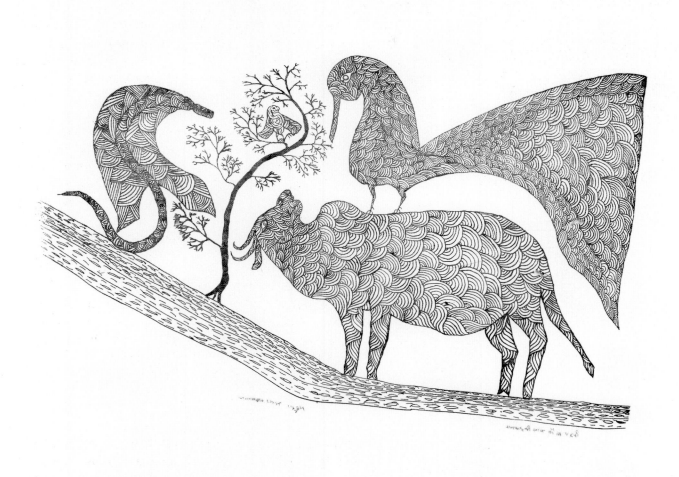

Fig. 22

to some of the art school trained artists around him, who often remained rigidly loyal to the medium. In order to have more freedom of experimentation and to distance himself from the intimidating comments of the art school trained artists and others around him at the graphics studio, Jangarh set up an alternative print-making facility outside. He began to silkscreen his works at home, expose them in the open sun and then print them at his friend Ram Singh's house in Bhopal where he had installed a makeshift printmaking facility. Jangarh's prints were a highlight of the Bharat Bhavan International Print Biennial, held in Bhopal in 1990.

Jangarh had attained great proficiency in fine black ink line drawings, which allowed him to play with textures and refine the personas of his gods and the characters of his legends. Jangarh also began to produce serigraphs of his line drawings to cope with the fast-growing demand for his work. When he participated in the Surajkund Crafts

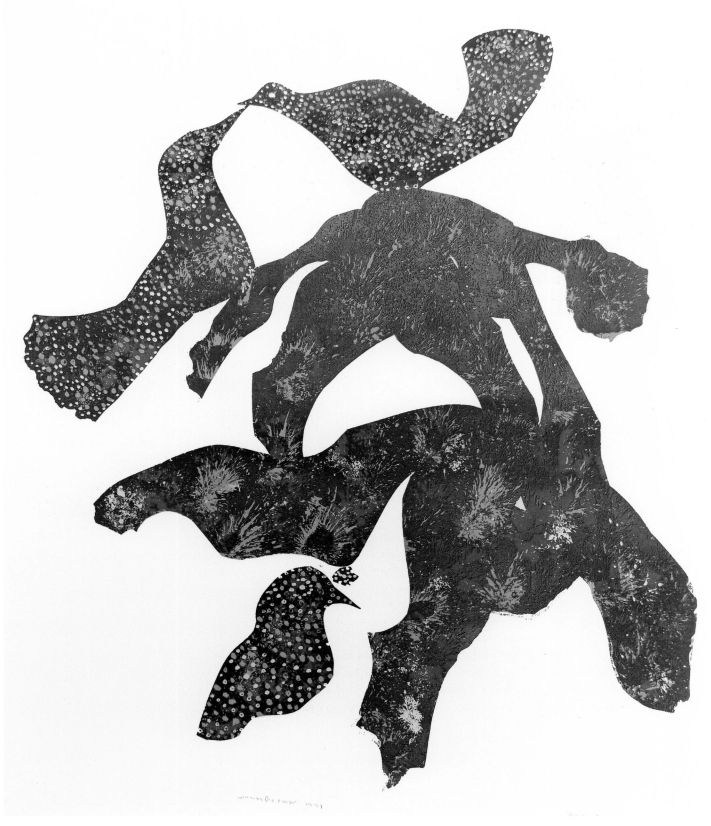

Fig. 23

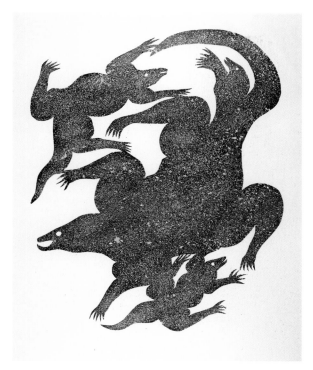

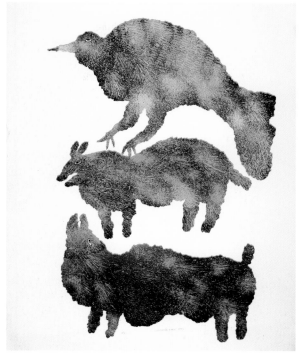

Fig. 24 Fig. 25

Mela[57] as a 'craftsman' in 1989, for example, he brought along a large pile of signed, numbered and dated serigraphs of his works. They were sold out within a week.

VI. Jangarh, Theatre and Music

As mentioned earlier, the Pardhans served as bards and travelling minstrels for the Gonds, narrating the history and mythology of the lost Gond kingdoms, their heroes and battles while accompanied by the *bana*, the musical instrument believed to be the abode of their chief deity Bara Dev. In fact, the *bana* is often considered to be Bara Dev himself. Though Jangarh never worked as a minstrel himself, music was in his blood. Ram Singh, his boyhood friend, says that they were both fond of the Ramleela theatre and watched many performances in Patangarh and around.

After coming to Bhopal, Jangarh developed close relationships with the stalwarts of modern theatre of the 1980s and 90s at Bharat Bhavan as well as in Bombay (now Mumbai) and Delhi. Ashish Swami,[58] a close friend of Jangarh's, told me that Jangarh was always present at the theatrical performances put up by

Fig. 23 A multichrome serigraph created with experimental splashing of inks. Jangarh Singh Shyam, 1991, serigraph, 65 x 40 cm. Collection and image courtesy: Ashish Swami

Fig. 24 *Chhipkali*; Lizards. Jangarh Singh Shyam, 1991, serigraph, 59 x 45.5 cm. Image courtesy: Museum of Art & Photography (MAP), Bangalore (PTG.01827)

Fig. 25 Giant bird swooping on two beasts. Jangarh Singh Shyam, 1997, serigraph, 66 x 51.5 cm. Image courtesy: Museum of Art & Photography (MAP), Bangalore (PTG.01825)

57 The Surajkund Crafts Mela is one of the major crafts bazaars of the country, organised by the Government of Haryana in collaboration with the Government of India

It is a 14-day event held annually in February, in Surajkund in Haryana, with over 300 craftspersons selling their wares directly to the buyer, without a middleman

58 Ashish Swami, a Shantiniketan-trained artist, was a close friend of Jangarh's and had worked as a technical expert on the murals painted by Jangarh at Vidhan Bhavan, Bhopal

Rangmandal, the theatre unit of Bharat Bhavan, and that he developed friendships with theatremakers Javed Zaidi, Dwarika, Amar Singh, Mahendra Raghuvanshi, Jayant Deshmukh, Vibha Mishra, etc. He held B.V. Karanth, the Director of Rangmandal at the time, in high esteem, and visited Delhi frequently. There he stayed mostly at the Lalit Kala Akademi's guesthouse, which was situated in the compound of the National School of Drama, where he grew close to several young students as well as actors and directors. Jangarh even designed some of the props and a poster for the play *Neeli Jheel ka Tantrik*, based on a novel by Dharmveer Bharti and directed by Lokendra Trivedi, which was presented in Delhi in November 1989 (Fig. 26). The conceptualisation of the tantric as it appeared on the poster was a result of his profound interest in portraying gods, priests, shamans, ghosts and tantrics. The entire bulk of his monochromatic drawings of the 1990s explored the technique of zigzag drawing, which he employed for creating the image of the tantric on the 1989 poster.

The gallery Art Heritage, run by theatre pioneer Ebrahim Alkazi, held an exhibition of Jangarh's paintings in 1990-91, introducing his work to the modern and contemporary art world of Delhi in a major way.

During his visits to Bombay, he would always visit the Prithvi Theatre in Juhu, where he often met Sanjana Kapoor, Sunil Shanbag, M.S. Sathyu, Shama Zaidi, etc., and some of them also acquired his paintings.

On the musical front, Jangarh was fond of listening to the renowned Pandawani singers Teejanbai and Ritu Verma, with whom he had developed a personal rapport. Jangarh himself was an accomplished singer and a flutist. Ashish Swami recollects that at a musical evening in memory of Begum Akhtar organised at the house of the renowned singer Rita Ganguly, Jangarh sang one of his favourite songs *mor desh ma bihan hoigava, bairi bairi man bhanwra nadan hoigava* (Morning has dawned in my village, and my heart, turning into my enemy, has become a restless, innocent bee). Similarly, when he participated in the Surajkund Crafts Mela in 1989, he sang many songs along with Nagin Tanvir, daughter of the renowned theatre personality Habib Tanvir.

Jangarh consciously sought out and pursued these friendships and associations, realising how deeply they nurtured his expressive potential and aptitude. He moved easily between his own creative universe and the 'art world.'

VII. The Vidhan Bhavan Mural Project (1996) and the Consolidation of the Pardhan Idiom of Painting

After the renowned architect Charles Correa had designed the building of the Crafts Museum in New Delhi, where I was Director, he and I developed a wonderful rapport about museums and museum spaces. He would ask me to join him on site visits at some of his projects, such as the Jawahar Kala Kendra (JKK) in Jaipur

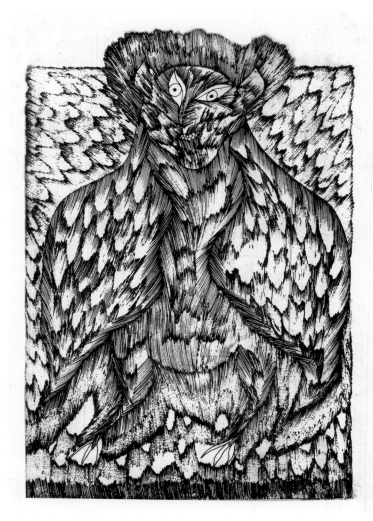

Fig. 26

and the Vidhan Bhavan in Bhopal, and I was always happy to oblige and deepen my understanding of the scope, spatial and otherwise, of museums.

Correa and I conceived ideas for wall paintings in some of the building complexes designed by him. The open and semi-open public spaces at the Crafts Museum (later renamed National Handicrafts and Handlooms Museum, NHHM) had already served as canvasses for the visiting village artists, who were in residence at the museum for one month at a time. Later, as the Madhya Pradesh Vidhan Bhavan (Legislative Assembly Building) designed by Correa was nearing completion, I was invited along with the artist Manjit Bawa, to advise him on the installation of a couple of murals as well as other art works to be displayed in the building.

It was decided to commission two large-scale murals for the walls of the building. I suggested commissioning at least one of the two murals from a tribal

artist, which I felt would only be appropriate, given that the then undivided state of Madhya Pradesh had a large tribal population. I recommended Jangarh for painting murals on one large area of the building. Correa and M.N. Buch, a senior bureaucrat, who was handling the project from the Government side, immediately agreed. The idea was to have the second mural done by a modern artist. I recall that Manjit Bawa was very keen to take on the job. The artist M.F. Husain, too, was mentioned.[59] On the question of whether a member of the advisory himself could be given such a commission, Bawa quit the advisory committee on moral grounds. I was again consulted on the issue and suggested the artist Gulammohammed Sheikh, who went on to execute the mural (a canvas painting affixed to the wall).

Besides the murals, a large collection of artworks was put together for display in the various rooms, halls and passages of Vidhan Bhavan. These included works by tribal and folk as well as by modern artists. Robin David was principally in charge of selecting works by artists from Madhya Pradesh, while Manjit Bawa procured the ones from Delhi, Bombay and elsewhere in India.

The artworks installed or displayed in several of Correa's projects, including at Jawahar Kala Kendra and Vidhan Bhavan, were not mere embellishments of the interior spaces. At JKK the cosmographic murals were directly related to the basic plan of the building complex, which metaphorically reflected the constellation of the nine planets. Similarly, the artworks at Vidhan Bhavan largely came from the formidable but marginalised tribal communities of Madhya Pradesh, for whom, too, laws would be legislated in the building. I must pause here and relate an anecdote that says a lot about Correa's thoughtful and highly layered philosophy of integrating works of art in his architectural projects. When the Vidhan Bhavan complex was nearing completion, the question arose of where to place an artwork by the artist Reghu entitled 'Family' and comprising three terracotta figures — a man, a woman and a child. The triad looked poor and helpless, with their mouths hanging open, staring skywards. Correa and I took a round of the entire building complex to find the right spot for their display. As we stepped out of the building onto the attached lawn next to the driveway leading to the entrance gate, Correa's eyes brightened. He said that we should place the fearful and helpless 'Family' at the periphery of the lawn near the gate, because these people, on behalf of whom the Assembly would soon legislate inside the building, would be too frightened to cross the threshold beyond the entrance. The impromptu decision for the placement of Reghu's terracotta family at the entrance spoke volumes to me about Correa's thoughts behind meaningfully incorporating artworks into his architectural projects.

Coming back to Jangarh's murals at Vidhan Bhavan, the question arose whether Jangarh would be able to handle executing a work on such a large scale — 6,500 sqft — something he had never done before. The government agreed to my suggestion to provide Jangarh the assistance of a 'technical expert.' Ashish Swami, a Shantiniketan-trained artist and a theatre associate, was appointed for the task. Ashish shared a close friendship with Jangarh and enjoyed his confidence. The two

had often travelled together to Delhi and Bombay and spent time meeting theatre artists and visiting art galleries. This had contributed immensely to Jangarh's exposure to the formal art world and its ways.

Before starting work on the mega mural project at Vidhan Bhavan, Jangarh came to the Crafts Museum in Delhi for a fortnight to seek my guidance on the spaces and the layout of the murals. I suggested that a scale thermocol model of that section of the building where the murals were to be installed be made, so that Jangarh could prepare a rough layout of the paintings on paper, approximating the broad concept he had in mind and pasting these on the walls of the thermocol model. This helped Jangarh to articulate his ideas for such a large-scale mural. When the model with the basic layout of the spaces and broad thematic ideas was completed, he dismantled it along each wall panel, and carried the pieces to Bhopal by train. Of course, the paintings as pasted on the model underwent several transformations during the process of creating the mural, but already at the preliminary sketch level, Jangarh had divided each wall section into three horizontal and loosely parallel bands, of which the top one in blue represented the sky, the middle one in green corresponded to forests and trees, and the brown one at the bottom stood for the earth and the underworld (Fig. 27). Once these different realms were marked, Jangarh peopled them with his gods, and the flora and fauna embedded in his memory comprising trees, birds, animals, reptiles and aquatic creatures (Fig. 28) to which were added a mammoth airplane (Fig. 29) and a leaping tiger (Fig. 30). According to Jangarh, the vast and alluring painterly space of the murals not only anticipated and determined the large scale of the images but also seduced him to add new ones, such as the colossal airplane, the gigantic tiger and the majestic bird about to take flight.

Ashish Swami was always present on site. He not only looked after the practicalities of procuring art materials, mixing the colours, and so on, but also occasionally helped Jangarh make the first sketch of some of the figures, if Jangarh sought his assistance (Fig. 31). For example, behind the initial sketch of the figure of the large tiger leaping across the three horizontal bands of the sky, the forest and the earth, an art-school trained hand — Ashish Swami's, apparently — is clearly discernible. The realistic rendering of the bulging jaws, the unfaltering, confident sweeps characterising the head, the slightly undulated tongue jutting out of the beast's mouth (Figs. 32 and 33) and the fully extended body and legs filled with pent-up energy as it leaps forward (Fig. 34) seems to have appealed to Jangarh immensely. Yet it stands oddly estranged amidst the other imaginary figures, such as the large majestic bird with open wings (Fig. 35), or its other variations (Fig. 36), the magnificent rendering of a beast attacking a flock of birds perching on a tree, which characteristically flies away in a winding row (see Fig. 27), or even the group of small, moth-like airplanes (see Fig. 29), which all stemmed from Jangarh's own visual vocabulary and which appear lively and animated in

59 Information: Ashish Swami

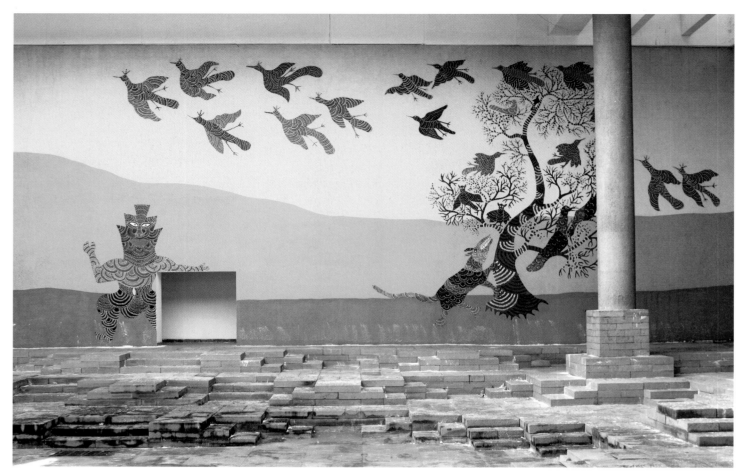

Fig. 27

Fig. 27 Detail of a mural at Vidhan Bhavan, Bhopal, showing the division of spaces into the sky (blue), the forests (green), and the earth and underworld (brown) serving as backdrop to the painting. Image courtesy: Jangarh Singh Shyam, 1996

Fig. 28 Detail of a mural at Vidhan Bhavan, Bhopal, showing crocodiles and a giant bird. Image courtesy: Jangarh Singh Shyam, 1996

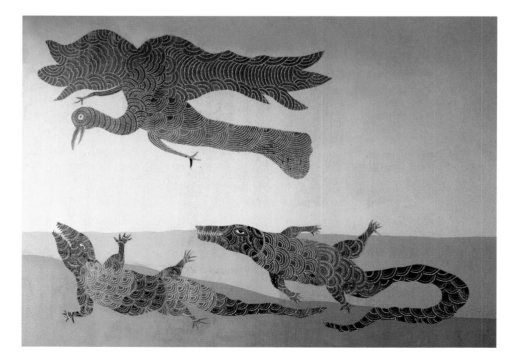

Fig. 28

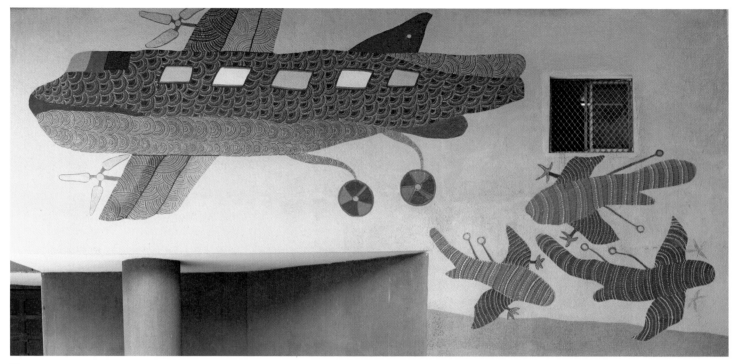

Fig. 29

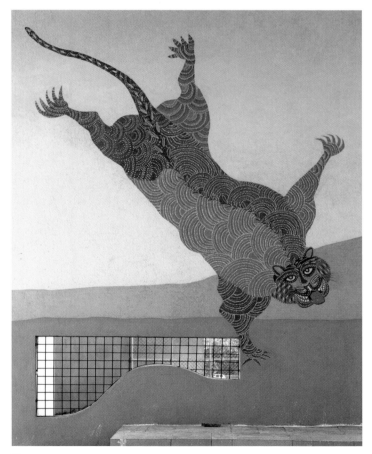

Fig. 30

Fig. 29 Detail of a mural at Vidhan Bhavan, Bhopal, showing a mammoth airplane in the proximity of small, bird-like planes. Image courtesy: Jangarh Singh Shyam, 1996

Fig. 30 Detail of a mural at Vidhan Bhavan, Bhopal, showing a large, leaping tiger. Image courtesy: Jangarh Singh Shyam, 1996

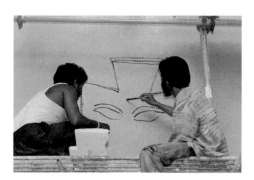

Fig. 31

Fig. 32

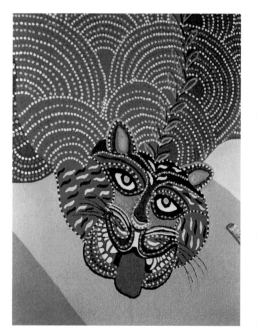

Fig. 33

contrast to the profane, textbook tiger that seems out of place in the overall pictorial schemata of the mural.[60] After Jangarh's lessons in incorporating the 'new' in his well-rehearsed visual language in limning the figure of a tiger in the Vidhan Bhavan murals, he often improvised upon the exciting discovery of transforming the received into the personal. The tiger in Fig. 37 is a part of that series.

The same is the case with the gigantic image of the airplane, which appears incongruous and received, compared to the rest of Jangarh's image world. Nevertheless, Jangarh apparently took a fancy to this new profane element in his painting, which brought about a sort of "revaluation of values."[61] Just below the giant airplane is a cluster of Jangarh's small aircrafts, which move playfully in a group, where the process of metamorphosis from bird to aircraft is evident (see Fig. 29). They bear resemblance to moths or birds, and stand out as creatures of the artist's imagination, unlike the inert and immobile giant machine, at once informed by the rules of perspective drawing and adhering to an unusual technical accuracy of depicting the cockpit, the propellers, the windows, the wings, as well as in dimensionally differentiating the underbelly from the elevation — all indicating the presence of a realistic and precise mechanical drawing beneath. The atypical presence of the image of the leaping tiger and the mammoth airplane clearly derives from a completely different visual catalogue than Jangarh's own.

However, it must be mentioned here that Jangarh, while being charmed by the perspectival and true-to-life renderings of the tiger and the airplane, did make them fully his own by covering them with his characteristic dotted fragmented wave patterns. Interestingly, Jangarh's surface patterning is somewhat in alignment with the principles of chiaroscuro and perspective, which were apparently indicated in the original academic drawings. Jangarh did not do away with these markers of realism but engaged with them by adapting his fragmented wave patterns to convey shade and light. He divided the bodies of the tiger and the airplane into darker and lighter sections, so as to intentionally retain the unfamiliar idea of dimensionality, while attempting to include the two newcomers in the overall visual scheme of the murals. This is a case of "art that neither meets the traditional criteria for art nor unambiguously belongs to the profane realm, while incorporating traits of both and taking their interrelationship as a theme."[62]

This concurrence of culturally rooted (albeit not static) and extraneous or profane imagery partially results from the joint execution of the murals. Yet Jangarh, the perpetual experimenter, saw new aesthetic and cultural value in these radical transgressions, and absorbed them into the larger scheme of his visual archive, while allowing their extraneous but auratic character to endure. As pointed out by Groys: "Both art and theory derive their effects, not from an external value-free principle, but from the tension between the different value levels that they embrace: the greater the tension, the greater the effect."[63]

The new perceptions that Jangarh developed while co-creating the mammoth airplane at Vidhan Bhavan, in a subsequent painting (Fig. 38), led him to transform the giant, immobile intruder into a more lively and humane creature. In doing so,

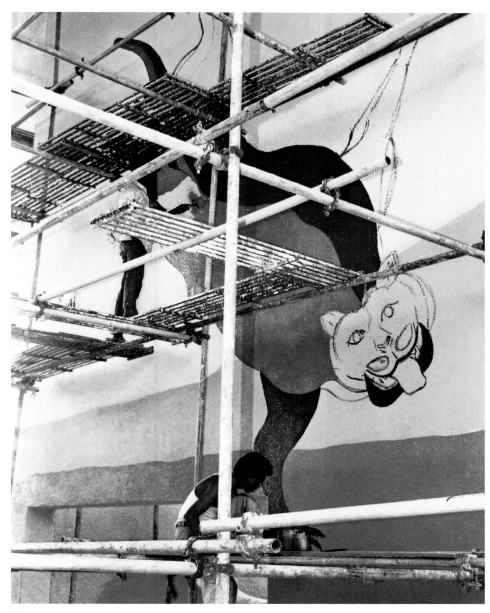

Fig. 34

Fig. 31 Ashish Swami (right) assisting Jangarh (left) in making the first drawing of Bara Dev at the site of the murals at Vidhan Bhavan, Bhopal, 1996. Image courtesy: Jangarh Singh Shyam

Fig. 32 Detail of the first sketch of the figure of the leaping tiger at the site of the murals at Vidhan Bhavan, Bhopal, clearly showing an art-school trained hand behind it, 1996. Image courtesy: Jangarh Singh Shyam

Fig. 33 Detail of the leaping tiger at the site of the murals at Vidhan Bhavan, Bhopal, after Jangarh reworked the initial sketch, 1996. Image courtesy: Jangarh Singh Shyam

Fig. 34 Work in progress on the murals at Vidhan Bhavan, Bhopal: Pardhan artists from Jangarh's team working on the sketch of the tiger, 1996. Image courtesy: Jangarh Singh Shyam

60 Also see Gulammohammed Sheikh's observation in this regard: "Does not the grand, leaping posture of the tiger disguise the hidden suggestion of a sprawled-out skin and the 'life-like' head as a trophy of a hunt?" Sheikh 1998: 27

61 Groys 2014: 10
62 Ibid.: 90
63 Ibid.: 81-82

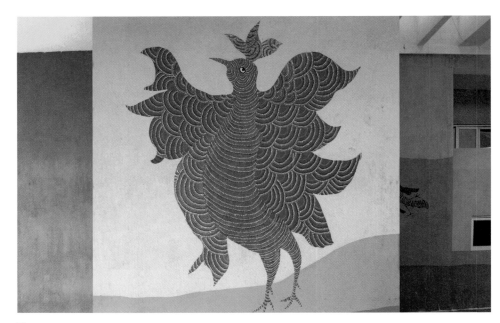

Fig. 35

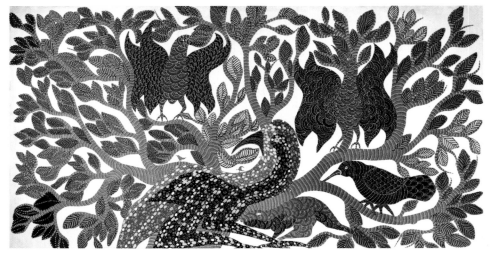

Fig. 36

he did not simply revert to his past rendering of the airplane as a bird or a fish, disregarding the new lessons in naturalistic conception but imbibed them into this idiom. He also provided a context to his mediated machine by depicting how, due to its loud, terrifying sound, the birds peacefully perched on the trees get frightened and fly away. In contrast, the giant machine transplanted onto the Vidhan Bhavan mural has no such context.

As the Vidhan Bhavan mural project was too large for Jangarh to handle alone, he put together a team of Pardhan boys from his village and neighbouring areas, who joined him in Bhopal. Some of them had previously already assisted Jangarh in filling colours or finishing certain areas of his larger works under his guidance.

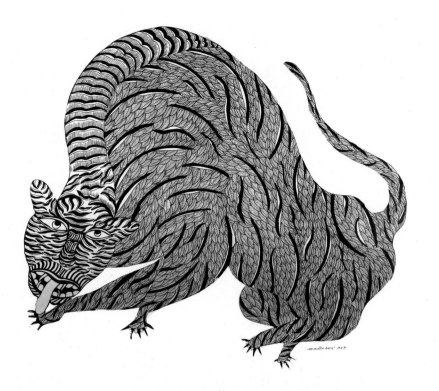

Fig. 37

In the process, several of his relatives and village friends were introduced to painting. The main artists who participated in the Vidhan Bhavan mural were Ram Singh Urveti, Narmada Prasad Tekam, Suresh Dhurve and Sumer Singh Kushram, in association with Subhash Vyam, Bhajju Shyam, Anand Shyam, Kalavati Shyam, Mohan Singh Shyam and Bhagat Singh. A few others came and went. Except for Bhagat Singh, who was a Gond and more of a general assistant, all the others were Pardhans. The Vidhan Bhavan murals thus were instrumental in bringing about and consolidating the 'Pardhan idiom' of painting, which flourished in Bhopal from the mid-1980s onwards under the misnomer 'Gond School,' as explained earlier. The participating artists were paid between Rs. 3,000 and Rs. 5,000 by Jangarh from his own fee, depending on the extent of their involvement.

Interestingly, it was this mega mural project that led several young Pardhan men around Jangarh to take up art as a career. They began work following the so-called 'Jangarh idiom' but eventually developed their own individual languages of expression. It is this diversification of individual artists that collectively constitutes the Pardhan school or idiom, which, when narrowed down to Jangarh alone, would be too exclusivist and unfair to a large number of post-Jangarh Pardhan artists, including his own son, who once said: "I do cityscapes, as like my father I did not grow up in a village but in the modern city of Bhopal. I reflect in my work, the environment in which I live."

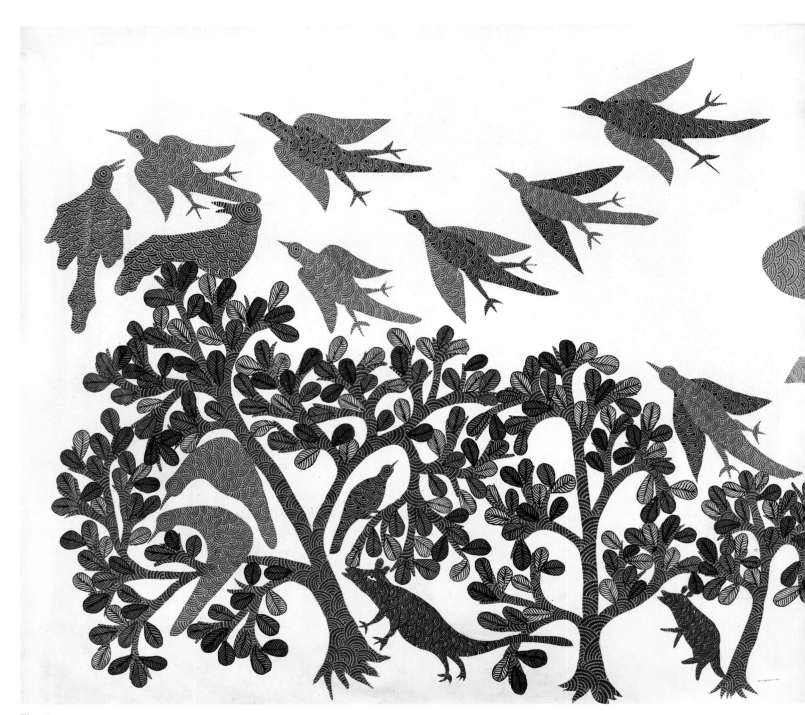

Fig. 38

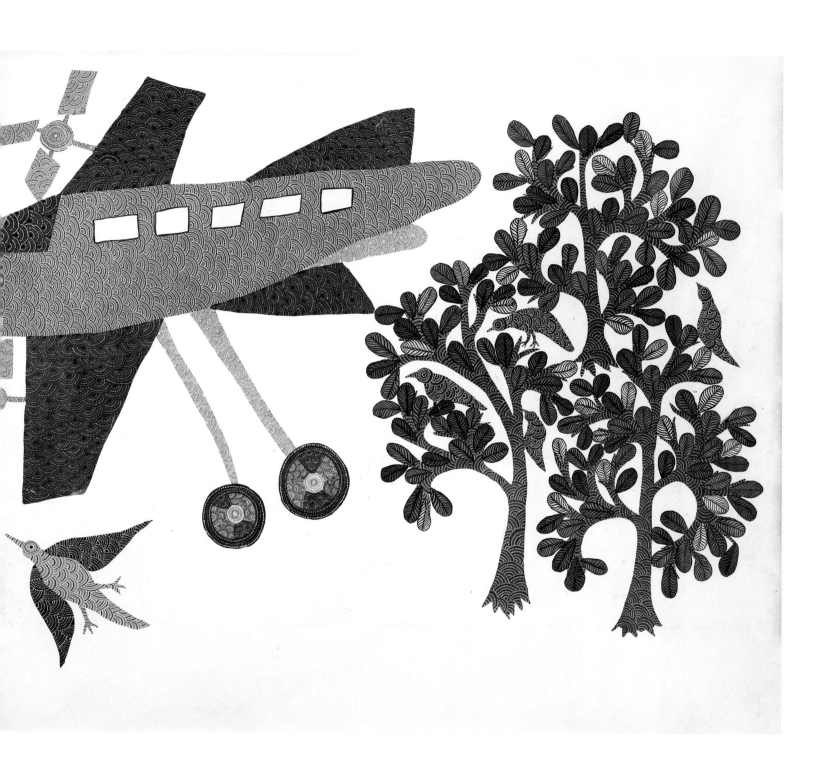

Fig. 39

VIII. The Narrative Turn

While continuing improvisations on his earlier themes of iconised single image paintings of gods, and portraits of birds in pairs, Jangarh had begun to show an interest in visual narrativisation already in the early 1980s. This shift from the iconic to the narrative has almost uniformly occurred in folk and tribal art wherever paper and modern pigments were introduced as new materials for painting — be it in Madhubani, the Warli areas or among the Pardhan artists in Bhopal. Before elaborating on this broad issue, let me mention a couple of examples of Jangarh's initial attempts in visual narrativisation. Around 1982-83 he created a painting entitled 'Kateli tree, Chameleon and Cobweb' (Fig. 39). The narrative strategy comprises a simple juxtaposition of three elements, as suggested by the title. There is no direct indication of an underlying fable or legend, or indeed of a succession of events in time. The three juxtaposed signifiers do not tell a story but "what we see is before our mind's eye, it has already been interpreted."[64] It is the depiction of a moment frozen in narrative time, as the three seemingly unrelated images are triangulated as in a conversation, which is not the case with Jangarh's portrayal of gods or the pairs of birds he painted during this period.

The chameleon bears the same colour as its surroundings while it looks apprehensively at the cobweb. According to the artists Ram Singh and Bhajju Shyam, there is no Pardhan legend about a chameleon and a cobweb. Perhaps Jangarh saw himself as the chameleon wondering whether he would be caught in the spider's web, or thinking that the spider may have spun its web, but he would not let it trap him. This imaginary dialogue between the chameleon and the spider marked the beginning of a sort of narrative tendency in Jangarh's work. Several years later, Jangarh produced another version featuring the same theme (Fig. 40), in which the plough-shaped branch became more decorative, the cobweb transmutated into a glowing sun, and the chameleon was now attacking the latter with its swiftly unfurling tongue. It is remarkable that several of Jangarh's images behaved like living organisms, they grew and morphed over time. Over the course of several years, the curious and apprehensive chameleon of his 1982-83 painting grew up and made up its mind to attack the cobweb in the later painting. Similarly, his cobras, crocodiles, avians with large, open wings, peacocks, tigers, foxes, deer, trees, as well as his gods kept transforming and reappearing in other contexts of his vast painterly cosmos. His conglomerate of images grew into a breathing archive from which he would extract an image and re-contextualise it in the ever-growing narrative trajectory of his work. This process of consciously re-using past images in his contemporary work was by no means static or repetitive, but centrifugal and forward-looking, and therefore, in the realm of the contemporary. Here, memory images that lay inert for years in the pile of his paintings and prints would suddenly transmigrate into the ongoing cycle of narrativising the inherited stories of his community.

The new, fathomless space of the white paper that Jangarh encountered after coming to Bharat Bhavan in the early 1980s lured him to delve deep into it. The empty space of the canvas served as a screen onto which a whole storm of

Fig. 39 *Kateli* tree, Chameleon and Cobweb. Jangarh Singh Shyam, early 1980s, pigment on paper, 50 x 40 cm. Collection and image courtesy: Bharat Bhavan, Bhopal

memories and associations of his community, its forests and landscapes as well as its legends could come to life. Stories of the forest, of trees and hills as the abodes of spirits, and imaginary animals mutating into living, ebullient characters began to occupy every bit of his canvasses. The desolate white space thus became the stage for enacting his personal and collective mythologies.

Such shifts from static mono-image paintings or from traditional, symbolic and iconographic representations to more fluid yet unexplored possibilities of narrativising myths and legends, and improvising with memory images can be observed in almost all vernacular painting in India and elsewhere, where paper and canvas were introduced as new surfaces for painting. As described earlier, the advent of paper led to stunning narrative explorations in the works of the Madhubani artist Ganga Devi or the Warli artist Jivya Soma Mashe, and many others, to varying degrees. However, there are also other astonishing examples of such transformations from symbolic form to narrative rendition within a comparatively well-grounded society, once the new enters through a natural process of gradual cultural diffusion and is imbibed in the long operative cultural milieu of the latter, and with abundant aesthetic awareness, while remaining within the orbit of established ritual conventions. This modus operandi is different from the secularising process that occurred in Jangarh's case. Let me mention a concrete example of such a transformative process from the recent past.

Over the last few decades, there has been a clear shift among the Rathwas and Bhilalas from basic aniconic visual forms to more elaborate narrative imagery in their sacred wall paintings illustrating their myth of creation. According to one ethnographic field record from the 1960s,[65] many Rathwa homes painted their house walls with their deities Pithoro, Baba Ind, and others, with a definite number of vermilion dots.[66] The same record notes a single instance, at a relatively well-to-do household, of a few equestrian figures depicted in lieu of the vermilion dots — a red horse stood for twelve dots, a green one for ten and a black one for two.[67] These isolated depictions of horses in lieu of vermilion dots and thereby their deities eventually led to the visual narrativisation of the community's creation myth, whereby the horses were absorbed into the procession of deities as part of the myth. The tribals replaced the vermilion dots with equestrian figures, in imitation of the royal procession of their Rajput rulers. This crucial ethnographic evidence suggests a clear process of transformation from a singular aniconic form to a naturalistic element constituting a larger visual narrative. This was possible due to the communities' openness to contemporary interventions, but happened as routine cultural diffusion.

Besides this, such interventions in relatively self-contained societies have led to another decisive shift, namely from the oral and aural to the visual narrativisation of legends, often marked by a secularisation and modernisation process.

64 Bal 1997: 163
65 Haekel 1963

66 Ibid.: 360
67 Ibid.: 361

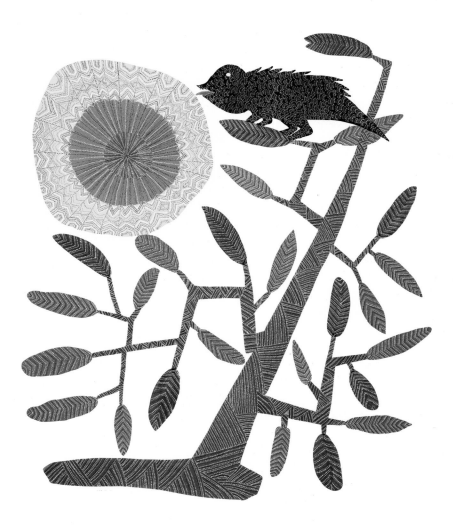

Fig. 40

Fig. 40 *Kateli* tree, Chameleon and Cobweb; a later version of Fig. 39. Jangarh Singh Shyam, 1994, pigment on paper, 183 x 152 cm. Collection and image courtesy: Museum of Art & Photography (MAP), Bangalore (PTG.0889)

As mentioned above, the Rathwa and Bhilala tribes had an earlier practice of using vermilion dots to install their deities on the sacred wall of the house, and the latter were ritualistically invoked through an oral recital of their creation myth. As the vermilion dots came to be replaced by the painted images of the characters of their creation myth, the orally recited myth now acquired a new visual form while retaining its status as a sacred object. The vermilion dots were still added to the painted depictions of the myth, to maintain the contiguity with the original markers of the deities.

It is remarkable that the conceptualisation of the myth's characters in this shift almost invariably occurs in contemporary terms. The deity Pithoro often sports Western clothes, while other divine characters are seen relaxing in colonial chairs and sofas. Both the oral narrative of the Rathwa myth of creation and its visual

depictions have continuously undergone transformations, imbibing in each rendering, elements from the present. For example, as the narrative of the myth of creation approaches the modern times, one verse describes the arrival of the colonial administrators: "Then came the *mamlatdar* (controller of lands and revenue)."[68] Another verse alludes to urban life: "Pithoro wears dark glasses, Pithoro wears a watch."[69] As described earlier, the painted versions also depict armed policemen, rifle-racks, railway trains, and even an image of a Rathwa aiming an arrow at an airplane as if shooting a bird.

Besides the gradual internal changes in beliefs and practices, which had occurred over decades and centuries in ethnic groups on account of processes of cultural diffusion as evinced above, factors such as postcolonial nation-building exercises comprising the formation of social and economic policies and development schemes, the institutionalisation of culture that brought the rural and tribal communities into its orbit via museums, galleries, art academies, ethnographic documentations and collecting practices, etc., opened up new possibilities for artistic expression for them. It is in this moment that the saga of their memories of the land, the forests and the hills, as well as their encounters with new worlds through migration finds narrative expression in concrete visual form. Often conceptualised in contemporary terms, they reflect their present social and political predicaments.

Narrative Devices in Jangarh's work

It is against this background that I will now analyse a few of Jangarh's drawings and paintings in which an explicit narrative turn is discernible. While I am aware of the overlaps in and the rather broad nature of the narrative typology within which I have bracketed the chosen paintings, it does point towards a visual narrative form that Jangarh intentionally devised for each of his drawings or paintings. My exploration works within this liberal framework. I am also aware that some of the mono-image drawings or paintings, including plain landscapes or portraits of deities or animals as described in the section entitled 'A Conjuror's Archive,' may have had a narrative context, too. My categorisation is only a working device and not a sweeping thesis.

Multiple Narratives: The Pandawani Kathas[70]

One of the masterly examples of the technique of multiple narrative devices in a single work is Fig. 41, which depicts episodes from two regional versions of stories in the same painting, i.e. the story of Sravana and King Dashrath from the Ramayana, and that of the five Pandavas and their wife Draupadi from the Mahabharata.

The whole painting is divided into irregular blocks of land, almost cartographic, wherein each block is rendered in a different colour and overlaid with intricate

68 Jain 1984: 76
69 Ibid.: 77
70 Though literally the term 'Pandawani' refers to the stories of the Pandava brothers from the epic Mahabharata, the rural Pandawani singers have incorporated the stories from the epic Ramayana in their minstrelsy

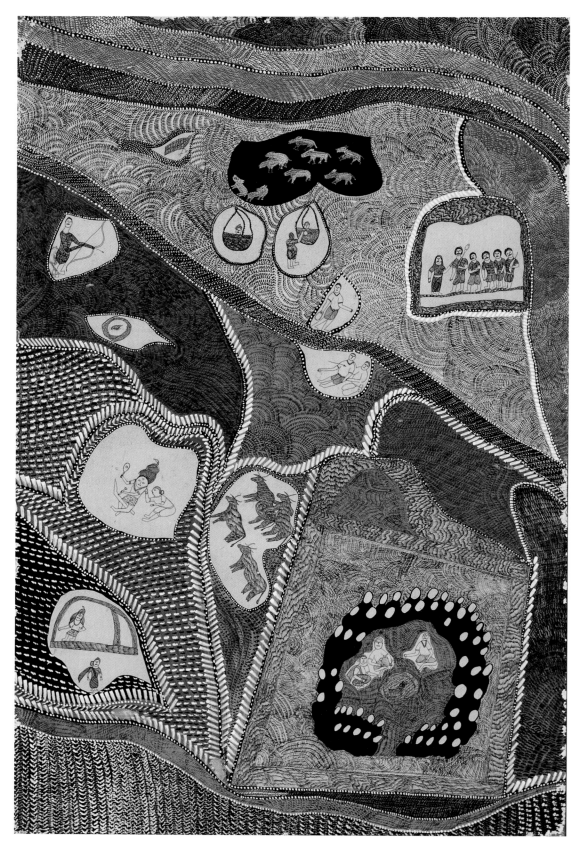

Fig. 41

textures in a darker shade, mainly using the fragmented wave, chevron or dotted pattern. The entire landscape is reminiscent of the aerial view of the ground from a mountain or an airplane — fields of different colours, forests, hills and rivulets, interspersed with an occasional settlement. The abstracted and impressionistic background landscape not only conveys the feeling of distance between the viewer's elevated vantage point and the faraway object of the gaze, but also brilliantly signifies temporal distance by indicating the hazy mythical time during which the stories of Sravana, Dashrath, the Pandavas or of Shiva and Parvati are set. The stories unfold in a series of asymmetric, off-white insets, which clearly stand out against the intricate background pattern and which show the scenes from the stories through fine ink drawings.

On the lower left side of the painting are two insets with Mahadev (another name for Shiva) and Parvati. Mahadev is seen carving a *naagar*, a plough, with the help of a chisel and a tool resembling a hammer, called *khotela*. Parvati is telling Shiva of an incident that had just occurred. She was returning from a stroll when she beheld first a group of *Sunha kutta*, wild dogs, and later a group of oxen, both trying to woo and copulate with a single female of their species. Parvati found this rather funny and burst into laughter. This enraged the two females and they prophesied that she, too, would soon have five husbands, all claiming and contesting her love. In the lower inset, Parvati is seen departing to start her new life in the Pandava realm. She is reborn as Draupadi and wedded to the five Pandavas.[71] A version of this story was created by Jangarh in clay-relief work and shown in the exhibition *Other Masters* held at the Crafts Museum, New Delhi, in 1998 (Fig. 42). Draupadi, along with her five husbands, is shown in yet another inset towards the right upper corner of the painting. A group of wild dogs and bulls, respectively, is shown in two separate places, one on the upper side and another in the lower half. In the upper left half of the painting are small insets depicting the Ramayana tale of Sravana taking his blind parents on a pilgrimage. Sravana carried his parents in a *kaavad* on his shoulder. When his parents became thirsty, he placed the *kaavad* under a tree and went to fetch water for them. Sravana was hit by an arrow shot by King Dashrath who was hunting in the forest and mistook the sound of Sravana filling up water from the river for that of a wild animal drinking water. A separate small inset shows Sravana going with a dried bottle gourd to fetch water. Dashrath aiming an arrow at Sravana is seen on the upper left, while Dashrath by the side of the dying Sravana and carrying water to the waiting parents shown seated in the two baskets of the *kaavad* is drawn in different insets. According to the artists Suresh Dhurve and Raju Singh Shyam, the bird inside a floating eye shown on the left is *phadki chidiya*, the bird living in the forest, who witnessed both the events portrayed in the painting. *Phadki chidiya* is a mythical bird, as it is omnipresent and considered to have been present when the first ever version of the tale was narrated in a cave, by the very first couple. *Phadki chidiya*

Fig. 41 Episodes from the regional Pandawani *kathas* depicting the stories of Sravana, Shiva and Parvati, and Draupadi and the Pandavas. Jangarh Singh Shyam, mid 1980s, pigment on paper, 155 x 110 cm. Collection and image courtesy: Bharat Bhavan, Bhopal

71 Unlike in the Hindu epic, Mahabharata, in which Arjuna is the hero, in Pandawani versions, it is Bhim who has that status

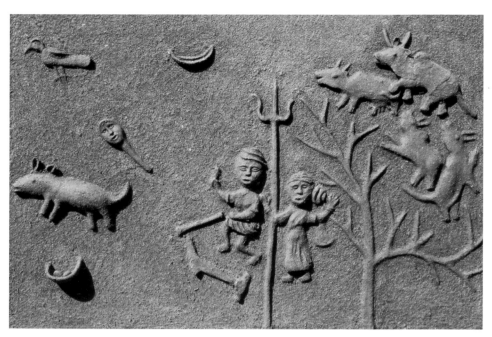

Fig. 42

also witnessed the events of the two epics, the Mahabharata and the Ramayana, unfold, and it was this bird which first narrated these stories that were later handed down from generation to generation. Once in a while on a clear, starry night, besides the constellations of *naagar*, the plough, and the hammer-like tool *khotela*, the constellation of the *phadki* bird with its two eggs can also be seen in the sky, all three to this day pointed out to children by elders.[72]

In this unique and brilliant painting, Jangarh evolved a narrative device which has no equivalent either in his own inherited tradition or in other genres of his narrative painting, such as the sequential, the monoscenic, the continuous or the scenoptic narrative, though he seems to have improvised elements from the last three — in the latter, the same characters appear on the visual plane at least twice, though not strictly within a single frame.

The scenic insets are not sequentially organised as in a comic strip, but scattered, and the viewer is expected to put together the fragments and thereby engage with the painting, not merely by passively looking at it but by 'reading' it across narrative time and space. The events of the stories of Sravana and Draupadi, respectively, stand in causal as well as spatial relationship to each other.[73]

What is also noteworthy is that the characters of these stories are shown sporting modern clothing, such as shirts and half pants, as the artist brings the past into the present, a device common to most contemporary folk or tribal narrative painting depicting the inherited legends.

Fig. 42 Episodes from the regional story of Shiva and Parvati with reference to Parvati's future incarnation as Draupadi. Jangarh Singh Shyam, 1998, clay relief work on board, 120 x 180 cm. Collection: Crafts Museum, New Delhi. Image courtesy: Jyotindra Jain, New Delhi

Composite Narrative: The Myth of Creation

Besides visually narrating stories through separate but interconnected episodes, Jangarh also evolved another complex and composite narrative device in which single episodes emerged in a continuous narrative, without indications of chronological or spatial segregation. One of the finest examples of this narrative device in Jangarh's work is the pictorialisation of the story of Kakramal[74] and Gichwamal,[75] which also happens to be the myth of creation of the Pardhans and the Gonds, but in its core form is prevalent in most of the central Indian tribal belt, and especially in the Eastern Indian tribal pockets. Jangarh has created several paintings based on this myth, using masterful technical and narrative devices. Before analysing these paintings, let me briefly outline the myth in a couple of Pardhan versions.

According to a version narrated to me by Ram Singh Urveti, Jangarh's childhood companion and a fine artist in his own right, the story begins with the Hindu concept of the four cosmic eons *(yugas)*, namely *Sat yug, Treta yug, Dvapar yug* and *Kal yug*. At the end of *Kal yug* (the Hindu apocalypse), the entire creation disappeared and all gods were destabilised. There were floods everywhere and no sign of the earth. The gods went to Bara Dev (also described as Bhagwan or Shivji) for help. Bara Dev rubbed some dirt from his body and made a crow from it, asking it to "look for clay to create the earth." The crow flew great lengths but found no clay. Finally, it went into the underworld and sat on the head of the great mythical serpent Shesha, which shook its mighty head and spat venom on the crow, which turned the bird black. The crow flew off again and spotted a protrusion above the water, on which it perched. The protrusion was actually Kakramal, the crab. The crow asked Kakramal to help him find some clay. Kakramal was friendly with Gichwamal, the earthworm. In fact, both were in a bond of friendship through the vow of *sakhi*.[76] Both went into the underworld, where the crab held the earthworm in its claws and took out some clay from beneath. They shaped it into three balls, which the crow brought to Bara Dev, who created the earth from it.

According to Ram Singh, there is more to the character of the crab Kakramal. Another version relates how, when Shiva mistakenly beheaded his own son in a fit of anger, he asked Parvati to go out and bring back the decapitated head of the first creature she met, which he would affix to the torso of the beheaded son. As Parvati went out, the first creature she saw was a crab with a trunk.[77] Shiva mounted the trunked head of the crab on his son's torso, who then became known as Ganesh. From that point onwards, the crab has had no head but only two eyes embedded in its torso, and therefore became known as *bina mund ka bagua* (the creature without a head), often posed as a riddle by travelling theatre companies

72 The story was collected by Shampa Shah from the Pardhan artists in Bhopal
73 For a more detailed articulation of this issue, see Bal 1997: 146
74 *Kakramal*, variously referred to as *Kekdamal, Kakdamal* or *Kekdamal Kshatri*
75 *Gichwamal*, variously referred to as *Kichakmal*, or *Raja Kichakmal*

76 Besides kinship relationships, the Pardhans of Patangarh have traditionally nurtured another form of mutual bond, namely *sakhi* or *bhajli* or *jamara*. This is not a consanguineous relationship but is established between two individuals through an oath. The oath is taken either by jointly sprinkling *Gangajal*, water of the river Ganga, or in front of *jamara*, young sprouts. With this ritual, two people establish a bond of a lifelong 'friendship' which lasts at least for one

generation and is a loose form of kinship. It is interesting that the *sakhi* relationship of the Pardhans is also superimposed on the characters of the Pardhan mythology
77 According to Ram Singh, during the cosmic eon of *Sat yug*, the crab had a trunk

during their village performances. In the painting under discussion, Jangarh has wondrously conflated the two separate versions into a synthetic whole.

Shampa Shah narrated to me one more version of the myth, which she collected from Pyare Lal Vyam:

> One day Bara Dev felt like creating. Rubbing a little dirt from his chest he went on creating creatures of all kind. Happy with his creation, he thought of bringing it to life on earth. However, when he looked down from the skies he could see no earth. There was only water — water everywhere. Finally, he created a crow and deputed it to bring some earth. The crow flew for three days and four nights and was completely exhausted. Suddenly, it saw something jutting out from the waters and immediately sat on it. It was the claw of Kakramal Kshatri — the crab, which was delighted to see a living creature and wanted to devour it immediately, proclaiming that it had been hungry for years. However, on hearing the crow's mission, the crab offered to help. It took the crow to the nether-world, the kingdom of Raja Nal/Raja Kichakmal [he has different names in different versions] and his queen Neel. The couple was happily gnawing away at the earth. When told about the mission, the couple flatly refused, explaining that they subsisted on it and thus could not part with it. The crab clutched Kichakmal Raja's throat so tightly, that he spat out a chunk of the earth. The crow quickly rolled it into a ball and placed it in its beak. The crow brought the lump of earth to Bara Dev, who asked the spider Makaramal to weave a web across the surface of the water, and then the Gond women were asked to plaster the earth on that fine web. Once the earth became hard and solid enough, Bara Dev populated it with his creation.[78]

Based on these myths, Jangarh created an extraordinary narrative work, in which the main characters of the legends are interwoven into a composite whole, enticing the curious onlooker on account of its tableau-esque configuration (Fig. 43). At first glance, the entire composition appears to be a spectacle of unrelated images, though it already hints at its narrative character. While the painting does not provide any indication of the temporal sequencing of the scenes, the spatial order is quite clearly structured. Below the uninhabited expanse of the sky, depicted through a seemingly endless layering of clouds, is the deluge of water. The space between the sky and the water is occupied by a majestic crow, created by Bara Dev and perched on the crab Kakramal's claw. In the portrayal of the crab, Jangarh brilliantly combined the common crab, which helped the crow obtain the clay for the creation of the earth, with the crab whose head was planted on his behead-ed son's torso by Shiva. The frequent presence of images of Ganesh in Jangarh's paintings could have two mythological references — that of the Hindu myth and that of the Pardhan story of the elephant-headed crab Kakramal (Fig. 45).

Below the space of the cosmic flood with the crab is the netherworld indicated by the serpent Shesha, on whose head the earth rests, according to Hindu myth. This dark space of the underworld is the home of Gichwamal, the earthworm, who possessed the clay from which the earth was later created by Bara Dev.

Fig. 43

Fig. 43 The Pardhan Myth of Creation. Jangarh Singh Shyam, 1997, pen and ink on canvas, 114 x 38 cm. Collection and image courtesy: Kavita Sanghi, Indore (DC.00245)

Jangarh created several versions of this theme. In one of them (Fig. 44), below the night sky studded with the proverbial 'nine lakh' stars, he has placed the magnificent figure of the crow perched on the two raised claws of the crab Kakramal emerging from the waters of the primeval deluge. At the bottom is the dark underworld, the seat of Gichwamal the earthworm. In one of the drawings relating to the same myth (Fig. 46), Jangarh has splendidly portrayed the crow's triumphant emergence from the water and taking flight to bring Bara Dev the earth for creation. He has intuitively captured the solitude of the cosmic deluge and the majestic flight of the bird by using his technique of creating luminous forms in his drawings.

In all three works, Jangarh with his pictorial minimalism and subtle imagination has skilfully recreated the fabled world in its primordial stillness, in which the entire mythical process of creation of the earth unfolds as a continuous narrative. The pictorial space itself acquires the attribute of temporality in which the narrative unfolds allegorically. In contrast, Nankushiya Shyam, Jangarh's wife and an artist herself, created a painting (Fig. 47) pertaining to the same theme in which an elephant-headed deity is shown emerging from the body of a crab. The crab's horizontally elongated body is shown with both its eyes embedded in the torso, illustrating the idiom *bina mund ka bagua* (creature without a head). Here the entire chimerical vision of the primal space and time as in Jangarh's paintings is absent, and the image adopts the form of a lifeless, derivative and commonplace icon. In another stunning portrait (Fig. 48), Jangarh has shown a crab with a trunk as in the Pardhan myth, placing the eyes on the upper edge of its body, referring to the same motif as in the myth.

Reductive Narrative: The Serpent Shesha Bearing the Earth on its Multiple Hoods

One of Jangarh's favourite themes in his painting is that of the serpent Shesha holding aloft the earth to save it from sinking into the mythical deluge. The core myth of Shesha is also central to Hinduism, and it may have migrated to the lore of the Pardhans and Gonds over decades, as is also the case with the stories of Rama and Sita, the Pandavas and Draupadi, or of Krishna, Ganesh, Hanuman, Shiva, etc., on account of prolonged cultural diffusion. Living in close proximity with their Hindu neighbours, the Gonds and Pardhans may have adopted several features from regional Hindu practices, and over time, these may have become part of their own myths and vice versa. Itinerant Pandawani singers and regional Ramleela performances, too, played a role in this process of acculturation. It is these coalesced versions, continuously in the process of transmutation on account of their multiple oral renderings, which formed the basis for Jangarh's paintings on themes such as 'Shesha and the Earth' or 'Krishna Quelling the Serpent Kaliya.' In the case of Jangarh's renderings of Sheshanaga holding the earth on its multiple hoods, the visual conceptualisation of the earth as a forested landscape, reminiscent of the age-old natural habitat of the Pardhans of the upper Narmada Valley, is immensely interesting.

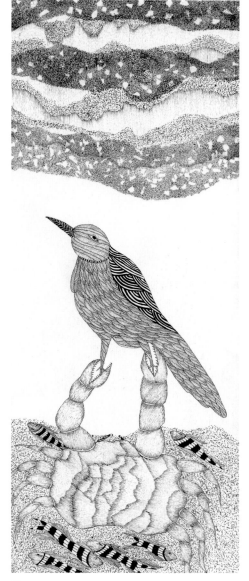

Fig. 44

Fig. 44 The Pardhan Myth of Creation. Jangarh Singh Shyam, early 1990s, ink on canvas, 114 x 38 cm. Collection and image courtesy: Kavita Sanghi, Indore (DC.00246)

78 Shampa Shah in her correspondence with the author on 18 May 2018

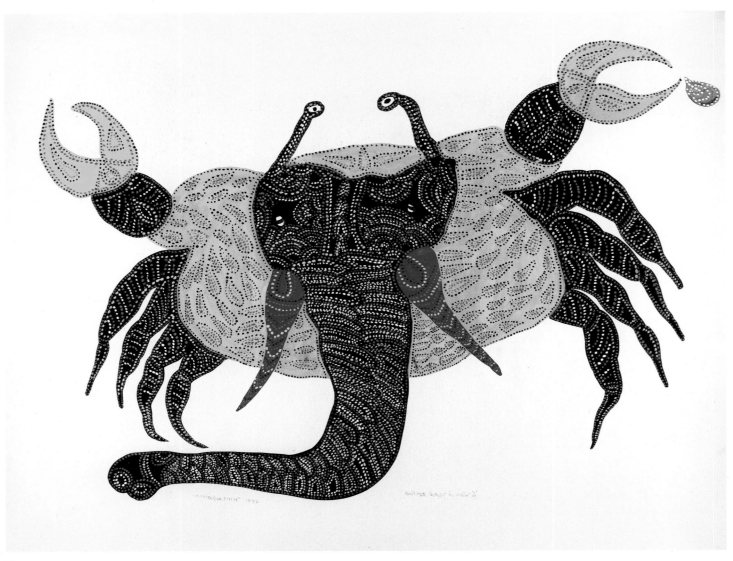

Fig. 45

Fig. 45 An Elephant-headed Crab; a character
from the Pardhan myth of creation. Jangarh
Singh Shyam, 1992, pigment on paper, 56 x
71 cm. Collection and image courtesy: Muse-
um of Art & Photography (MAP), Bangalore
(PTG.01754)

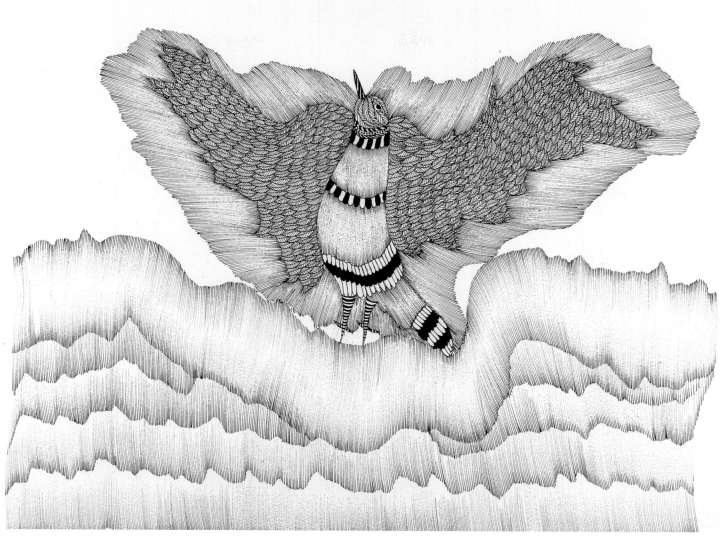

Fig. 46

Fig. 46 An episode from the Pardhan myth of creation: the crow brings earth from the under-world, for creation to take place. Jangarh Singh Shyam, 1997, pen and ink on paper, 56 x 71 cm. Collection and image courtesy: Museum of Art & Photography (MAP), Bangalore (PTG.01769)

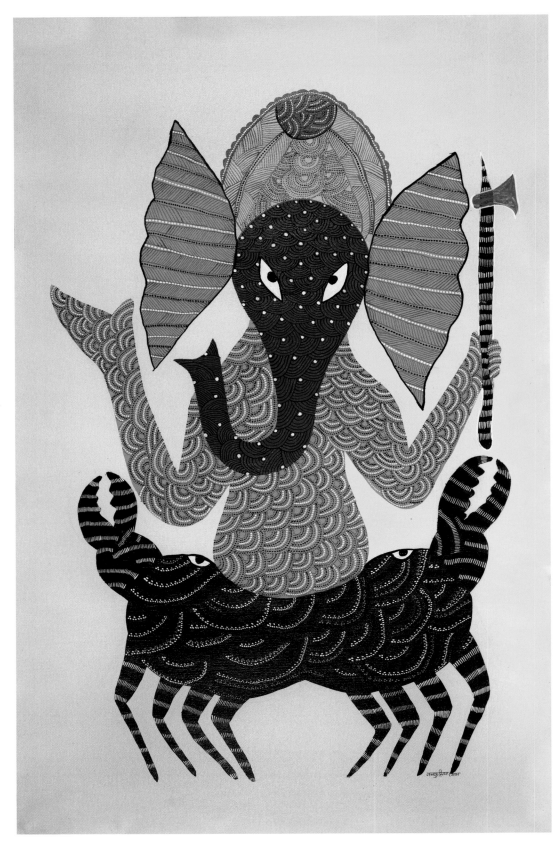

Fig. 47

Fig. 48

The Puranic Hindu myth describes Shesha, who dwells in the netherworld, wearing the entire earth as a crown. When Shesha yawns, the earth and the primordial waters shake and shiver. In the Pardhans' more didactic version, an earthquake occurs when Shesha shakes his head, disapproving of the burden of sin on earth.[79]

In a couple of variations on the theme of Shesha and the earth, Jangarh depicts the former with a prominent trident amidst his hoods. The trident, which is a Shaivite symbol, bears several meanings in the Hindu as well as the Pardhan myth of Shesha. At the time of the dissolution of creation in the last stage of the eons, Shiva, who resides in Shesha's hoods, emerged and consumed the entire creation to bring it to its final end. As mentioned earlier, Shesha spewed venom on the crow created by Bara Dev and blackened the bird, invoking the notion that Shiva resides in Shesha.[80] Jangarh, in at least three of his paintings (Figs. 49 to 51) based on the theme, displayed a fine sense of creative imagination by visually reducing the broader narrative of Shiva and Shesha into a single compact emblem, namely the trident. In his large-scale mural for the celebrated international exhibition Magiciens de la Terre, held in Paris in 1989, for which I was a consultant for the Indian vernacular art component, Jangarh had painted a version of the serpent

Fig. 47 *Ganesh aur Kekda ki Kahani.* Amalgamation of the Hindu myth of Ganesh and the Pardhan myth of creation. Nankushiya Shyam, 2011, acrylic on canvas, 118 x 75 cm. Collection and image courtesy: Museum of Art & Photography (MAP), Bangalore (PTG.0860)

Fig. 48 Pardhan conception of the crab having a trunk. Jangarh Singh Shyam, early 1990s, pigment on paper, 56 x 76 cm. Collection and image courtesy: Shama Zaidi, Mumbai

79 Information: Shampa Shah
80 In Hindu mythology, Shiva is also known as *nilakantha*, 'blue-throat,' as he had consumed poison and retained it in his throat. In fact, there is a whole trajectory of how

the benevolent Rudra of the *Rigveda* percolated into the popular, ritualistic pantheon in various forms, including as Shiva, and over centuries, began to pervade the regional belief systems, right up to the indigenous tribal populations.

As such, the presence of Shiva in tribal mythology may not always be of canonical Hindu origin. For an Indological discussion on this, see Pradhan 2014: 168-177

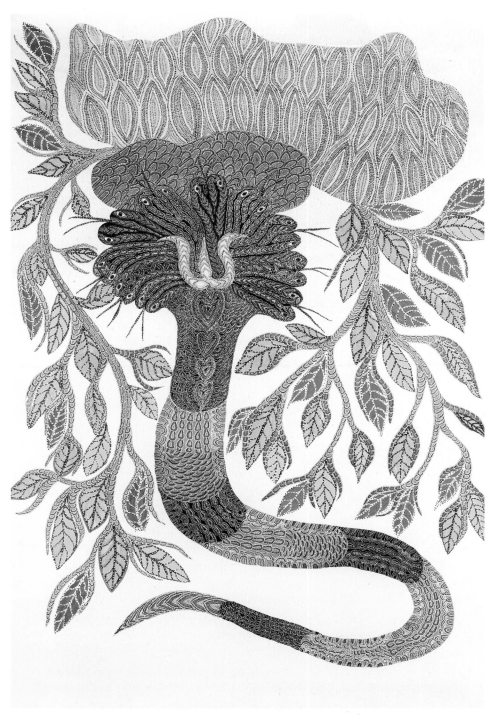

Fig. 49

Shesha holding the earth — the latter shown as a forested landscape and depicted by a large, looming tree. Here, the motif of Shesha as the abode of Shiva is prominent: he is represented by an anthropomorphic head culminating in a trident.

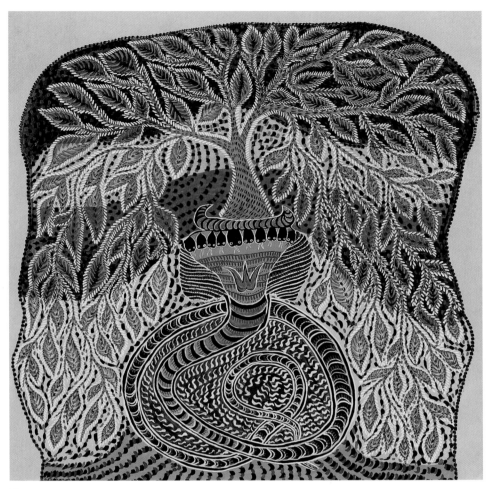

Fig. 49 The Serpent Shesha holding the Earth on its Hood. Jangarh Singh Shyam, late 1980s, pigment on paper, 150 x 100 cm. Collection and image courtesy: Museum of Art & Photography (MAP), Bangalore (PTG.0838)

Fig. 50 The Serpent Shesha holding the Earth on its Hood. Jangarh Singh Shyam, late 1980s, pigment on paper, 135 x 115 cm. Collection and image courtesy: Bharat Bhavan, Bhopal

Fig. 50

In this series, Fig. 49 shows one of Jangarh's most powerful works. The earth resting on its hoods is a rocky hill with a dense forest, with the branches of a tree hanging down to frame Shesha's head like a lustrous halo. The earth, for Jangarh, is like the memory of the immediate forested surroundings of Patangarh (Fig. 49). The serpent Shesha is treated with utmost affection and dedication, as is evident in the exuberant miniature patterning done all over its body.

Jangarh's fascination for portraying serpents in various forms was boundless. In his painting 'Krishna Quelling the Serpent Kaliya' (Fig. 52), the Hindu myth is marginalised by showing Krishna as a diminutive figure, while Kaliya is enshrined in the centre and delineated with loving textural patterns. The theme of Kaliya and Krishna seems to serve merely as an excuse for the painterly engagement with the reptile.

The paintings 'The Serpent Shesha holding the Earth on its Hood' (Figs. 49 to 51) are marvellous examples of a complex narrative abridged as magnificent icons.

Fig. 51 The Serpent Shesha holding the Earth on its Hood. Remarkably, the earth is symbolically represented by a tree in full bloom. Jangarh Singh Shyam, late 1980s, pigment on paper, 210 x 146 cm. Collection and image courtesy: Museum of Art & Photography (MAP), Bangalore (PTG.0842)

Fig. 52 Krishna Quelling the Serpent Kaliya. Jangarh Singh Shyam, 1992, pigment on paper, 57 x 72.3 cm. Collection and image courtesy: Kavita Sanghi, Indore (DC.00247)

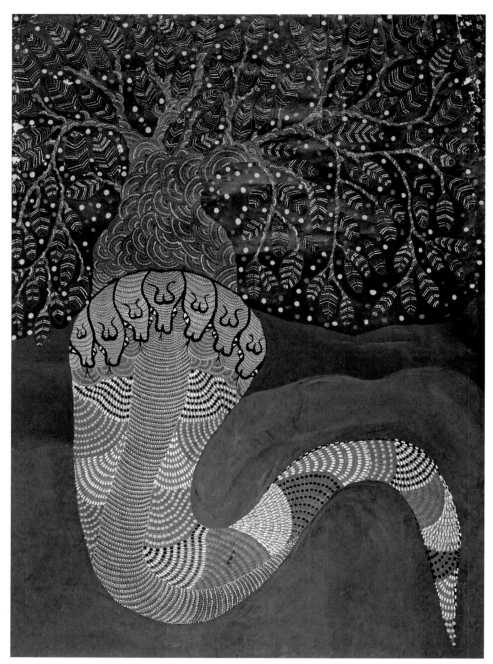

Fig. 51

Monoscenic Narratives: The Story of the Tiger and the Boar

When a longer, orally narrated story is compacted into just one climactic scene in a work of visual art, it falls under the category of monoscenic narrative. Jangarh used this form to illustrate several of his forest tales. One such was the story of the tiger (*sher*) and the boar (*suar*). The term *suar* is used for the common pig as well as the wild boar.[81] According to one version of the story narrated by Suresh Dhurve and Raju Shyam to Shampa Shah, once upon a time, a tiger and a boar

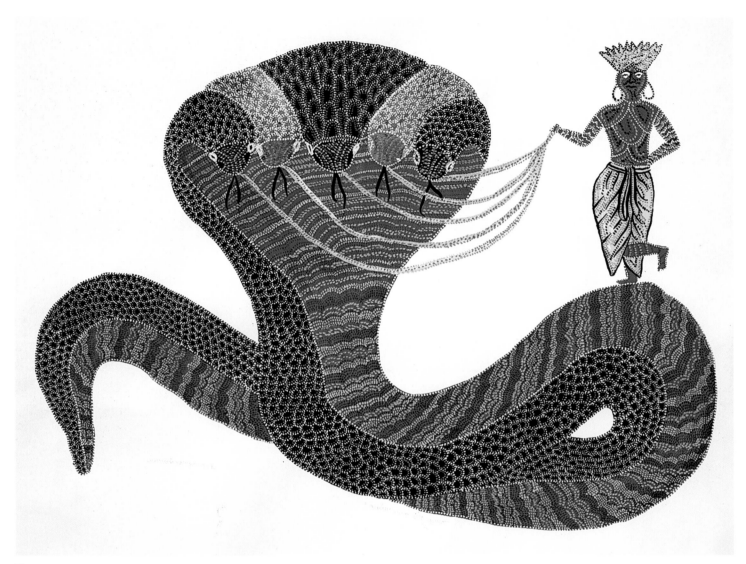

Fig. 52

were inseparable friends from their childhood on. Later, even when they had families of their own, they continued to live together.

However, when the two friends would return home in the evenings after their day's sojourn in the forest, the boar's piglets often complained about the violent behaviour of the tiger's cubs towards them. The boar decided to move away from the tiger. The tiger grieved the separation and sang to the boar: "*lahut, lahut suara*

81 *Badiya*, or the common pig, which is sterilised, roams around the village and is used for pork. It is believed that once sterilised, the energy of the animal is preserved and it grows larger. *Akala*, on the other hand, is a wild pig or a boar with tusks. A boar with large or well-developed tusks is the 'king of boars' and moves with a retinue of other male and female boars

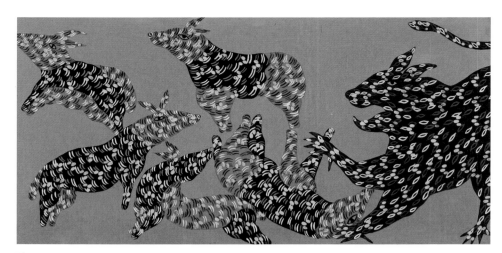

Fig. 53

mitauli, larkan ke jhagda mein kahe risauli?" ("Come back, come back, my friend, why are you so distressed just because of our children's quarrels?") Jangarh was so fond of this stanza of the song that he and his wife Nankushiya Shyam would often sing it together in chorus.[82]

Jangarh narrativised the story in one of the paintings (Fig. 53) by using the mono-scenic technique. Here the tiger is shown coaxing the boar, who is half-heartedly responding to the tiger's conciliatory gestures. Jangarh wanted to capture that moment in the story when the tiger addresses the boar with these enticing verses. In other versions (Figs. 54 and 55), the tiger steps out from behind a tree and sees the sulking boar lying on the ground, waiting to be coaxed by his old friend. Nankushiya Shyam has done a more literal rendering of the two animals in a physical embrace (Fig. 56).

An Episode from the Gond Epic

The Pardhans were the bards of the Gonds. They orally preserved the epic of the Gond kingdoms and narrated episodes to their Gond hosts during their annual *mangteri* visits to the latter's homes. The instant rendering of an episode from the Gond epic (Fig. 57) is perhaps the only painting that Jangarh ever did, pertaining to the legendary Gond kingdoms and their internecine warfare.

According to Ram Singh Urveti, Jangarh compacted the tale of the battle between two Gond chieftains, Hirakhan Kshatri and Tapsariya, in which a *sanbarah* (boar) that was sent by Tapsariya to kill Hirakhan Kshatri was in turn killed by the latter with the help of a tree. The entire episode is compendiously represented in a monoscenic mode of narration. The specific reference to killing the boar with the help of a tree stems from Jangarh's deep cultural knowledge about the habits of different birds and animals — a boar can only be successfully attacked and killed from behind, when the animal's back is turned towards a tree, which provides protection to the boar hunter.

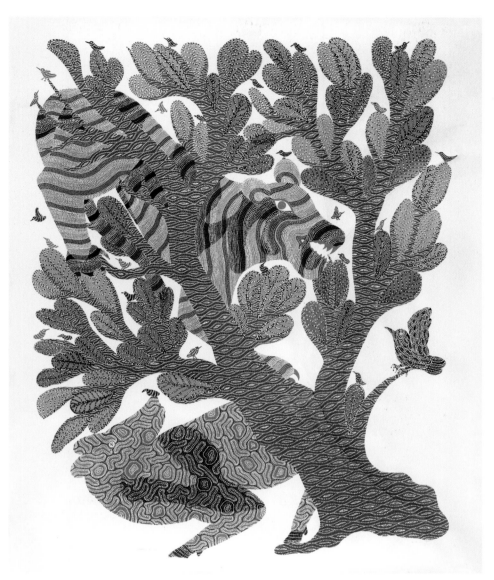

Fig. 54

IX. Retrieving the World Left Behind: A Place from Where to Speak

Jangarh settled down in Bhopal in the early 1980s. He earned both fame and fortune as an artist there. Yet, as evidenced by the profusion of paintings that he created and left behind, his village and its forested surroundings were never erased from his mind.[83] In a rare canvas painting from the early 1990s (Fig. 58), Jangarh depicts a young boy playing the flute and seated under a tree, hosting birds,

82 Information: Shampa Shah
83 Several years after moving to Bhopal he revisited his village and sang in chorus with his sisters a song that he had composed himself: 'The earth calls out, "Tell me, Raja, why are you leaving me? You will never find such love in the city as you have found in your village!",' quoted in Tully 1991: 288

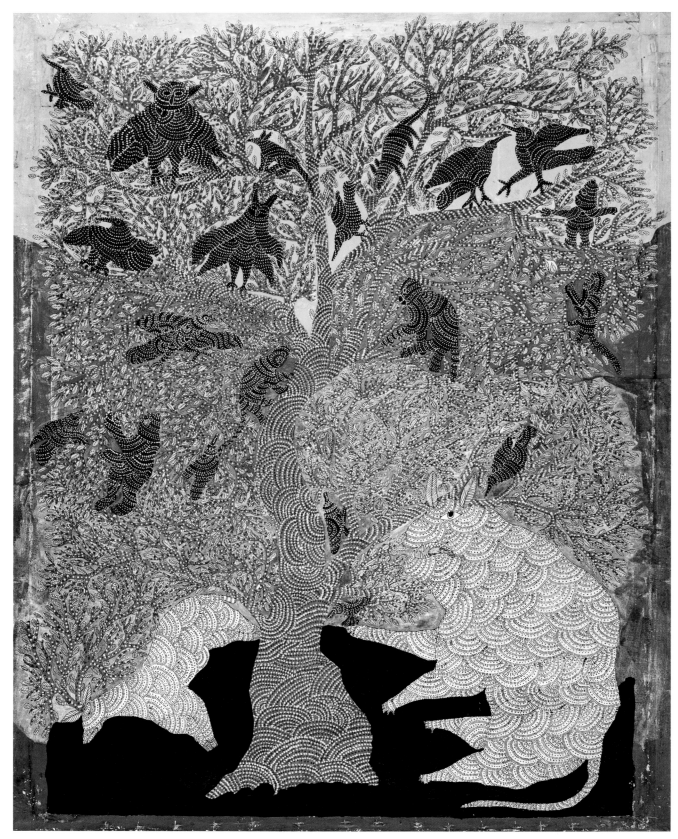

Fig. 55

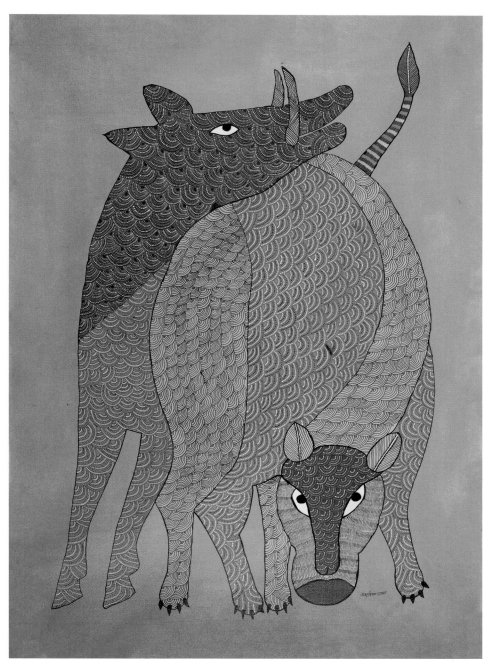

Fig. 56

Fig. 55 The Story of the Tiger and the Boar. Jangarh Singh Shyam, n.d., acrylic on canvas, 130 x 90 cm. Collection and image courtesy: Museum of Art & Photography (MAP), Bangalore (PTG.0837)

Fig. 56 *Sher aur Suar ki Kahani*; The Story of the Tiger and the Boar. Nankushiya Shyam, ca. mid 1990s, acrylic on canvas, 137 x 94 cm. Collection and image courtesy: Museum of Art & Photography (MAP), Bangalore (PTG.0863)

a beehive and a large cobra — the latter peacefully listening to the mystic melody of the flute. The boy is surrounded by cows and calves, some galloping towards him, enticed by the flute's tune. The painting is unconventionally divided, diagonally from the bottom left towards the top right. The boy, apparently a cowherd, is seated on a yellow, sunlit patch of ground while the cows seem to emerge from the emerald green pasture adjacent to it. At first glance, the painting seems to allude to the myth of Krishna, the flute-playing cowherd par excellence.

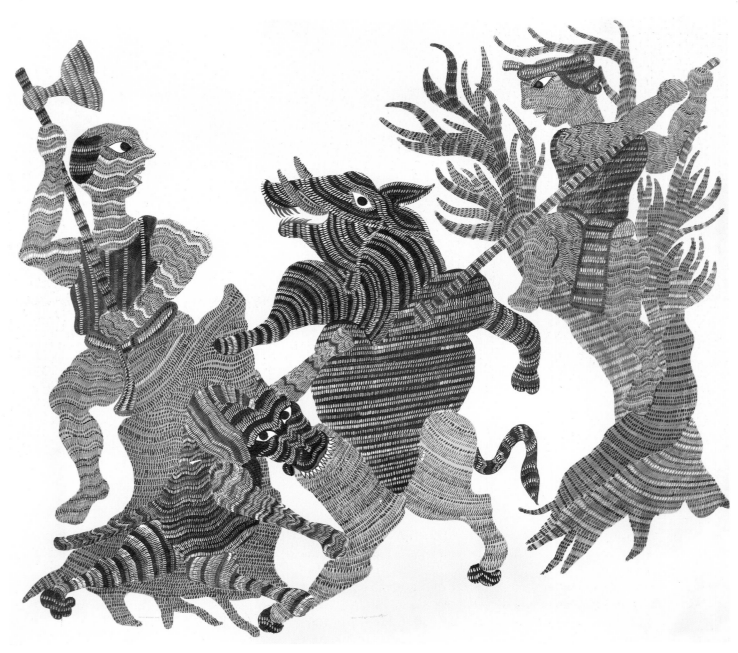

Fig. 57

However, a closer look calls attention to the fact that the boy has no typical characteristics of Krishna — no peacock feather on his forehead, no blue body — features that Jangarh carefully rendered in his painting of 'Krishna Quelling the Serpent Kaliya' (Fig. 52). Jangarh once mentioned to me that as a teenager, he used to take the cows for grazing to the village Sanpuri, next to Patangarh. His future wife Nankushiya belonged to that village. Jangarh was an accomplished flute player and told me that he would play his flute for hours, sitting under a tree, while the cows grazed. The painting, done almost a decade after his migration

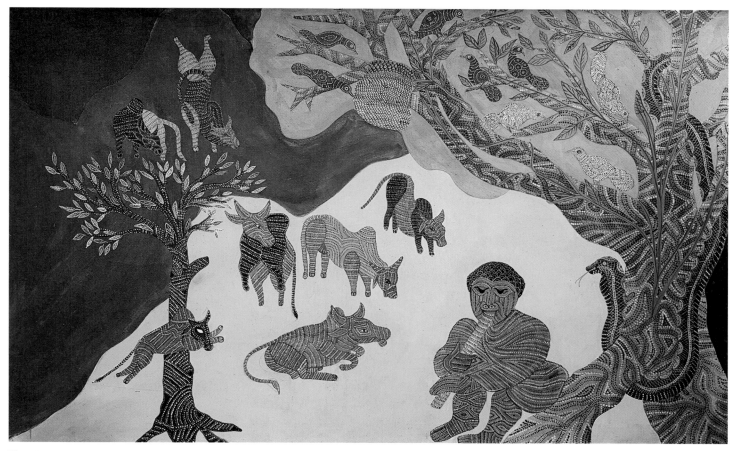

Fig. 58

to Bhopal, evokes this enigmatic binary: Jangarh's memory image of himself intertwined with the Krishna legend. In all probability, this is the only painting in which Jangarh's self-image charts out a place from where to speak. He remained haunted by the memory of his village teeming with gods and demons; shamans and priests; birds and crabs, scorpions and reptiles, lizards and crocodiles, trees and bushes. In his imagination, he continued to dwell in that world and in close proximity with them. From his earliest childhood on he had observed their characteristics, their body language, habits and peculiarities of behaviour, and had heard fables and legends about them. They had played a pivotal role in his life and beliefs, and had continued to emerge and re-emerge in different incarnations in his thought until they were given a tangible visual form in the body of his paintings. This entire realm that had remained latent in his mind's eye over the years, began to come alive, image by image, in response to the new, alluring and pristine space of the white paper, which was offered to him in Bhopal. As the concepts began to move from one context to another, a highly personalised range of images began to attain visual form in the very process of their creation.

As can be observed from his large oeuvre, Jangarh felt most comfortable with the pictorial narration of the forest legends that he had heard as a child. Often,

Fig. 57 An anecdote from the Gond epic: the annihilation of *sanbarah*, the boar. Jangarh Singh Shyam, 1992, pigment on paper, 144 x 162 cm. Collection and image courtesy: Museum of Art & Photography (MAP), Bangalore (PTG.0856)

Fig. 58 Young Boy Playing the Flute in the Forest (self portrait?). Jangarh Singh Shyam, ca. mid 1990s, acrylic on canvas, 75 x 110 cm. Collection and image courtesy: Mark Tully and Gillian Wright, New Delhi

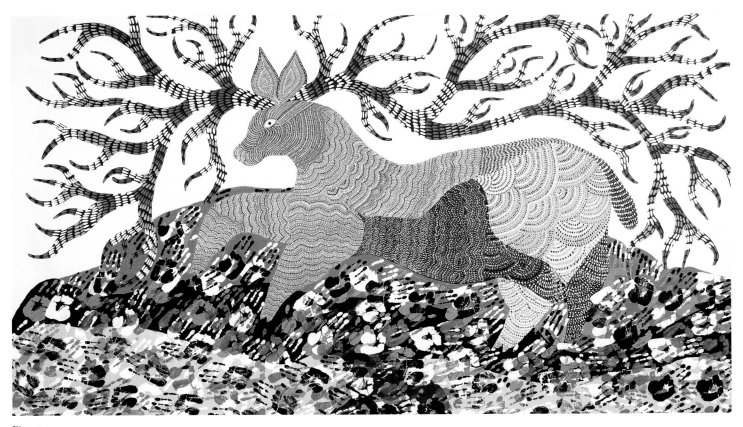

Fig. 59

a single image that appeared on his canvas, such as a tree, an animal or a fantastical creature, was actually part of a larger narrative. Jangarh's continuous engagement with the natural environment from which he came, also raises the larger issues of nostalgia, autochthony, memory and belonging as a place from where to speak.[84] That said, we must recognise the subtle paradox in Jangarh's complex case as an artist — the place from where he spoke was not the actual world left behind, but the world he redeemed and recreated in his paintings.

This sense of loss and nostalgia arose not merely from his migration to Bhopal, but also from the long-drawn tribal communities' experience of their forests depleting and the gradual but definite erosion of their age-old way of life deeply rooted in the forest. The twenty-ninth review report on the safeguards for tribals points out how, on account of the Government's Forest Policy, "tribals have been robbed of their forests. ... The only forests which are really well-preserved in India are the wildlife sanctuaries. ... [T]hat wildlife is preserved at the expense of the tribals, who are no longer allowed to live in the forests. ... The tribal people and the wild animals have coexisted reasonably well from times immemorial. Wildlife has not been destroyed by bows and arrows, the real culprit is the outsider."[85]

Ironically, the magnificent swamp deer with long horns spreading out like the branches of a tree frequently painted by Jangarh are apparently based on Jangarh's first face-to-face encounter with the beast at a wildlife sanctuary.

Shampa Shah confirmed this in a letter to me: "I am told by Anand Shyam that Jangarh first saw a *barasingha*, a swamp deer, at the Kanha (National Park) where a few years earlier, Bharat Bhavan had organised an artists' camp. The animal with its tree-like, beautifully branching horns caught his imagination and became a recurring fixture of his, and later, all Pardhan paintings."[86] Anand Shyam confirmed to me that the tribal artists' camp held at Kanha in 1980-81 was jointly organised by the Forest Department *(Van Vibhag)* of the Mandla District and Bharat Bhavan, in which one Jailal Kushram of Patangarh, who was a *banjaria* or forest guard there, played a key role. According to Anand Shyam, the workshop was held at the Dak Bungalow in Kanha National Park.[87]

An observant eye immediately notices that Jangarh's depictions of the swamp deer in all of his paintings reveal an attempt at a vestigial realism, which apparently stemmed from the experience of encountering the beast at a close range (Fig. 59). The portrayal of this particular animal stands in stark contrast to the highly fantasised and ebullient conception of the entire menageries of birds and animals in Jangarh's painting. Soon after this thrilling, face-to-face encounter with the swamp deer at Kanha, Jangarh created the large-scale murals on the outer walls of the domes of Bharat Bhavan, for which he did two renderings of the animal (Figs. 60 and 61). Both make evident Jangarh's attempt at imbibing the newcomer into his larger conception for the murals, in which the attempted naturalism of the swamp deer stands out vis-à-vis the large avian, the flying peacock and the twirling crocodile stemming from his own imagination. Yet it is striking to note here that the artist in Jangarh absorbed the swamp deer into his paintings by covering their bodies either with his signature dotted patterns or with coloured palm impressions. The tree-like horns of the beast allured him so much that he invoked the entire forest through its sprawling branches. In a later work, Jangarh again portrayed the swamp deer, this time standing on a mound created by similar palm impressions. As in the above-mentioned case of Jangarh percipiently engaging with the extrinsic images of the airplane and the tiger in the Vidhan Bhavan murals, here, too, he assimilates the profane image of the swamp deer within the overall scheme of the painting, fully aware of the value of these two aesthetic currents converging.

X. A Conjuror's Archive

In the decade of the 1990s, Jangarh produced an extraordinary array of black ink drawings on white art paper, each signed, dated and captioned. Although he had created ink drawings before, too, they were few, and technically simple and conventional. Broadly speaking, the earlier drawings were monochromatic

84 The phrase 'A place from where to speak' evokes the notion of a conceptual space, from where the right to express is legitimised
85 Quoted in Tully 1991: 293

86 Anand Shyam in conversation with the author in New Delhi on June 9, 2017
87 Kanha National Park is a wildlife sanctuary spread over the districts of Mandla and Balaghat of Madhya Pradesh

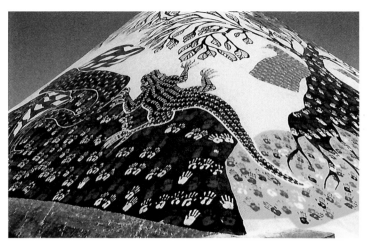

Fig. 60

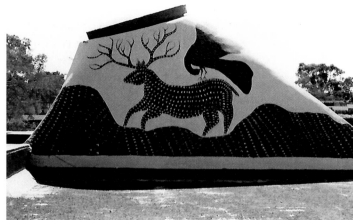

Fig. 61

improvisations on some of his coloured works, featuring the characteristic thick outline, fragmented wave or trellis patterns and regular drawing. From approximately 1990 onwards, Jangarh embarked on a whole series of black ink drawings done in a unique technique consciously generating a graphic effect resembling stencilling, which he deftly and discerningly articulated to create an atmospheric effect of depth, layering and luminosity. Using this highly auratic visual language, Jangarh created his own universe of beings and creatures, each individually portrayed with its idiosyncrasies, as observed in myth and in nature, and then transformed into an imaginary entity.

The period of the 1990s when Jangarh evolved this magical language of drawing also coincides with his intense printmaking activity. He produced a bulk of serigraphs of his own works, especially the line drawings, which he produced at a small facility he had set up at the house of his friend Ram Singh Urveti. As mentioned earlier, one major incentive for producing these large-scale serigraphic prints was the demand for his work at the Crafts Museum in Delhi and the Surajkund Crafts Mela in Faridabad (Haryana) in the early 1990s, where he was invited at my instance for 'crafts demonstrations' and to sell his works. There he sold, on average, 150 to 200 prints in the price range of Rs. 300 to Rs. 500 each. As serigraphy is also a stencilling technique involving positive and negative areas marked on a silkscreen; this may have played an inspirational role in Jangarh's dramatic play of chiaroscuro in the new black ink drawings.

Ram Singh Urveti informed me[88] that the sudden dramatic turn evident in Jangarh's line drawings of the 1990s resulted from his discovery of Rotring pens and the jet black, waterproof Rotring ink, which he had initially procured during one of his foreign trips. According to Ram Singh, Jangarh used Rotring point 3 and 4 for the finer drawing of parallel lines and other textures, and point 5 for the outline. On account of the non-availability of Rotring ink in Bhopal, Jangarh tried to use the local variety, but it failed to produce the same crispness of line and its requisite gradation. Ram Singh also mentioned that before starting a new ink drawing, Jangarh used to make a rough sketch in pencil. One of the most innovative and striking features of his drawings of that period is his experimentation with the graded tonality of

Fig. 60 Renderings of swamp deer and other creatures, on the domes of Bharat Bhavan. Jangarh Singh Shyam, ca. 1981-82, pigment on lime wash; location: Bharat Bhavan, Bhopal. Image courtesy: Prakash Hatvalne, Bhopal

Fig. 61 Rendering of a swamp deer on the domes of Bharat Bhavan. Jangarh Singh Shyam, ca. 1981-82, pigment on lime wash; location: Bharat Bhavan, Bhopal. Image courtesy: Prakash Hatvalne, Bhopal

Fig. 62 *Gidhali Pakshi* (Cluster of vultures). Jangarh Singh Shyam, 1995, pen and ink on paper, 68.5 x 53.5 cm. Collection and image courtesy: Vivek and Shalini Gupta, Delhi (DC.00250)

each stroke of the pen attained by varying levels of pressure exerted on the pen while in motion. He tried to lend volume to a form through a typical chiaroscuro comprising patterns — from dark to light — of a multitude of graded parallel strokes, as in a comb. By placing such graded masses opposite each other within the outline of a given form, he achieved the effect of vestigial rotundity or simply that of luminous sunbursts (see Fig. 63). Using the ambiguity that results from this technique in a range of variations, and in combination with simple drawing or more tangible and explicit ornate patterning, Jangarh evolved a felicitous vocabulary enabling him to give visual form to his memory images emanating from his inward world of allegory, chimera and fable. At a more concrete level, he applied the newly innovated technique of vestigial chiaroscuro to render rocks and hills, tree trunks and grassy fields, the scales of fish and crocodiles, the feathers and plumage of birds as well as undulated earth, water bodies and clouds.

Fig. 62

Fig. 63

Another one of Jangarh's stencilling techniques in his drawings involves creating a fine, graded spray of ink for the background and to render the layers of clouds in order to construct hazy, imaginary landscapes inhabited by his characteristic crabs, scorpions, snakes, birds, trees, gods and spirits (see Figs. 44, 84 and 85).

Jangarh did not come from any tradition of fine ink drawing on paper. In his village, he drew figures in charcoal on the lime-washed walls of houses and temples. This practice was rooted in the Pardhan custom of drawing charcoal figures on the *mangrohi*, two pegs made of wood from the *dumar* tree that are ritually installed on the ground under a wedding booth. Such drawings are customarily done by the groom's best man and his female counterpart. Jangarh once mentioned that he would rarely miss an opportunity to act as the best man at his village weddings, just so he could draw charcoal figures on the *mangrohi* pegs.[89] The breakthrough, via access to drawing paper and Rotring pens, "made possible an understanding of cultural innovation"[90] for Jangarh, which he then took far beyond the established conventions of drawing with ink on paper, as practiced by the 'art-school artists' from whom he had inherited these new materials and the first lessons in this type of drawing, in the first place. Through these mediations, Jangarh was able to cross the threshold of academic drawing and offer something radically different to create his own canon, thereby entering the "cultural archive," as Groys calls it.[91] Jangarh's experimental deviations are perhaps best summed up in the words of Michael Baxandall: "At any time painters have special occupational ways of seeing too, and these are obviously powerfully in play in pictures. … Living in a culture, growing up and learning to survive in it, involves us in a special perceptual training. It endows us with habits and skills of discrimination that affect the way we deal with the new data that sensation offers the mind."[92] Jangarh's experimental deviations in his ink drawings in response to the new materials as well as the tame manner of drawing during his first years in Bhopal result from this "new data."

Let me go into a few examples of Jangarh's ink drawings of the 1990s, in which he proverbially flexes his muscles as an image-maker, by brilliantly exploring the innovative possibilities of the medium. The zigzag effect, the gyrating flow, the illusive dimensionality and the optical phantasm, all resulting from the technique, are reflectively used to achieve the effect of forward movement or vibration, as in the drawings depicting birds in flight (Fig. 62), Hanuman zealously flying through the sky (Fig. 63) or the fierce battle between a snake and a mongoose (Fig. 66).

Snake and Mongoose

The fight between the snake and the mongoose is of great interest to the Pardhan *guniya* (diviner and healer) and the *shodhe* (practitioner of black magic). It is believed that when one of the two is wounded in the battle, it goes into the forest, chews a certain herb, is rejuvenated and returns to resume the fight. Metaphorically,

Fig. 64

Fig. 63 Hanuman carrying the Mandara Hill with herbs to cure Lakshman's injury. Jangarh Singh Shyam, 1995, pen and ink on paper, 71 x 58.5 cm. Collection and image courtesy: Kavita Sanghi, Indore (DC.00251)

Fig. 64 *Pret* (ghost), using a unique technique of luminous chiaroscuro evolved by Jangarh around 1990-91. Jangarh Singh Shyam, 1992, pen and ink on paper, 35.5 x 27.5 cm. Collection and image courtesy: Vivek and Shalini Gupta, Delhi (DC.00248)

88 Ram Singh Urveti in conversation with the author in New Delhi on May 21, 2017
89 Information: Ram Singh Urveti
90 Groys 2014: 86
91 Ibid.: 82
92 Baxandall 1989: 107

Fig. 65

the snake and the mongoose are the *shodhe* and *guniya* in Pardhan belief, who seem to learn a lot about the healing properties of plants from such fights. Jangarh has placed the two rivals amidst the plant world (Fig. 65).

Chachan and the Snake

One of the most striking examples of using this technique for achieving the effect of force, action and forward movement is Fig. 67, in which a gigantic eagle with large, open wings is shown swooping down on a snake. The bird is shown amidst a cloud-like, luminous aura featuring zigzag edges created by innumerable graded parallel strokes of the pen, which add to the surge of the bird's descent. By almost detaching the bird's wings from its body and fanning them out across the entire space, Jangarh enhances the bird's plummet towards its prey. In another work employing the same technique (Fig. 68), Jangarh brilliantly intensifies the force of the attack on the snake by blending the cloud-like, layered auratic forms of Fig. 67 with the bird's wings. Here the snake, combative yet poised, is also placed amidst

the same radiating mass of light and shade. Another one of his drawings entitled 'Cockfight' (Fig. 69) belongs to the same genre and period.

Jangarh had a special interest in the themes concomitant with tussles between two animals nurturing a traditional rivalry, such as the snake and the mongoose, the snake and the peacock or the *chachan*, or the tiger and the boar. Their depictions bring out Jangarh's close relationship with the creatures of the forest and, perhaps even more so, with the imaginary forest of Jangarh's memory, from which these creatures emerged from time to time, to inhabit his canvasses.

Fig. 66

Portrait of a Scorpion
Over time, Jangarh mastered the new language of creating luminous textures and patterns, and used it to conceptually portray the smallest of creatures hidden in the interstices of his imagination. His magnificent portrayal of *vichhi*, the scorpion (Fig. 70), is undoubtedly one of his finest works. It is deeply rooted in the Pardhan belief that scorpions are not only endowed with a highly poisonous sting

Fig. 67

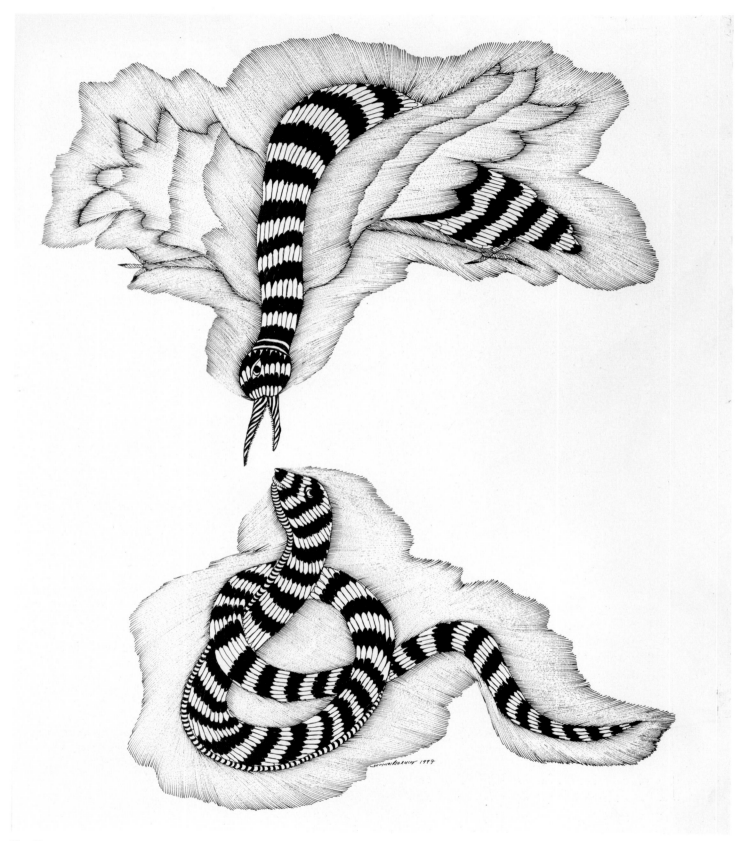

Fig. 68

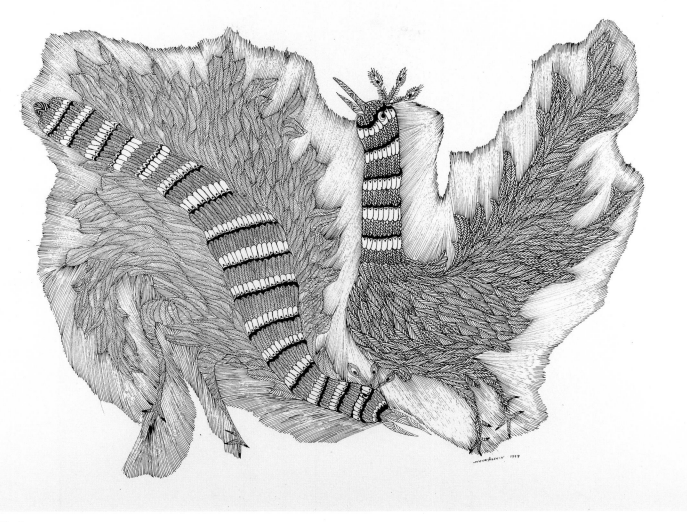

Fig. 69

but that they can be used as a sorcerer's weapon to cast an evil eye on an enemy or adversary. This belief gives the scorpion a mysterious aura that connects the worldly with the otherworldly. However, it must be emphasised that Jangarh was not so much illustrating the cultural beliefs surrounding the scorpion, but was aesthetically driven to portray the latent power and toxic potentiality concealed behind its quiet demeanour, as it usually lies in a seemingly archaic slumber beneath a boulder or under a heap of dry leaves, which is how Jangarh would have encountered it numerous times. In this impressionistic portrayal, the scorpion is hardly recognisable in its zoomorphic form. It is rendered as an assortment of its body parts — torso, tail, claws and pincers. The segmented tail curving forward with the venomous stinger at its tip is foregrounded. It is evident that, proceeding from the idea of portraying a scorpion, Jangarh got almost sensuously entangled in the aesthetic urge to draw — creating minute patterns and a whole web of textures that abstract the creature into a mental image. In a similar vein, albeit a few

Fig. 68 *Chachan* and the Snake. Using the technique of creating auratic forms by zigzag edges most effectively, the artist has lent force to the theme of a bird attacking a snake. Jangarh Singh Shyam, 1997, pen and ink on paper, 71 x 56 cm. Collection and image courtesy: Museum of Art & Photography (MAP), Bangalore (PTG.0735)

Fig. 69 Cockfight. Jangarh Singh Shyam, 1997, pen and ink on paper, 56 x 71 cm. Collection and image courtesy: Museum of Art & Photography (MAP), Bangalore (PTG.01771)

Fig. 70

years before the scorpion, Jangarh portrayed a more naturalistic spider, for which he had used his zigzag field to create the spider's web (Fig. 71).

Mask for Fixing the Evil Eye

Before Jangarh settled down in Bhopal in the early 1980s, he used to work as a labourer on road construction sites around his village. He also cultivated a couple of acres of land that he had inherited. This gave him first-hand knowledge of agricultural rites and rituals. Whenever he was disillusioned with life in Bhopal, he talked of going back to his village, which was always vividly present on the screen of his mind. Besides giving form to a couple of his field and village deities, he created several intricately textured drawings and paintings based on his memories of a farm ritual called *nazar bandhani mukhauta* or 'mask for fixing the evil eye.' This refers to the custom of burying a dead bullock halfway in the middle of the field, keeping its head and torso above the ground. The carcass is eventually eaten by birds and other animals, and the field thus remains shielded from the evil eye (Fig. 72).

Fig. 71

Jangarh's great mastery of creating a vast range of textures can be seen both in his paintings and his ink drawings. In the latter, in particular, he wove this visual constituent into a whole gamut of structures, grains, tissues, fabrics, veins, pores, meshes, scales, folds and plumage, to characterise every bird, animal, reptile, every tree, branch, root, leaf and cloud, every water body and the sky, as these emerged on the pristine white space of the paper as allegorical images stemming from his visually charged memory archive. It is this aspect of his textures and patterns that immediately distinguished them from their mere decorative infill function, as often construed by art historians. However, it must be clarified that the interplay of text, texture and textile (all share the same etymology) in his drawings was not merely an effect produced by clever draughtsmanship, but constituted their very *raison d'être*. In the end, it was still his compelling passion and almost sensory engagement with creating visual forms with pen and ink that drove him to this wondrous enterprise.

In this particular drawing, which was created in 1990, the dead bullock is portrayed with intense engagement. The net-like skin of the animal is woven, knot by knot, and features sections of varying density, thus creating the effect of shading and contouring of the dead animal's bone structure, especially around the dewlap, under the falling lower jaw. The stillness of the dead bull is juxtaposed with the euphoric agility of the birds and the swift leap of the mongoose feasting on the former.

In a variation on the same theme, drawn in 1995 (Fig. 73), only the head and neck of the dead bullock is shown, with its body covered in a ripple pattern, indicating its skeletal form. Interestingly, Jangarh, a devotee of Shiva, has added a *shivalinga*, the phallus symbol of Shiva, just above the dead bull, covering it with the same textural pattern to indicate that the bull, Shiva's vehicle, has merged with Shiva himself after its death. The deification of the bull is suggested by the gauzy radiance around the mask and by the obeisance paid to the *shivalinga* by a stray

Fig. 70 Portrait of a Scorpion; *Vichhi*. Jangarh Singh Shyam, 1995, pen and ink on paper, 71 x 56 cm. Collection and image courtesy: Museum of Art & Photography (MAP), Bangalore (PTG.0734)

Fig. 71 *Makadi*; a spider. Jangarh Singh Shyam, 1993, pen and ink on paper, 46 x 38 cm. Collection and image courtesy: Vivek and Shalini Gupta, Delhi (DC.00252)

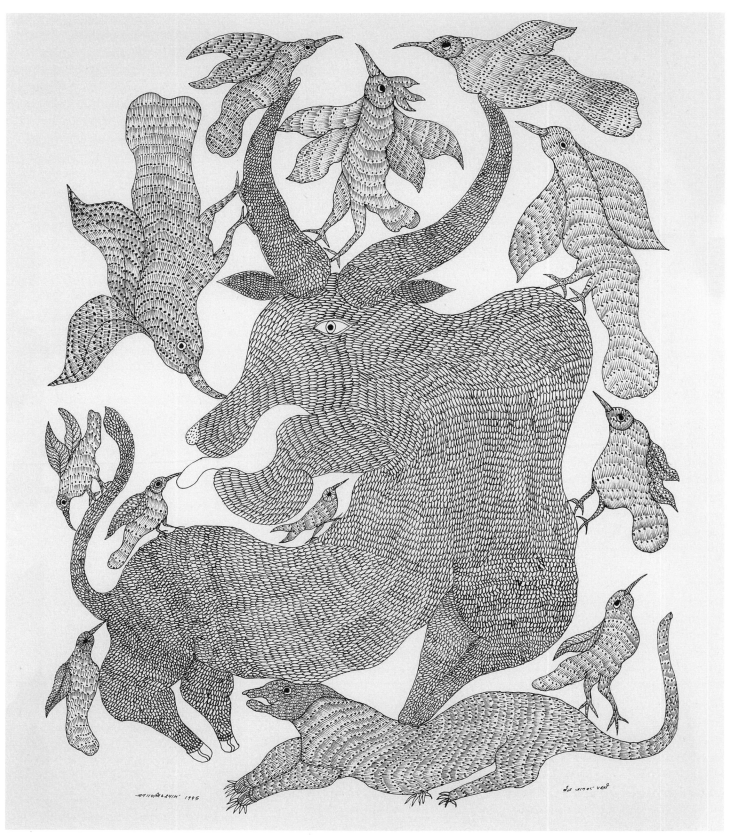

Fig. 72

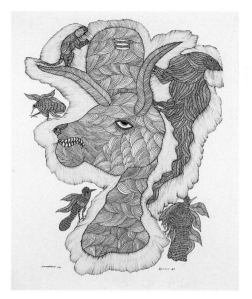

Fig. 73

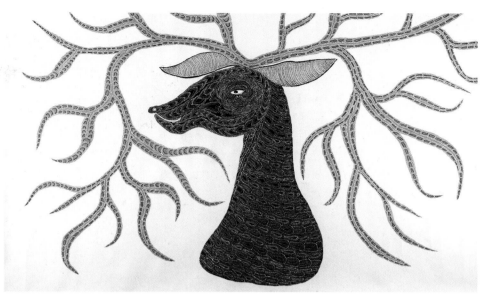

Fig. 74

monkey. Fig. 74 shows a multichrome variation of an evil eye mask with the head of a stag.

Birds in Union

As seen above, by 1995, Jangarh had evolved a whole new array of minute textures to effectively portray his characters and themes. We also discussed above the expressive power of the radiant zigzag fields with which he gave an individual disposition to his themes. The decade of the 1990s formed the peak of his ink drawings. The vast arena of fine new textures and patterns that he produced during the period not only lent a sense of the spectacular to his drawings, but also made his characters appear highly alluring. Between 1995 and 2000, he made two exquisite drawings depicting two birds in intimate union. Fig. 75 shows a rooster and a hen in copulation. The male is shown seated majestically with its head crowned by a resplendent cockscomb and its body haloed by a joyous reed of dazzling feathers. The female, in contrast, looks passive and subdued, below. By contrast, in a drawing created in 2000 (Fig. 76), while dealing with the same theme of two birds in coitus, Jangarh does not hierarchise the supremacy of one over the other but shows them entwined, sharing plumage of the same texture. Here, he abstracted the union into a sprawling, florid expanse.

Haril and its Chicks

Jangarh's disposition towards abstraction came from multiple sources. While Jangarh was deeply rooted in the tradition of clay-relief work, which usually reduced the figures and characters to geometric forms, the tendency towards abstraction seen in most of the drawings under discussion seems to emerge from his inclination towards conceptual renderings, and away from a geometric or naturalistic approach. In his portrayal of the *haril* bird (Fig. 77) with its chicks, the birds' bodies are all covered in a diaper of minute flowers as an abstracted rendering of

Fig. 72 Mask for Fixing the Evil Eye; *Bail, Janwar, Pakshi* (Bull, Animal, Birds). Jangarh Singh Shyam, 1995, pen and ink on paper, 68.5 x 53.5 cm. Collection and image courtesy: Vivek and Shalini Gupta, Delhi (DC.00253)

Fig. 73 Mask for Fixing the Evil Eye; *Bail Mukhauta, Pakshi* (Bull Mask and Birds). Remarkable is the *shivalinga* issuing from the head of the bull, which is also Nandi, Shiva's vehicle. Jangarh Singh Shyam, 1995, pen and ink on paper, 68.5 x 53.5 cm. Collection and image courtesy: Vivek and Shalini Gupta, Delhi (DC.00254)

Fig. 74 Mask for Fixing the Evil Eye; a variant. Jangarh Singh Shyam, probably mid 1990s, 91 x 146 cm, pigment on paper. Collection and image courtesy: Museum of Art & Photography (MAP), Bangalore (PTG.0839)

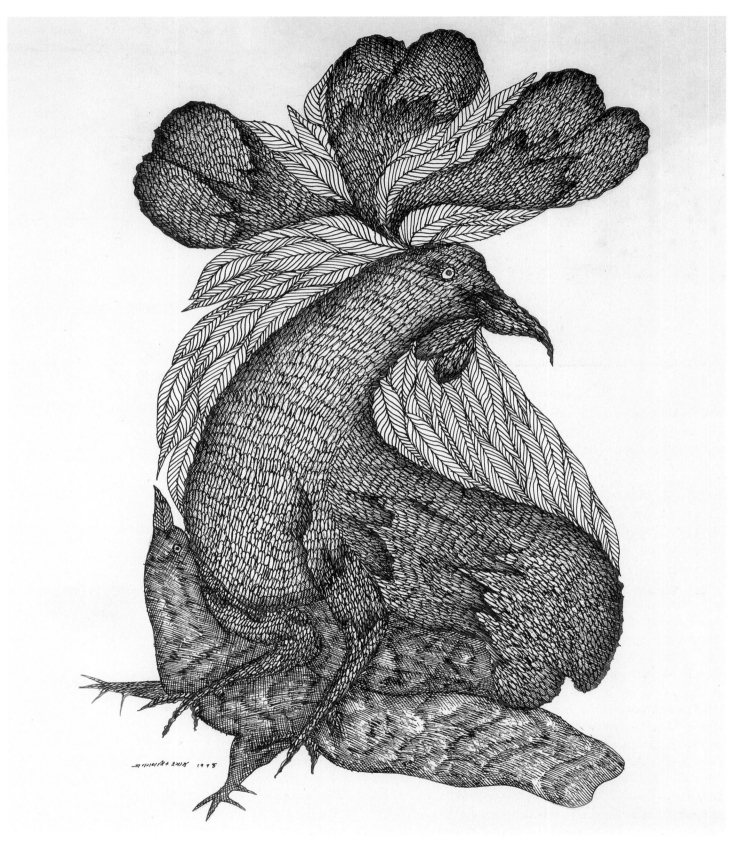

Fig. 75

Fig. 75 Birds in Union; a rooster and a hen in copulation. Jangarh Singh Shyam, 1995, 46.5 x 31 cm. Collection and image courtesy: Museum of Art & Photography (MAP), Bangalore (PTG.0704)

Fig. 76 Birds in Union. Jangarh Singh Shyam, 2000, pen and ink on paper, 35.5 x 28.5 cm. Collection and image courtesy: Kavita Sanghi, Indore (DC.00255)

Fig. 76

its plumage. The swirling abstract patterning conveys the impression that Jangarh made this drawing as if under a spell, stopping only once he had translated his vision onto the sheet of paper. The intense aesthetic labour and craftsmanship that he invested in rendering the bird speaks to a contiguity with its referent that inhabited Jangarh's imagination. It is for this reason that the bird crosses over from the decorative to the conceptual.

Foreplay of Lizards

From the multiple versions of this theme painted by the artist (Fig. 79), it once again becomes apparent that his engagement with the world of creatures and his

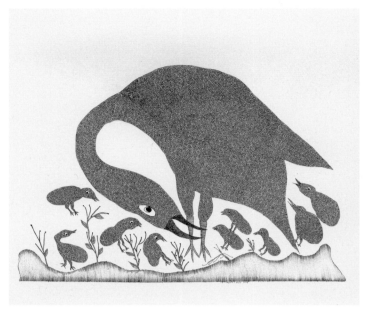

Fig. 77

Fig. 78

minute observation of their physiognomy and behaviour repeatedly became the subject matter of his paintings. However, his concern was not detailing zoological exactitudes. Instead, he brilliantly used his visual language of textures and patterning, in combination with exposing the inner mechanisms of the creatures as seen through their translucent skin, bringing to the fore the feeling of stimulation — that of the darker male with clenched teeth and the pink female in passive submission. In many of the portrayals of creatures that inhabited Jangarh's memory world, he metamorphosed himself into their consciousness.

Peacock Treading the Primeval Earth

The painting (Fig. 78) seems to allude to the widespread tribal myths of creation prevalent in the Central Indian tribal belt, especially from central-eastern Gujarat to the upper Narmada valley in Madhya Pradesh, which has numerous references to the earth as being divided into several *khands* (continents, compartments, divisions). According to the Pardhan artist Ram Singh Urveti, the fanciful peacock is shown treading the compartmentalised, mythical earth of Jangarh's community lore. According to another version, the peacock is trudging through fields divided by hedges, with a water body on the lower left side, picking up seeds sown in the furrows, which are ornately depicted in the artist's typical idiom.

The Primeval Earth

In an improvisation on the theme of the Primeval Earth as depicted in Fig. 78, Jangarh has created here (Fig. 80) a highly detailed version in which the liminal space between the earth and the underworld is delineated as being populated by frogs, fish, crocodiles, crabs, tigers, deer and even forest spirits, presided over by

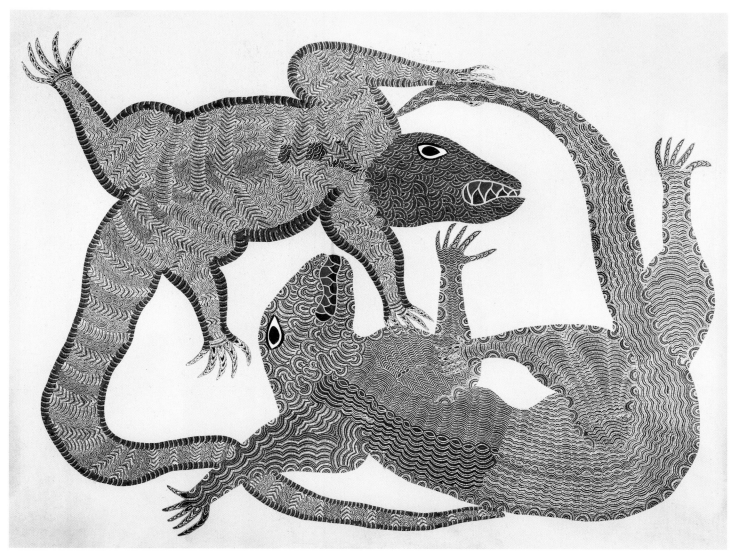

Fig. 79

the serpent Shesha, the upholder of the earth. A diaper of yellow dots all over the bright segments of the earth, lends a festive touch to the whole.

Two Peacocks and a Snake

In this painting (Fig. 81) the mood is joyous and celebratory. The ornate patterning covering the two peacocks echoes the sun's luminosity and makes their demeanour appear even more evocative and sensuous. The decorative tendrils and paisley motifs seem to be inspired by art nouveau designs, which Jangarh might have seen in books and which are completely different from his dotted patterns seen elsewhere in his work. This once again speaks to his openness to the new, which itself is often played out as the theme. The flat, blue water body from which the snake emerges,

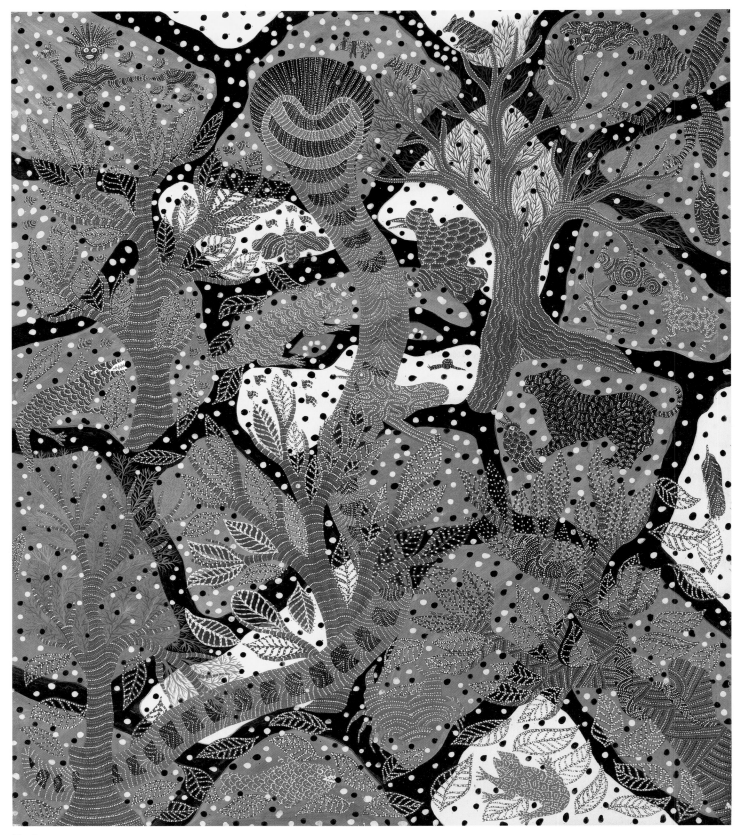

Fig. 80

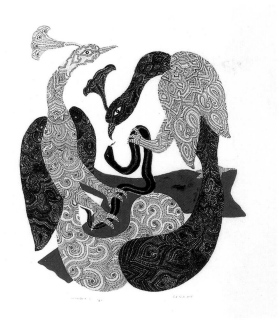

Fig. 81

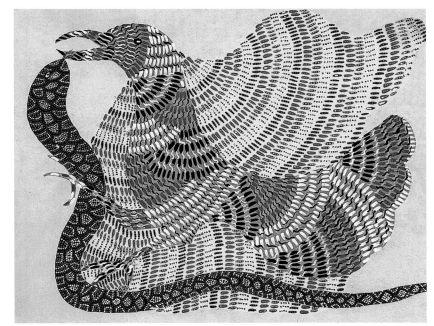

Fig. 82

provides the eye relief from the merely ornamental. The dramatic eye contact between the peacock and the snake creates a kind of enclosure, which evokes many metaphors.

Chachan and Snake

After meticulously observing the textures, scales and plumage of birds and reptiles, Jangarh moved away from their naturalistic representation and became engrossed in creating imaginary forms and patterns as he rendered birds, animals and reptiles to lend each a persona of its own. In this work (Fig. 82) the bird with its textured open wings spanning the entire canvas, dominates, while the snake, drawn with equally charming scrupulousness, confronts the avian, which stems from the artist's aesthetic partiality towards the helpless but poised serpent.

Peacock

This form of peacock with open wings is an iconic motif in Jangarh's work and occurs time and again in various contexts (Fig. 83).

Snake Holes and Birds of Prey

In 2001, the year in which he passed away, Jangarh conducted new and bold experiments to explore the language of his monochromatic drawings in order to more imaginatively articulate the themes of his painting. He had, by then, become highly proficient in combining freehand drawing with paper stencilling and spraying. His experiences as a printmaker had already drawn him into the vast possibilities of graphic effects. Ram Singh, his erstwhile printmaking partner, says that Jangarh used two types of paper stencils — the positive and the negative. Positive here denotes the cut-out shape itself that is used as a stencil, while the negative

Fig. 80 The Primeval Earth. Jangarh Singh Shyam, ca. 1990, 182 x 82 cm. Collection of the Fondation Cartier pour l'art contemporain, Paris

Fig. 81 Two Peacocks and a Snake; *Mor aur Saap*. Jangarh Singh Shyam, 1993, pigment on paper, 105 x 75 cm. Collection and image courtesy: Bharat Bhavan, Bhopal

Fig. 82 *Chachan* and Snake; A bird of prey attacking a snake. Jangarh Singh Shyam, ca. mid 1990s, pigment on paper, 63.5 x 86.3 cm. Collection and image courtesy: Kavita Sanghi, Indore (DC.00265)

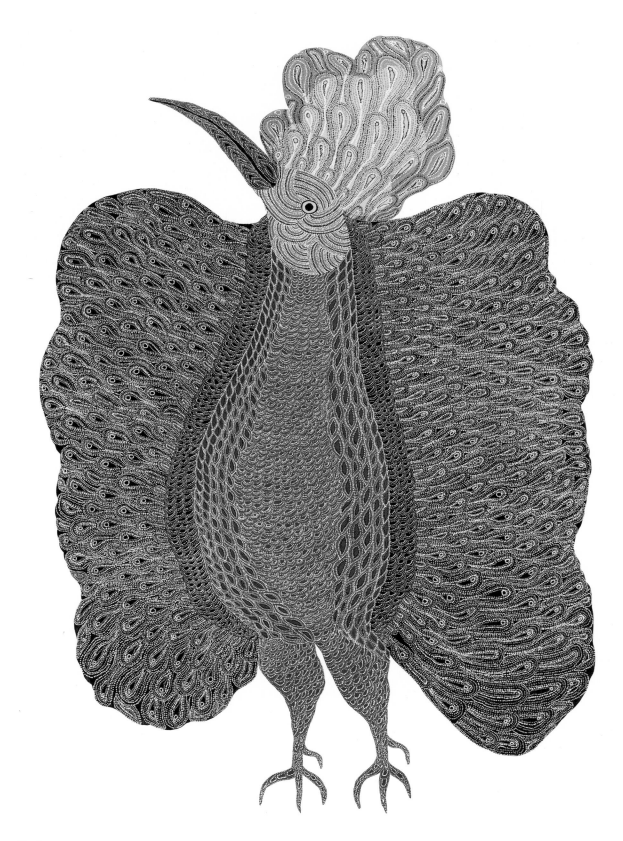

Fig. 83

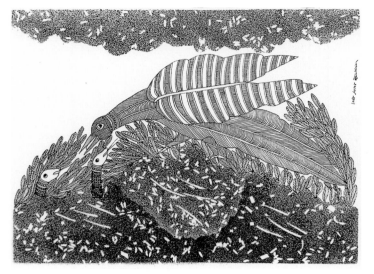

Fig. 84

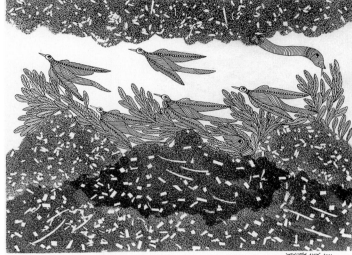

Fig. 85

stencil consists of a form created through the hollow spaces cut into a sheet of paper. In Figs. 84 and 85, Jangarh added yet another texturing device to his expressive equipment. Here, he had scattered small shreds of paper over the darker areas of the anthill, snake holes as well as the undulated ground surface and used these bits as stencils, which imparts a sort of spectacular gleam to the drawings. The white space between the two dark areas, earth and sky or two rocks, provides visual relief to the composition while Jangarh's favourite theme, the scuffle between two natural enemies — here, the snake and the eagle (or a similar local bird that preys on snakes) — mysteriously unfolds. The most remarkable facet of the drawings is the invention of a distinctive graphic technique to convey the quintessence of his memory images.

Python (Ajgar)

The giant, non-venomous snake grows to the length of two to four metres and kills its prey by constriction and asphyxiation. It often has psychedelic patterns on its skin. When sedentary, it lies with its body entwined around trees and branches, as depicted here by Jangarh. Playing with the graded green and yellow tones of the trees and the brown of the python's body, Jangarh has abstracted the moment of its merging with the landscape as it lies embedded in it (Fig. 86).

The Emergence of Thakur Dev at the Naag Panchami Festival

Shampa Shah,[93] after studying the serigraph (Fig. 87) and after consulting Ram Singh Urveti and Mayank Shyam, has provided the following description of the work:

It seems that the serigraph is about monsoon, and is related to the festival of Naag

Fig. 83 Peacock. Jangarh Singh Shyam, ca. 1990, pigment on paper, 152 x 125 cm. Collection and image courtesy: Museum of Art & Photography (MAP), Bangalore (PTG.00063)

Fig. 84 Snake Holes and Birds of Prey. Jangarh Singh Shyam, 2001, pen and ink on paper, 55 x 77 cm. Collection and image courtesy: Gursharan Singh Sidhu (DC.00266)

Fig. 85 Snake Holes and Birds of Prey. Jangarh Singh Shyam, 2001, pen and ink on paper, 55 x 77 cm. Collection and image courtesy: Gursharan Singh Sidhu (DC.00267)

93 In correspondence with the author

Fig. 86

Panchami, dedicated to the snake deity also known as Thakur Dev. The Pardhans believe that Naag Dev appears amidst the clouds on that day. In this serigraph, the geographical terrain, as it moves from the river to the adjacent fields, gradually begins to rise and finally culminates in an anthill. From the overcast sky above, it appears as if there is a rain of ants of the variety that grows wings, flies for a while and then drops dead. These usually appear at the onset of monsoon, which prompts the farmers to start sowing. Anthills are the habitat of snakes. Naag Dev is the clan deity of the Urvetis. On the day of Naag Panchami, everyone propitiates Naag Dev, but the main oblations are made by a member of the Urveti clan. It is believed that through him, the deity makes predictions about the monsoon and the farm yield for the current year.

The deity shown amidst the clouds, too, is Naag Dev, as it appears to have a reptilian character. According to Ram Singh, Naag Dev emerges to enjoy the first shower, indicated by the swaying movement of the snake around the anthill.

According to Mayank, however, the entire scene depicts the *hariyali amavasya*, which is the biggest festival of the Pardhans of the Patangarh region. In this drawing, Jangarh has captured the transformation of the landscape around his village that occurs with the onset of monsoon. It is at this time that all creatures of both genders come together and that the sight of copulating snakes is considered auspicious by the Pardhans. It is for this reason that the artist has depicted a vast range of plants and animals in this work.

Medo ki Mata
Besides depicting birds and animals in his ink drawings of the 1990s, Jangarh also iconised deities as well as priestly and shamanistic figures. In 1995, when Jangarh's use of his newly developed technique to envelope a form with several radiant aureoles comprising zigzags peaked, and he had created whole menageries of birds and animals using this idiom, he also portrayed some of the deities in the same language of expression. His ink drawing of the deity 'Medo ki Mata' (Fig. 88) stems from this background. Her whole body seems to radiate lustre. In her right hand, she holds a wooden staff known as *devikham*, which features a white flag on top. In her left hand is the bowl for drinking the blood of the sacrificial animal, her tongue juts out like that of the goddess Kali and at her feet are the sacrificed goat and pig. On either side of her feet is a *kalash*, an earthen pot filled with water and topped with an earthen oil lamp. It is believed that a quartet of goddesses guards the field from all four directions, namely Karnar Dai in the north, Gatha Thakrai in the south, Maharelin Dai in the west, and Medo ki Mata in the east. Like Bara Dev, Medo ki Mata only accepts a white animal as a sacrifice. As mentioned earlier, the Pardhans did not have a tradition of representing their deities in anthropomorphic form. It was Jangarh who first conceptualised them in human form based on his recollection of the shaman's demeanour when possessed by a certain deity and combined with his own subjective visualisation.

Mashvasi Dev
A year after drawing Medo ki Mata, he rendered the image of Mashvasi Dev, a fishing community's deity, who is shown carrying a bow and arrow with which he kills fish (Fig. 89). His devotees, when possessed by him, are believed to be able to

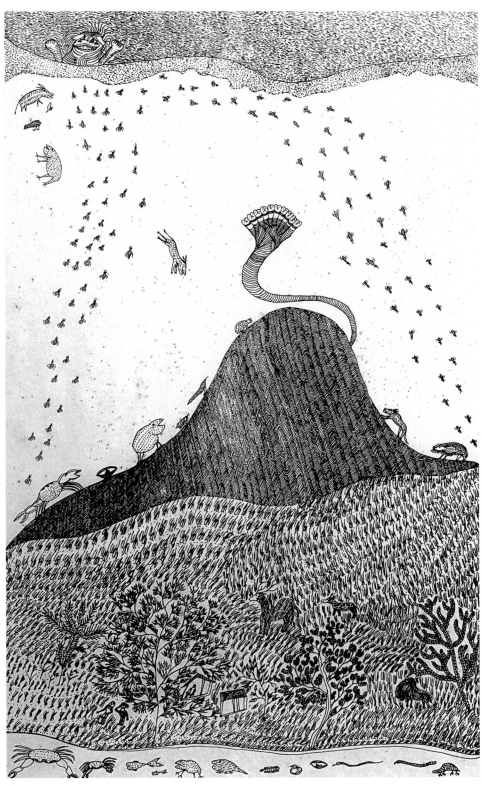

Fig. 87

Fig. 86 Python; *Ajgar*. Jangarh Singh Shyam, 1992, pigment on paper, 56 x 71 cm. Collection and image courtesy: Museum of Art & Photography (MAP), Bangalore (PTG.00073)

Fig. 87 The Emergence of Thakur Dev at the Naag Panchami Festival; the appearance of Naag Dev (serpent deity) on the occasion of the festival of Naag Panchami, in the monsoon. Jangarh Singh Shyam, ca. mid 1990s, serigraph, 82 x 45 cm. Collection and image courtesy: Mark Tully and Gillian Wright

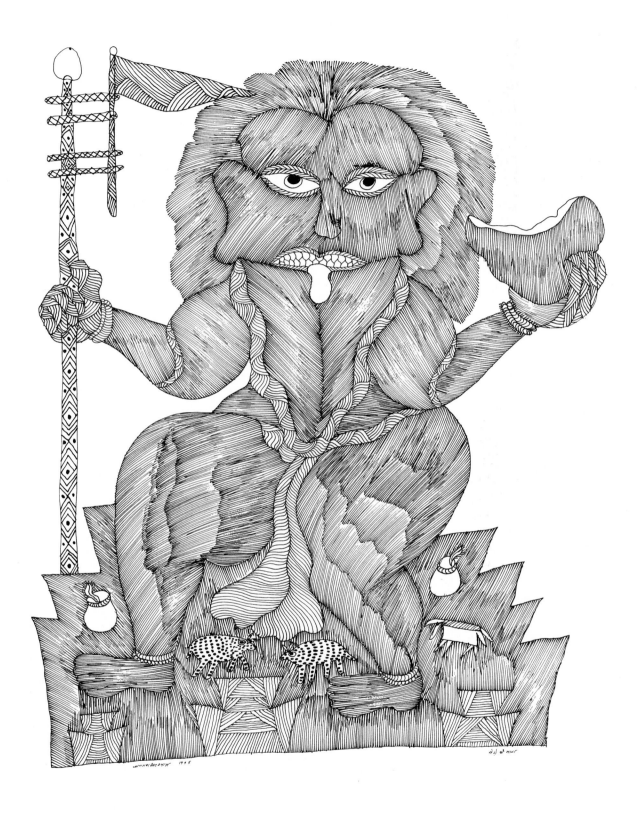

Fig. 88

spot fish in water and kill them with their arrows just as the deity himself. Here, the deity's arms and the face are shown covered in a pattern emulating scales.

Karme Ma

The Pardhans of Patangarh are divided into different exogamous clans (*gotra*). Most of the Pardhan artists based in Bhopal took their clan names as their surnames, especially once they began to sign their paintings. Each clan has a clan deity. For example, Karme Ma is the goddess of the Shyam clan, to which Jangarh belonged; Marahi Devi is the goddess of the Marawi clan; Kali of the Tekam; and Bagh Dev of the Kushram. The preeminent goddess Phulwari Devi, though mainly the goddess of the Tekam and Marawi clans, is revered by all Pardhans of the region.

Jangarh painted several of these deities, among which those of Karme Ma and Phulwari Devi are particularly striking. His depiction of Karme Ma, the goddess of his own clan (Fig. 90), is at once festive and soulful. The painting with its minutely dotted multichrome textural patterns exuding fluorescence was created in 1991, the same decade when Jangarh discovered the radiant textures of his minutely detailed monochromatic works.

Phulwari Devi

Phulwari Devi is another powerful iconisation of a Pardhan clan goddess. The entire conception, especially the symbolism of the colouration is steeped in the

Fig. 88 Medo ki Mata; a field goddess. Jangarh Singh Shyam, 1995, pen and ink on paper, 68.5 x 53.5 cm. Collection and image courtesy: Vivek and Shalini Gupta, Delhi (DC.00256)

Fig. 89 Mashvasi Dev; a fisher folk's deity. Jangarh Singh Shyam, 1998, pen and ink on paper, 71 x 56.5 cm. Collection and image courtesy: Kavita Sanghi, Indore (DC.00257)

Fig. 90 Karme Ma; the goddess of the Shyam clan of the Pardhans. Jangarh Singh Shyam, 1991, pigment on paper, 68.5 x 53.5 cm. Collection and image courtesy: Vivek and Shalini Gupta, Delhi (DC.000258)

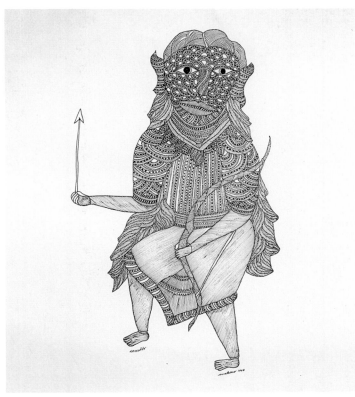

Fig. 89

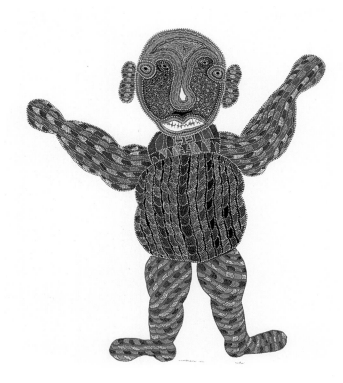

Fig. 90

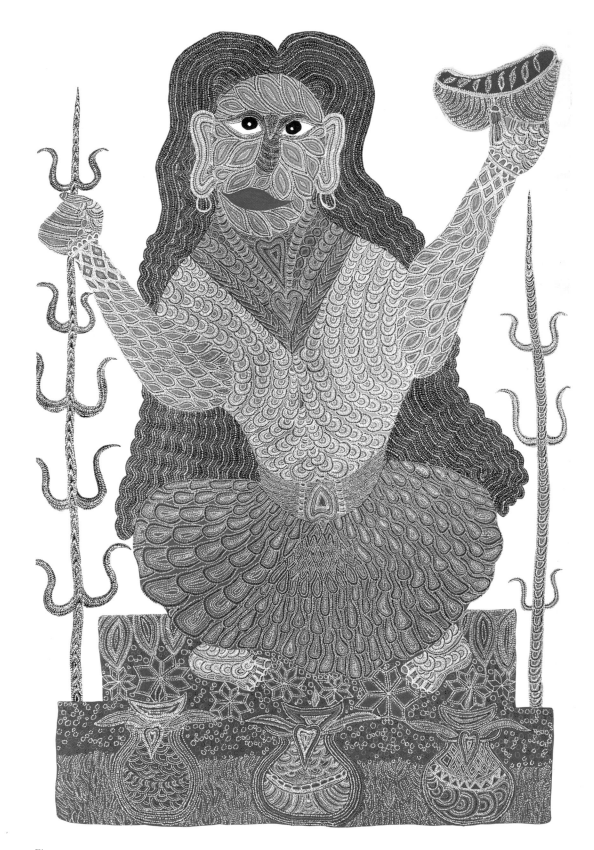

Fig. 91

myths and beliefs relating to the origin of the goddess. According to a Pardhan legend, the river Narmada (Jangarh's village Patangarh is situated in the upper Narmada valley) was engaged to Sonbhadra, who got delayed on his way to his wedding. Anxious Narmada asked her sister Jahila to go look for the bridegroom's procession. Jahila did not have any clothes on, so Narmada gave her bridal attire to Jahila for her to receive the bridegroom in. Sonbhadra, mistaking Jahila for Narmada, married her and turned east, while Narmada continued to flow westwards. On hearing this, Narmada became furious and began to splash and splatter her water all over. From these sprinkles, the goddess Phulwari Devi was born.[94] As Narmada's body was smeared with the bride's customary yellow turmeric paste, the sprinkles that fell on the riverbank turned into the yellow clay known as *ramraj*, which is often used by the Pardhans as a yellow pigment for wall paintings.

In the iconisation of the goddess Phulwari Devi in his painting (Fig. 91), Jangarh's referencing this story of the goddess has a direct bearing on the colours' symbolism and therefore on its aesthetic conceptualisation as a whole. The anger of the heartbroken bride Narmada is visible in Phulwari Devi's eyes. Her body, face and limbs are shown ornately covered in turmeric paste. The pedestal *(madhiya)* on which the goddess is installed is blue to represent angry Narmada's splashing water. Even the goddess's bowl is shown as overflowing with water, and the entire background is washed in light blue. It is worth noting here that the main shrine of Phulwari Devi is situated directly on the bank of the river Narmada. The entire conception constitutes an aesthetic interpretation of the legend, rather than its literal or sectarian iconisation.

Shiva

Shiva held a prime position in Jangarh's belief system. The Narmada river valley is dotted with innumerable Shiva shrines on both of its banks. Fig. 92, painted in 1992, a year after that of his clan goddess Karme Ma (Fig. 90), is one of the rare portrayals of the deity by Jangarh. The two works display an obvious stylistic affinity in terms of the complete immersion of his artistic self in punctiliously creating joyous patterns as a marker of his personal devotion to the deities. Shiva is here shown holding his trident in his right hand and a mendicant's pot in the left. His tiger skin loincloth, in the form of a hunter's trophy, is tied to his waist with a snake serving as a cummerbund. The most striking feature of the image is the combination of the anthropomorphic Shiva and his symbolic phallus form, indicated by his cylindrical head. As mentioned earlier, Jangarh also used this device in rendering the dead Nandi or bull in the painting entitled 'Mask for Fixing the Evil Eye' (Fig. 73), in which it is shown with a protrusion on its head representing the *shivalinga*.

Fig. 91 Phulwari Devi; the personification of the river Narmada. Jangarh Singh Shyam, ca. early 1990s, pigment on paper, 148 x 100 cm. Collection and image courtesy: Museum of Art & Photography (MAP), Bangalore (PTG.0899)

94 The story was narrated to me by the artist Ram Singh Urveti on May 21, 2018, in Delhi

Fig. 93

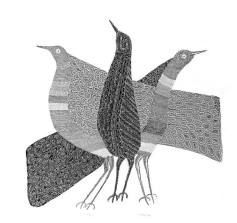

Fig. 92

Fig. 94

Fig. 92 Shiva; portrait of Shiva combining his anthropomorphic form with his phallus symbol. Jangarh Singh Shyam, 1992, pigment on paper, 68.5 x 53.5 cm. Collection and image courtesy: Vivek and Shalini Gupta, Delhi (DC.00259)

Fig. 93 Shiva's Trident; conceived as a dancing peacock. Jangarh Singh Shyam, 1998, pen and ink on paper, 70 x 56 cm. Collection and image courtesy: Museum of Art & Photography (MAP), Bangalore (PTG.01765)

Fig. 94 Composite Figure of Peacocks Forming a Trident. Jangarh Singh Shyam, late 1980s, pigment on paper, 36 x 30 cm. Collection and image courtesy: Gursharan Singh Sidhu (DC.00268)

Shiva's Tridents

The banks of the river Narmada have been home to several tribal communities of Madhya Pradesh over millennia as much as to innumerable shrines dedicated to Mahadev/Shiva. Each shrine has its own local Mahadev and is revered by the local villagers and tribals. The banks have acted as a great melting pot of Shaivite cults, where tribal as well as regional and canonical Hindu beliefs and practices have bled into each other, over centuries. Jangarh's personal faith in Shiva predates his migration to Bhopal and his renderings of the deity in various forms have resulted from his profane, imaginative faculty. In other words, he created his own iconographies of the deity, sensuously visualised through line and colour, rather than from the prevalent cultic norms.

Besides incorporating Shiva's trident in the hoods of the serpent Shesha in Figs. 49 and 50, for example, Jangarh, in a highly poetic manner, limned the trident, Shiva's emblem, in different forms of the peacock. In an ink drawing dated 1998, the trident is conceived as a dancing peacock (Fig. 93) with the three prongs constituted by the bird's raised neck and head flanked by its two wings, while in a painting from the late 1980s, the composite figure of three peacocks (Fig. 94)

brilliantly form the trident, and their tails, stylised as rectangular planes, cross each other to create a sculptural dimensionality.

Ganesh

One of Jangarh's favourite subjects was Ganesh, often inscribed by him as 'Ganesh Musha,' with *musha* referring to his vehicle, the mouse. The term *musha* derives from the Sanskrit *mushaka*, which is not commonly used even among Hindus. It appears to have entered the tribal world of the Pardhans through itinerant Hindu missionaries, such as the Bhagats,[95] who draw them into popular Hindu culture by making them take vows of abstinence from meat or alcohol. They also narrate Hindu legends to them. Undoubtedly, the process of such tribal-Hindu assimilation has been at work for many centuries.

Jangarh has done dozens of renderings of the "Hindu" Ganesh with his highly prominent *musha*. In almost all cases, these particular renderings do not imitate the common Hindu representation of the god as a vermilion-covered saffron deity; rather, the images originate from his own painterly locution comprising radiant colourful stripes, waves and ripples formed by multiple dotted lines. As an artist of distinction, Jangarh transcended the traditional iconographic concerns and immersed himself in the very act of painting, allowing it to determine the conception of the image. It is at this juncture that Jangarh's Ganesh images cross over from the cultic into a personal and secular space. The same process operates to varying degrees in several of his depictions of the deity (Figs. 95 to 98).

Ganesh Playing the Flute

One of Jangarh's most perplexing images of Ganesh is Fig. 99. In this black ink drawing, he seems to synthesise the Pardhan myth of the elephant-headed crab with the Hindu conception of the deity with his mouse vehicle. Here the head of

Fig. 95 Ganesh; a Portrait. Jangarh Singh Shyam, ca. mid 1990s, acrylic on canvas, 84 x 88 cm. Collection and image courtesy: Museum of Art & Photography (MAP), Bangalore (PTG.0907)

Fig. 96 Ganesh and his Mouse. Jangarh Singh Shyam, late 1980s, pigment on paper, 56 x 71 cm. Collection and image courtesy: Museum of Art & Photography (MAP), Bangalore (PTG.0746)

Fig. 95

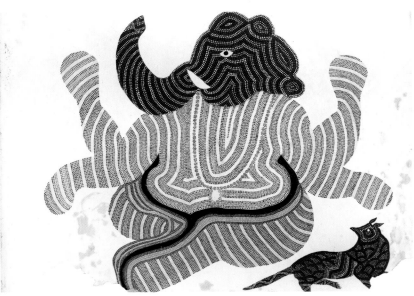

Fig. 96

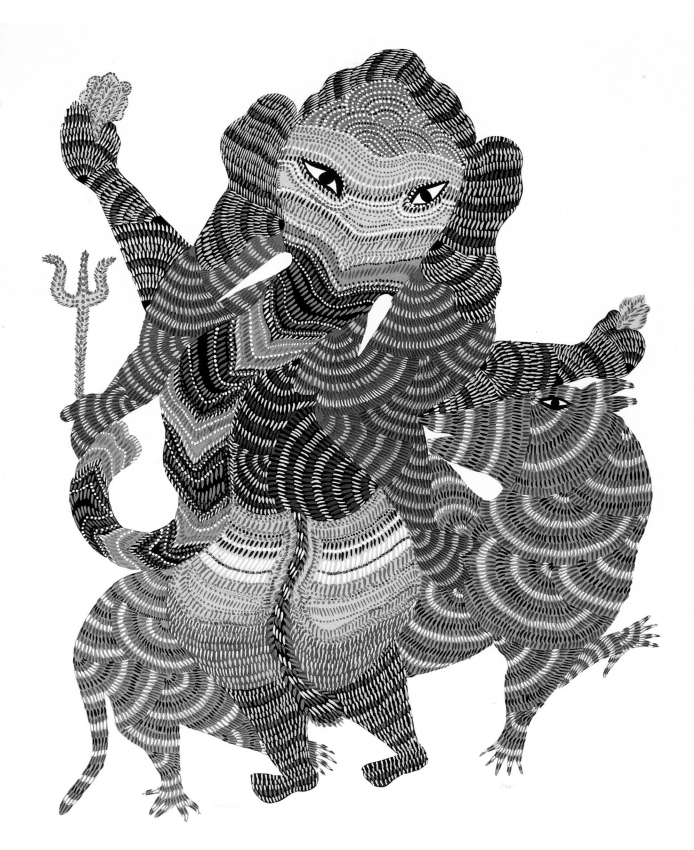

Fig. 97

the god is the same as that of the crab in Fig. 43, but his stance evokes Krishna playing the flute and speaks to the artist's personal imagination and the permeability of cultural influences flowing from the tribe and village to the elite and vice versa, as pointed out by Kramrisch.[96]

However, the most intriguing feature of Pardhan mythology and the related paintings by Jangarh is their twofold presence of the deity, i.e. Ganesh as elephant-headed and crab-headed god. Here, two mythologies, those of the Hindus and of the Pardhans, commingle as already described in the context of Fig. 43. It is possible that Jangarh refers to the Hindu Ganesh as 'Ganesh Musha' to differentiate it from the crab-headed tribal Ganesh.

Ganesh-Shiv

As seen earlier, Jangarh gave imaginary visual forms to his deities, and in the process he innovated personal iconographies. One such is the composite image of Ganesh-Shiv (Fig. 100). In this 1994 drawing, the Shaivite symbols of the trident and the *shivalinga* are seen on the forehead of the four-armed Ganesh. The only basis in Hindu mythology for this combined image is that Ganesh is the son of Shiva. Yet by horizontally elongating the head of the deity and embedding the eyes in his forehead, he simultaneously evokes the tribal myth of the trunked head of a crab placed by Shiva on the torso of his son, as described in the context of Fig. 100. This is another example of the complex layering of Jangarh's cultural memory and his highly subjective conceptualisation of images that compel the viewer not just to look at, but into it.[97]

Bahari Batoran

Besides figures of deities, Jangarh produced a series of portraits of priests, shamans, soothsayers and spirit healers. One such is that of Bahari Batoran/Jatadhari Baba (Fig. 101). Bahari Batoran literally means 'sweeping with a broom.' Pardhans believe that this divine personage appears from time to time carrying a broom of twigs and a club. He is believed to roam the village streets seizing evil spirits with his broom and winnowing fan, and disposing of them. In Jangarh's iconisation Bahari Batoran is shown as Jatadhari Baba (mendicant with long hair and beard), as he entered Jangarh's imagination with his powerful and frightening glance that would exterminate even the most resilient evil spirits instantly. Jangarh's deities were his mental images, which occupied the newly-found secular space of the paper or canvas, and were not meant as objects of worship.

Since there was only a rudimentary convention of creating visual forms as in the ritual clay relief work (*nahador/dhigna*) or casual scribbling of figures on the exterior walls of houses or local shrines, there was little by way of an artistic tradition for Jangarh to fall back on for inspiration. Yet his arrival at Bharat Bhavan and his resulting encounter with paper, poster colours, fine-tipped pens and pitch-black inks quickly inspired him to conjure up the entire universe of his native village in

Fig. 97 Portrait of Ganesh. Jangarh Singh Shyam, 1995, pigment on paper, 71 x 56 cm. Collection and image courtesy: Museum of Art & Photography (MAP), Bangalore (PTG.0738)

Fig. 98 *Ganesh Musha*; Ganesh on his mouse. Jangarh Singh Shyam, 1997, ink on canvas, 114 x 38 cm. Collection and image courtesy: Kavita Sanghi, Indore (DC.00287)

Fig. 99 Ganesh playing the Flute. Iconisation of Ganesh playing the flute in a stance resembling Krishna, partially using the technique of stencilling with a graded spraying of ink. Jangarh Singh Shyam, 1997, pen and ink on paper, 117 x 41 cm. Collection and image courtesy: Kavita Sanghi, Indore (DC.00249)

Fig. 100 Ganesh-Shiv; the artist's conceptualisation of a combined image of Ganesh and Shiva — the latter represented by his phallus and trident symbols. Jangarh Singh Shyam, 1994, pen and ink on paper, 40 x 35 cm. Collection and image courtesy: Gursharan Singh Sidhu (DC.00269)

95 For decades now, Hindu missionaries have been travelling through the Indian tribal and rural areas, convincing people to take vows to abstain from meat, alcohol and animal sacrifice

96 Kramrisch, see footnote 53
97 Thomas 1991: 9: Introduction

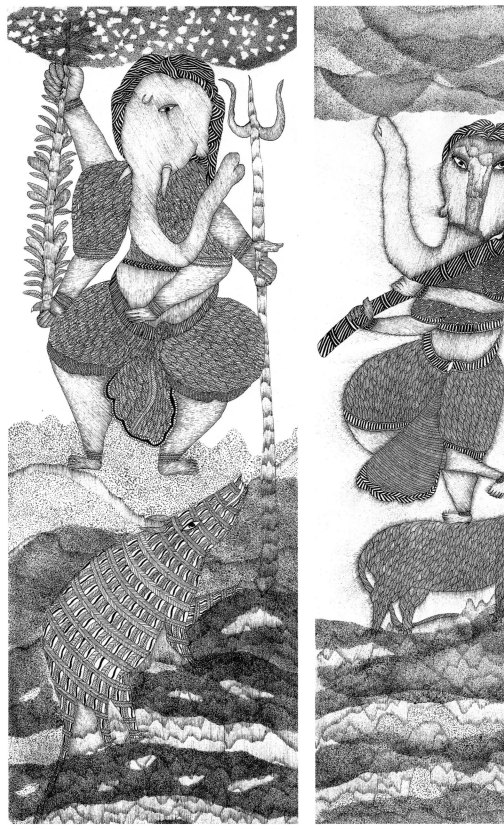

Fig. 98

Fig. 99

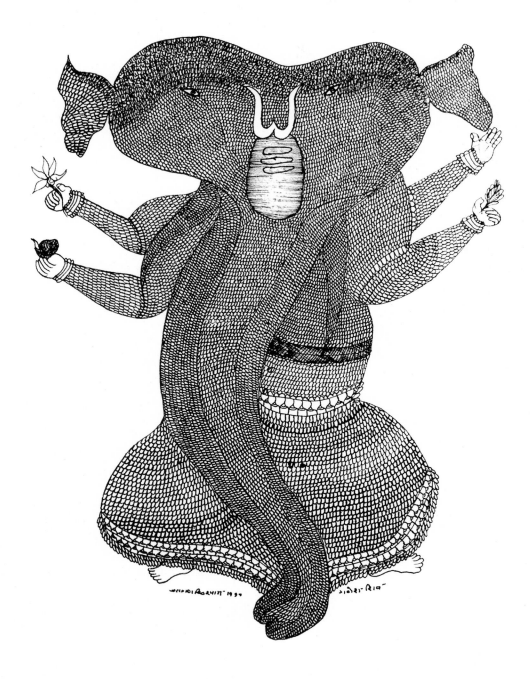

Fig. 100

the form of memory images. Jangarh's entire body of work is an unchronicled archive in which images constantly generated and regenerated themselves, both as cause and as effect of one another.

Shivalinga/Ghuri Dev

The installation in the foreground with a phallus-shaped stone surrounded by offerings of pebbles, fruits and coconuts is described as Ghuri Dev (Fig. 102). The painting is a nostalgic remembrance of the days when the Pardhans of Patangarh ruled over the forests around their village, where they collected firewood, fruits and berries, grazed their cattle and hunted. Ghuri Dev was installed with a prayer while entering the forest, to protect them from ghostly spirits and wild animals. Though this ritual has become extinct due to restrictions on the entry of the tribals into the forests on account of the government's forest policy, Jangarh has tapped into the collective ancestral memory to conjure it onto the pictorial space from where he speaks.

Duda Rakshas

In Pardhan belief, Duda Rakshas is a demon dwelling in the forest, which assumes the form of a *bhuri bhens* (brown buffalo) and was killed by Narayan Dev (this also evokes a reference to the myth of the goddess killing Mahishasura, the buffalo demon). In Fig. 103 the demon is shown squatting on a bed of leaves inside a cave, roasting the meat of his victim. Jangarh has divided the painting into two diagonal halves. The black space is that of the cave while the red space indicates the night sky studded with the stars seen from inside the cave. The radiant blue of the

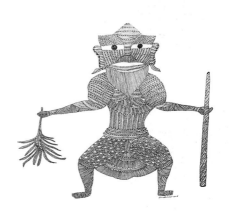

Fig. 101

Fig. 101 Bahari Batoran. Portrait of a divine personage who cleans up the village of evil spirits and disease. Jangarh Singh Shyam, 1998, pen and ink on paper, 56.5 x 49.5 cm. Collection and image courtesy: Gursharan Singh Sidhu

Fig. 102 *Shivalinga*/Ghuri Dev. Jangarh Singh Shyam, 1998, pigment on paper, 56 x 71 cm. Collection and image courtesy: Museum of Art & Photography (MAP), Bangalore (PTG.01770)

Fig. 103 Duda Rakshas; Demon in the Forest. Jangarh Singh Shyam, n.d., pigment on paper, 141 x 193 cm. Collection and image courtesy: Museum of Art & Photography (MAP), Bangalore (PTG.0834)

Fig. 104 Collaborative painting by Indian tribal and Australian aboriginal artists. Ladobai, Jangarh Singh Shyam, Djambawa Marawili and Liyawaday Wirrpanda, 1999, acrylic on canvas, 182 x 500 cm. Collection: Crafts Museum, New Delhi. Photograph: Laxman Das Arya. Image courtesy: RMIT Gallery, Melbourne

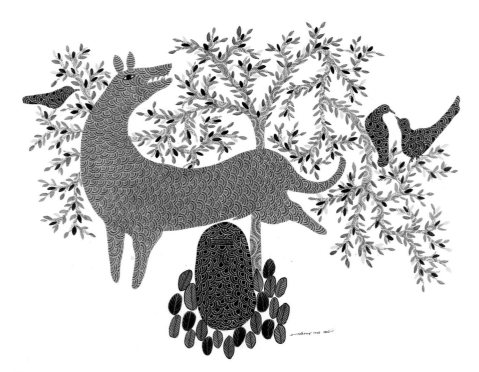

Fig. 102

Fig. 103

bed of leaves and the incandescent red of the night sky bear testimony to Jangarh's subtle perception of colours and their expressive power.

Collaborative Painting of Jangarh, Ladobai, Marawili and Wirrpanda
In 1999, on suggestion from the Australia-India Council and in association with it, I organised a unique experiment at the Crafts Museum (Fig. 104). In collaboration with Jangarh Singh Shyam and Ladobai, two Australian aboriginal artists created a single large painting. Jangarh and Ladobai recreated on the canvas, scenes from their creation myths, while Marawili and Wirrpanda painted aboriginal geographies filled with images of primordial memory.

The outcome was astonishingly powerful. The coming together of these four artists did not result in four fragmented works; rather, they harmonised in an artistic embrace that was gentle but compelling, and interactive without being transgressive. Looking at the completed canvas, I felt the intensity of the two teams' engagements with their archaic territories, both mythical and cartographic. Interestingly, the Indian pair sat on one side of the canvas and painted the left and the central portions, while the Australian duo worked on the opposite side. The painting therefore offers two different vantage points, with the blue of both oceans providing a fluid unity to the painting.

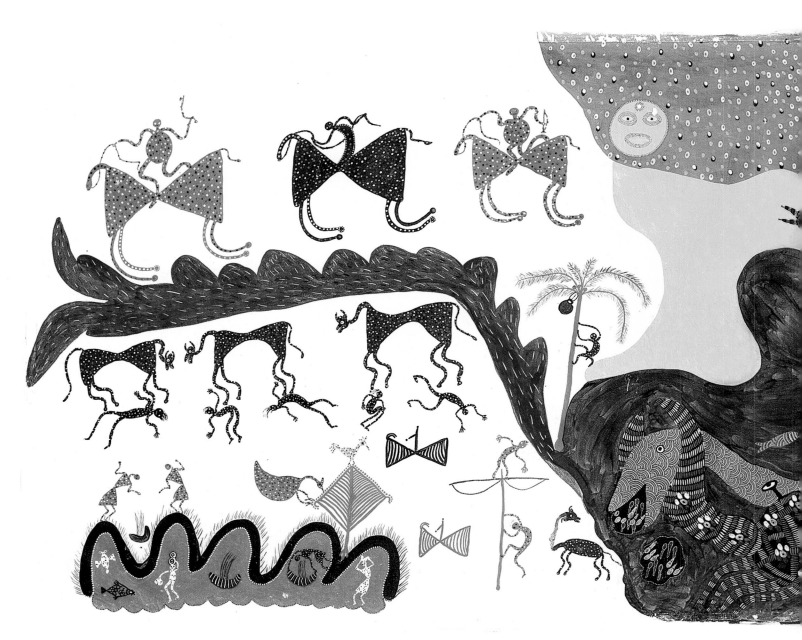

Fig. 104

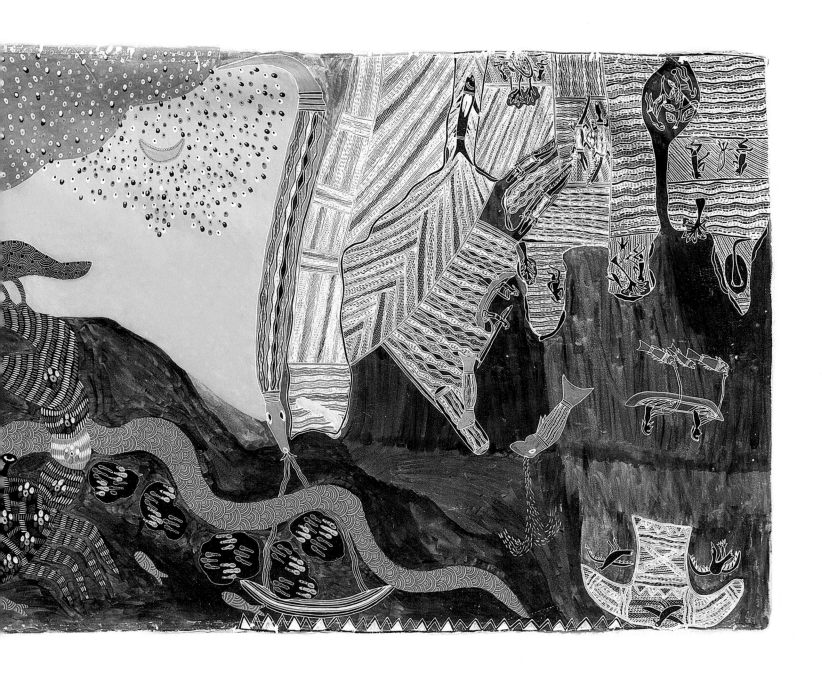

TRAPPED IN CROSSING

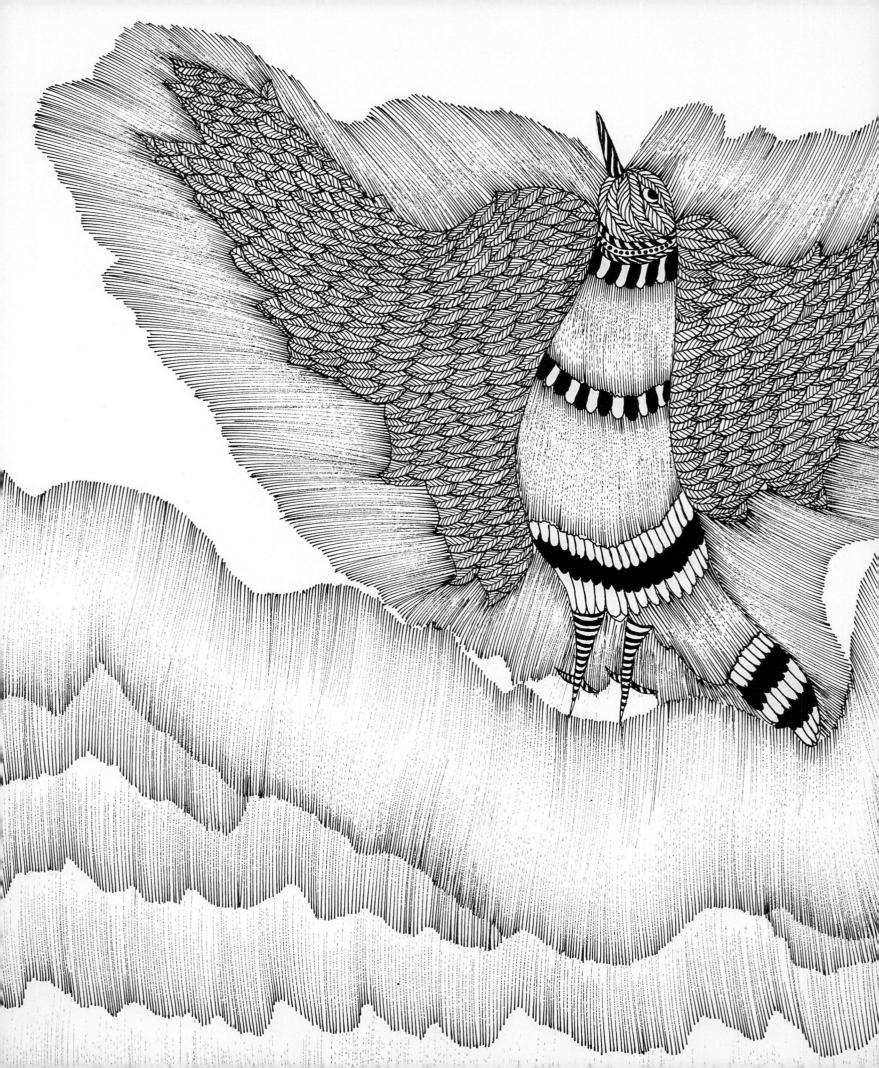

On July 3, 2001, Jangarh Singh Shyam reportedly committed suicide while doing an artists' residency at the Mithila Museum in Oike, Tokamachi, in the Niigata Prefecture of Japan. Jangarh, along with other folk artists, had travelled to Japan for three months, to create a bulk of paintings for the Mithila Museum, on a fixed salary of Rs. 12,000 per month. The Museum usually retained some of these works for its own collection and sold the rest to raise funds to run it. From his letters written a few days before his death, it is clear that Jangarh was facing an anxiety-ridden situation at his Japanese host's place, and that he was desperate to return home on completing his three-month commitment. It appears that when his hosts commissioned additional work from him and extended his visa for another three months, Jangarh, already deeply lonely and homesick, panicked, and in utter anguish and helplessness took the extreme step of hanging himself on his host's premises.

Two material accounts are available to us concerning Jangarh's condition, thoughts and state of mind, at least during the last fifteen days before he ended his life. These are two personal letters that he wrote to his wife and mother, respectively, in Bhopal during that agonising fortnight; the second one reached the family only after his suicide. The other is a detailed report from a staff member of the Mithila Museum dated July 13, 2001, which in its tone and tenor reads like an official chronicle of Jangarh's movements and behaviour during the last three days of his life. In this report, besides certain touching details, there are a couple of passages of an inadvertently poetic quality, which reveal Jangarh's inner disposition and the condition of his mind just a couple of hours before he ended his life:[98]

> At around noon he went back to his residence for taking meal. Usually, he put off the light before coming out of the work room but the light was still on. He kept spectacles and a cap on the Working Desk and he could have started painting immediately after coming back to the room.

98 There are a number of spelling and grammatical errors in this letter, which were too frequent to mark and, as such, I have left them as in the original letter

Kitchen was clean and Sabji was prepared and kept for two meals and the Rice cooking pot was clean and kept. The room was kept well and the floor mat which is used for sleeping was kept as sitting purpose.

Small puja place was kept on the rack and 27th June's Fax which was written in Hindi was folded and kept in the left side. Under the medicine box, there was a letter came from India dated 18th June but the content was nothing particular about.

After the above situation, from the night of 30 June to 14 pm of 3 July he lost the balance and connection between the reality and he created his own world and he cut all the connection with life, wife, children and friend and he took the path of death.

This is the only record we have of Jangarh's last moments. The image of him carefully placing his spectacles and cap on his work desk, of putting his room in perfect order, of keeping aside the prepared vegetables for the next meal, of placing the neatly folded up fax — the last communication from home — in his *puja* place, and of snapping, in despair, all connection with an unresponsive world, are as haunting as they are reflective of his persona.

The only tangible remnants we have that provide a glimpse into his inner life over his last two weeks, are the two letters that he wrote home. What is most striking about them is not just the expression of an acute feeling of desperation but the reiteration of a looming premonition of death — a prelude, as it were, to what was to come. I reproduce below both letters in their entirety and in translation, as these speak of his gentle, kind and loving personality as much as of his utter sense of loss in the impermeable web of the art world and its norms.[99]

I. Jangarh's Letter to his Mother

Auspicious Shri Hari
Place Tokamachi, Japan 14-06-2001

My greetings to my revered mother by touching her feet and to dear Nankushiya, you be happy forever and give to our dear children, Mayank, Gudiya [his daughter Japani], Manish, daily and endless love and blessings, and greetings to Dileep, Ram Bhagat, Makadam, and love to Uday, and my greetings may be accepted by Shyamabai and love to Ram Singh and Rupa, and convey my greeting to Bhajju and Deepa, Suresh and Sindhiya, Venkat and Anand, and Subhash and Durga. Further, please know that I am all right over here. You don't worry and just look after yourself, as here I am looking after myself. My health is not great, it is all right — I am not only hopeful but fully convinced.

Write me the news that with my mother and children you are well. Nankushiya, perhaps they will not let me return till July or August because they have given me large works [to complete] and have also put up an exhibition. [The following lines are written in his mother tongue rather than Hindi] I cannot tell you how I am surviving here. Board and

Figs. 105 and 106 Facsimile of the front and back page of the original letter from Jangarh to his mother, dated 14-06-2001

lodging is fine but I don't like it here anymore. My visa, too, will expire on July 13, I don't know whether they will put me [in an airplane], these thoughts occupy my mind. Anyway, don't think about me. Yes, there is a person from Bihar who perhaps will come to Delhi, who has told the agent something about me, who appears to be somewhat upset [with me]. The rest is fine. The letter sent to you may be kept safe. Give my greetings to Thakur Saheb and Didi and tell them about my visa, don't know what will happen, but don't worry. And I have received whatever letters Ram Singh had sent. Yes, have received Gudiya's letters too — don't put anything inside [the aerogrammes]. I am not able to write in full detail [illegible] they see [read everything]. You, too, don't write much about me here. I am trying to finish the work — let's see if I can manage. That way they are saying that you leave on July 26 with that Lala Pandit of Bihar. Don't know what they will do — perhaps because I could not come here the previous year, they are upset with me. If they don't let me come back then, tell [Daya] brother [of Kanpur] that he [illegible] phones Madam asking her to send me back in July. What should I say, I came here in ill health but you don't worry, tell Didi, etc. they are the only people who look after us. Had there been a 'culture visa,' I would not have given it so much thought but I have a tourist visa [illegible]. Madam had obtained culture visa for Pandit. Anyway, if God is kind, I will come back, you don't worry, keep the children with affection. I can phone less frequently, tell brother to phone and not [just] write letters [illegible] keep writing letters till when I don't come back — what should I say or not say [illegible] the rest is fine. I am working continuously, will try to finish, let's see till when it will be done. Go to Amma and ask her briefly and send the letter properly sealed. My greetings to friends and relatives. They will let me go by August, that is my guess. You, mother and children, don't worry. I will phone if I have time in between and if they allow it. Yes, I have received the letter of Daya Bhaiyya. If he tells Madam, only then will they relieve me. They have said that they will tell me on July 2-3 [illegible]. If they let me know I will give you the information. The rest later — know what I have written in our language.

Tell Ram Singh if he can send them soon, he should send me photographs of some good work [illegible] six or seven photos of [his?] paintings. All is well. That Bihari is not a good person. He is a telltale and a gossipmonger. I am writing this in fear.

99 Photocopies of these letters were given to me by Nankushiya Shyam, Jangarh's widow, along with a letter of no objection for publishing them in this book. The letters were transcribed for me from Jangarh's handwritten version in clear Hindi script by the Pardhan artist Bhajju Shyam, Jangarh's nephew, who also helped me to accurately translate these first into standard Hindi and then into English. I have tried to keep the translation as literal as possible, and where a few words were not clear, I have indicated so in the translated version. I am reproducing facsimiles of the original letters for authentication. Even so, if any discrepancy has remained, it is inadvertent and Bhajju Shyam and I stand corrected. All the clarifications as put in the footnotes are a result of comments received from Bhajju Shyam during his sessions with me in Delhi from May 29-30, 2017

श्री हरि कृष्ण स्थान वेत्रा भान्यी

प्रिय नीमा माता जी के चरण स्पर्श प्रणाम । गोपाल 14-6-2001

Fig. 105

आप मझे

AEROGRAMME
邦空便

To, श्री मार्ग जनाई शिया वार्ड श्याम
C-1651, विहाई-ई निमाला सर्जन पोट
प्रोफेसर कालोनी मोरेशा
(म.प.) INDIA

श्र. एस श्याम
भिवला म्यूजिक चेटा माची वोडे,
निगाला जापान
948-0081 JAPAN

Fig. 106

TRAPPED IN CROSSING / 117

II. Jangarh's Letter to his Wife, Nankushiya

Shri Hari Auspicious
Place Tokamachi, Oike, Japan 30-06-2001

Dear Nankushiya, may you remain happy forever and give my love and blessings to the children — heaps of love to Mayank, Gudiya and Manish, and love to Dileep [Jangarh's elder brother's son], Bhagat [the domestic help] and Uday [Jangarh's cousin], and greetings to all the members of the family, and convey my greetings to my mother by touching her feet.

Please know that I am well here and hope that you are well. Convey my greetings to Thakur Saheb and Didi [Jangarh's police officer neighbour and his wife], my love to Subhash [Jangarh's brother-in-law] and Durga [Subhash's wife]. Further, this is the only news:

Nankushiya, you be well along with the children and do not worry about me. Yesterday, on 29-06-2001 they took me to Yokohama to extend my visa, they have extended the visa for three months. I cannot say anything, don't know what will happen. Tell mother, too, not to worry. Let's see when I can return. I feel there is some foul play with regard to me. They are saying that I can go on 26-07-2001 or on 27-07-2001 but I do not think they will let me go. I am very miserable, now it is in God's hands. Ask Amma [a soothsayer][100] in detail about whether I am going to be in any trouble. Write it in a letter and seal it well. Handle the daily household expenditure with restraint. Tell Madam [the representative of the Mithila Museum based in Kolkata] to send the payment, telephone her. Tell Didi or Thakur Saheb to send a letter or a fax to the Director asking him to send me back. And when it is to be written — the name of the Director is Tokio Hasegawa. The address is the same. If you send it on my name they will not understand [for whom it is]. Sakurako had said she will come to meet me but she has not come yet. I don't know what they are thinking. Find out from Phis Makadam these people got me out of a good house saying 'go' and tell them to go [the meaning of this sentence is unclear]. Discuss with Amma or any wise person whether there will be any mishap with me. I am surrounded by these worries every day. You don't worry, whatever happens, whatever God does [illegible] and write me the telephone number of Didi. I told them to send me back on July 6 or 12 but they are saying that presently there is a wait for air ticket booking. And ask whether there was any talk with Madam. Yes, Madam has sent some medicine. I had faxed her. Does Dhirendra come home? If he sends any fax he should send it only to the Director — saying 'send him,' send it under your name. I don't know whether I will be able to see you people [again] — there is such a feeling. Bhagat should also think or ask somebody else or enquire with Amma whether there will not be trouble for me. The rest is fine. I feel Sakurako, too — they are all playing a game. And that masseur called Prasad who used to come — what all did he do or not do — everything is going awry. Tell Bhagat, if possible, I will phone him on Sunday. Yes, give a proper thought to all that I have written [illegible] Why am I feeling so lonely this time? And whether Subhash [unclear] people have come back from the village, ask them, too, to do something for me and be careful with your expenses. Tell Thakur Saheb to take care of my matter. Now once again getting a tourist visa done

[illegible] I left Tokamachi [illegible], I [illegible] visa is done from Yokohama. I don't know what will happen, my fate is with God alone.

The rest is fine. Give my love to the children again and again. Has my mother returned from the village? They are saying that I can go by July 27 but I have no trust in when they will relieve me.

Give my greetings to the neighbours and relatives, and to Ram Singh, Rupa, Bhajju, Venkat, Anand and their families. And tell Ram Singh that if they don't let me go in July, he will ask Sundar to talk to Jain Sahab [Jyotindra Jain] that he should talk to the Director to send me back, this is the only request for Ram Singh. The rest is fine. Write a letter. The Maharashtrians are expected to arrive here. You don't worry much and look after your health and give my love to the children. Please think seriously about what I have written, and make an effort and find out what they say.

Much daily love and blessings to you.

Your husband Jangan Singh

A couple of days before leaving for Japan for three months, Jangarh had phoned me to say goodbye. He mentioned that he was going there unwillingly and that he had apprehensions about spending such a long period of time away from his family, and in a place as isolated as Oike, where he had suffered bouts of loneliness during an earlier visit, too.

Over the years, Jangarh and I had developed a sense of friendship. It began with his spending a month at the Crafts Museum as artist-in-residence, and deepened while we installed the exhibition *Other Masters* (1989), which, besides featuring his own paintings, also had him working for over a month alongside his mother and sister Shyamabai to create a replica of the traditional clay relief work of Pardhan houses. We met again when he spent about two or three weeks with me in Delhi while preparing a facsimile model of his murals to be painted on the walls of the Assembly Building of the Madhya Pradesh Government.

During these stays he revealed much about his life and his creative process. It was then that we developed a feeling of amity and trust in each other. In the last letter written from Japan just three days before his death, he had sought my intervention in getting him sent back home from Japan. Unfortunately, the letter arrived in Bhopal only after he had ended his life. To this day, the episode continues to haunt me and this is what gave the impulse for writing this book as a tribute to him.

100 Jangarh referred to his mother as Mataji, and to the Muslim soothsayer, to whom he was very close, as Amma

प्रिय नन्दु प्रिया तुम सदा प्रसन्न रहो एवं प्रिय बच्चों को मेरा प्यार...

[हस्तलिखित पत्र — अधिकांश पाठ अस्पष्ट]

Fig. 107

AEROGRAMME
भारत वायु पत्र

To,
श्री मती नन्दु किशोरिया व्याह श्याम
C-165/1 निरालो नगर विहाइंड वीरने
शेकेटर कालोनी गोविंदा
(M.P.) 462002 INDia

Second fold here

Sender's name and address

जे. एस. श्याम
किंबला प्युकिया उ4फे वोका आरी
निशानागर गापान
948-0081 JAPAN

Nothing may be contained in this letter.

वन्यूटर को व्याह देगा और गरल से व्याह व्याह था द्वार गीवि से आगे की गर्ड
27- अगाई हो दवली रही की नाग अनदेपुर मुझे खिलाप पढ़हा रहा है
की नवर दिर्दे गर अनु नागि व्याली वाली को प्रयाग करना वारामसिंह स्रार की भाजू
टेंच्द आगापेद भागुरिटगो की प्रयाग व्याना मोरिगाव सिंह की्षय व्हला यसिंधु
स्याले ने नही दिर्ट्जो तो स्थुरिहरो करला नोग साहय से वोहेगा-भ्र साराव्यट-सो वर्ट
की कि उन मोरोगमो भार्ष प्रागोग होगम सिंह के लिये शेर सम्बा वोड पढ़ लिखगा
महूरी भवागमट वरा स्थाप आगी वाले हो दव जाय बिला नहिर्गामा गा भाषो
1भामपट का स्यालेग रहगा करन्यो को श्याप जो किल्या स्ट्रह उसने वोट हो और्गार रिग्या
नगार के देख इग्रगाणा व्यार स्थाणिही आगको मेरे प्रिरगिगना व्यार आगागीर
आगाये वही नागानाटि

When Jangarh called me before his departure and voiced his concerns, I advised him not to go to Japan in such an uncertain state of mind and asked him whether he was going there for the money. He emphatically denied that factor and told me that he would easily earn more in India itself for work done over a period of three months. He said he had agreed because there had been pressure from the Japanese side, and that a Japanese representative from the Museum had been constantly trying to persuade him to go. He said something along the lines of: "I could not refuse, because by temperament I am very shy, and I felt a sense of guilt that even the previous year I had declined the offer to go there."

It is noteworthy and therefore all the more upsetting that both Jangarh's genesis as a renowned artist and the miserable end of his life are deeply associated with the museum — an institution that over many decades has assumed powers to establish canons of art, often launching artists' careers, and thereby prompting the art market. A couple of years ago, I was asked by a Delhi-based art gallery to authenticate a few paintings from their collection as Jangarh's. They were not signed by the artist. In the gallerist's own words, the contention was that if I were to authenticate them as Jangarh's works "these will turn to gold." Jangarh's reputation had snowballed by the early 1990s. He had by then become a great favourite of investor-collectors of art and commercial galleries. After his death, his market value skyrocketed, particularly with the sale of one of his paintings at Sotheby's in New York for $31,000, which at the time was an unheard-of sum for a contemporary Indian folk or tribal artist's work. His paintings began to be insured for millions of rupees, when loaned to international exhibitions.

From Jangarh's last two letters it becomes amply clear that the minimum three-month extension of his Japanese visa — he was to stay on for only a part of that period in order to produce more works for his host museum — triggered a panic in him, as he had already been feeling desolate towards the end of his first three months there. The Mithila Museum authorities had explained to him that he need not stay the extra three months but only about 20 additional days to finish certain works. It should be mentioned here that a degree of the cost of running the Mithila Museum comes from selling some of the works of the artists-in-residence, as it does not have sufficient independent funds and runs on a shoe-string budget.[101] In his letters, Jangarh repeatedly asserts that he was not sure whether the bulk of the work given to him could be completed within a month or not, and this made him feel acutely disheartened. Let me highlight some excerpts from the letters:

> "Nankushiya, perhaps they will not let me return till July or August because they have given me large works [to complete] and have also put up an exhibition."

> "I am trying to finish the work — let's see if I can manage. … [P]erhaps because I could not come here the previous year, they are upset with me."

> "I am working continuously, will try to finish, let's see till when it will be done."

> "They are saying that I can go by July 27 but I have no trust in when they will relieve me."

Ironically and deeply tragically, Jangarh's 'discovery' and his death were both rooted in and entangled with the process of developing a museum. The trajectory of the 'museum effect' in the life and work of Jangarh leads us to the larger question of the provenance of works by folk and aboriginal artists created and acquired in and for museums. Let us for a moment linger on this feeling of terminal despair that gripped Jangarh in the last fifteen days before his death and becomes tangible in several premonitory expressions in his letters:

"I feel there is some foul play with regard to me"; "now it is in God's hands"; "Anyway, if God is kind, I will come back, you don't worry, keep the children with affection"; "Discuss with Amma"; "whether there will be some mishap with me. I am surrounded by these worries every day"; "I don't know whether I will be able to see you people [again] — there is such a feeling"; "my fate is with God alone." Behind these anxious thoughts lurks an indication of psychosis — that he was being observed and that others were going to cause him harm, that his letters were being opened and read, and that he was being singled out by the organisers and other artists. He writes:

"I am not able to write in full detail [illegible] they see [read everything]. You, too, don't write much about me here"; "know what I have written in our language"; "I can phone less frequently"; "what should I say or not say?"; "send the letter properly sealed"; "I will phone … if they allow it"; "I cannot say anything"; "They are all playing a game"; "That Bihari is not a good person. He is a telltale and a gossipmonger. I am writing this in fear."

The above quotes from his letters echo his profound sense of isolation — a feeling that was perhaps intensified when he did not receive any response from his family in Bhopal.

Jangarh's demise in a foreign land under these circumstances caused a flutter in the international art world. The Indian press widely reported the incident. I organised a prayer meeting at the Crafts Museum in New Delhi on July 7, 2001, which was attended by some of India's most eminent artists, art critics, writers, art collectors as well as musicians, including the artists M.F. Husain, Manjit Bawa, Ranbir Kaleka, Vivan Sundaram, Ram Rahman, Harsha Vardhan; the art critics Geeta Kapur, Gayatri Sinha, Suneet Chopra, Yashodhara Dalmia, S. Kalidas, Jaya Jaitly; the writers Nirmal Varma, Krishna Baldev Vaid, Champa Vaid, Ramesh Chandra Shah, Ashok Vajpeyi; the academics Sudhir Chandra and Suresh Sharma; the musician Subhadra Desai; and Kathak exponent Rashmi Vajpeyi as well as the art collector Gursharan Sidhu, among others.

101 Summarised from a written communication dated July 5, 2001, by Ms. Miyoko Hasunuma, Curator of the Mithila Museum, sent to the author

Jyotindra Jain
(JYOTINDRA JAIN)

Niranjan Acharya

M.F. Husain

Manjit Bawa Siddharth Suresh Sharma Champa Vaid
Suneet Chopra Chopra Rashmi Vajpeyi
O.P. Jain Sashya Iris Jain
(KRISHNA KUMAR)

Jutta Jain-Neubauer Gayatri Sinha

Milan Verma Gursharan K. Sidhu

Yashodhara Dalmia Harbans Raj Rohin

Geeta Kapur Joshi
RANBIR KALEKA

S. Harsha Vardhana Anil Kumar Aggarwal
KRISHNA BALADEVUARD Manish Pushkale
Ramesh Chandra Shah

Sarrin सुभद्रा देसाई

Omkari Dhawan Elfi Baschiera

Vivan Sundaram

Balu Khan

Gade Chhatora

Sanjib

Anjalee Wakankar

"People Tree"

Fig. 109

During this meeting, a resolution demanding that a thorough enquiry into Jangarh's suicide be conducted by the governments of Japan and India was adopted, which was drafted by Ashok Vajpeyi and signed by the art fraternity present during that meeting. The original document with the signatories to this resolution is reproduced as Fig. 109.

It was reported that Jangarh Singh Shyam's body arrived in a coffin at Bhopal airport after midnight by a special flight, and was received by the officers of the District Administration, as well as his artist colleagues, friends and family. His body was immediately taken to Hamidia Hospital for the post-mortem examination. The next day, it was moved to Bharat Bhavan, where people could pay their respects and have a last glimpse of the city's exceptionally talented artist. He was cremated in Bhopal on July 12.

Here, a reference needs to be made to the appalling issue over the cost of repatriating Jangarh's body. One morning, soon after his demise, I received a telephone call from the Mithila Museum, informing me that the cost of sending Jangarh's dead body by air was extremely high. It was therefore suggested that he be cremated in Japan, which would be much cheaper, and to pay the amount saved to Jangarh's family. I was furious to hear this and asked them to immediately send the body to Bhopal, as the question of Jangarh's cremation would be deeply linked to the sentiment of his family and the art world of Bhopal and India at large. I then spoke to Aftab Seth, the then Indian Ambassador in Tokyo, about this impetuous offer. He, too, was enraged and promised to enquire. Apparently, Akhilesh, a Bhopal-based artist and then Deputy Director of Bharat Bhavan, too, had received a similar offer by phone from the Mithila Museum. Akhilesh is quoted as saying: "He has made a peculiar offer. He says he had budgeted rupees two lakh to fly down Shyam's body. But now he has apparently discovered it will cost six lakh. So he says, why not cremate the body in Japan itself, which will cost only rupees 50,000, and fly the ashes to the family, which can then keep the rest of the two lakh."[102] Anand Shyam, Jangarh's nephew, has given me a written account of these negotiations over Jangarh's dead body based on his recollections today. Anand says that he and Ashish Swami, the coordinator of Jangarh's Vidhan Bhavan mural project, went to meet Jamuna Devi, the Deputy Chief Minister of Madhya Pradesh, and requested her to organise the funds. She, herself a tribal, talked to Digvijay Singh, the Chief Minister. The requisite funds were arranged and Jangarh's body was brought back to Bhopal by a special plane.

What does one say to all this? A tribal artist's aspiration to make a decent living in an urban centre lured him into the ruthless global marketplace of art, whose pressures he was not equipped to cope with. He was trapped in crossing.

Fig. 109 Facsimile of the signature sheet approving the resolution passed by eminent personalities from the world of art and culture

102 Renuka Narayanan, Tribal Painter's Suicide in Japan, in: *Indian Express*, Saturday, July 7, 2001

At this juncture, it would only be fair and appropriate on my part to put forward the position of the authorities of the Mithila Museum on the issue of Jangarh's demise during his residency there.

The Museum staff has explained in some of their official statements and in a letter addressed to me soon after Jangarh's demise that, though they had indeed extended his visa for three months for technical reasons, Jangarh was clearly informed about his confirmed booking on a flight back to India on July 27, 2001, a little over three weeks before Jangarh ended his life on July 3. The Mithila Museum authorities had a feeling that after 30 June, 2001, Jangarh suddenly no longer appeared as his usual self. In one of the documents sent to me they wrote: "After the above situation, from the night of 30 June to 14 pm of 3 July, he lost the balance and connection between the reality and he created his own world and he cut all the connection with life, wife, children and friend and he took the path of death."

Dr. J. Jain
Senior Director
Crafts Museum, Ministry of Textiles, Govt. of India

Miyoko Hasunuma
Curator of Mithila Museum
Oike, Tokamachi, Niigata, JAPAN
July 5, 2001

Dear Dr. Jain;
Thank you for your calling yesterday.
We are extremely sorry about the sudden demise of Mr. Jangadh Singh Shyam.

We would like to assure his wife and family that we feel deeply for them in their sad bereavement.

The details as we know at the moment are as follows:

He came to Japan on 13th April on a short stay Visa. The Visa would expire on 12th July. We had applied for 15days' extension. They issued 3 months' Visa as a formality but late Mr. Jangadh Singh was fully aware that he would be leaving for India on 27th July.
He was in fact, quite happy to know that he would not be traveling alone, as Mr. Lala Pandit, Terracotta Artist would be accompanying him back to India on the same day.

However, a fax written in English came on 26th June from India mentioning his wife was very serious and needed his help. He sent back a fax on 27th June but after that he stopped shaving and looked very depressed. We asked him what was troubling him but he did not say anything.
On 1st July, Sunday, he talked to his family a little longer than usual. On 3rd July in the morning, he came for breakfast and Mr. Tokio Hasegawa asked him how he was and he replied that he was fine. After that he was painting in the Museum workshop and at 12:15 p.m., Ms. Ogose who is a member of the Museum had a short conversation with him. After that he retired to his room and when he did not come back to the Museum main fall for a long time, we sent Mr. Hatakeyama, a voluntary member to call him. It was then that Mr. Jangadh Singh had taken his life. Immediately Police was called to conduct the investigation.

Figs. 110 and 111 Facsimile of the front and back of the original letter written by the Mithila Museum authorities to Jyotindra Jain, then Director of the Crafts Museum

Fig. 110

III. The Letter from the Mithila Museum, Japan

To represent the position of the Mithila Museum on the issue, I reproduce here one of the letters addressed to me, dated July 5, 2001. Jangarh's own two letters addressed to his mother and to his wife quoted in full above were written on June 14, 2001, and June 30, 2001, respectively (the latter arrived in Bhopal only after his demise), and mainly emphasise his distress about a possible delay in returning home, but the Mithila Museum communications suggest that something transpired between the night of June 30 and July 2, which unsettled him so immensely that he took this extreme step on July 3. Since no conclusive investigation has been conducted on the matter, the actual cause of Jangarh's abrupt end remains an enigma. Yet one thing is certain: this time, Jangarh was trapped in a calamitous crossing from which he could not escape.

Now the matter is under the jurisdiction of Japanese Police and Indian Embassy.

What perplexes us the most is why a person knew he was going to return shortly to his homeland would take such a step?

For your perusal, we are sending the Certificate of the Reservation of the date of departure issued by Biman Bangladish Airlines. Further, we are enclosing the Fax message in which Mr. Jangadh Singh requested for some medicines.

Now we are collaborating with Indian Embassy to send the mortal remains of Late Jangadh Singh by Air India to Delhi AI309 on 7th July, Saturday.

Sincerely yours,

Miyoko Hasunuma

(MIYOKO HASUNUMA)

Fig. 111

AFTERWORD

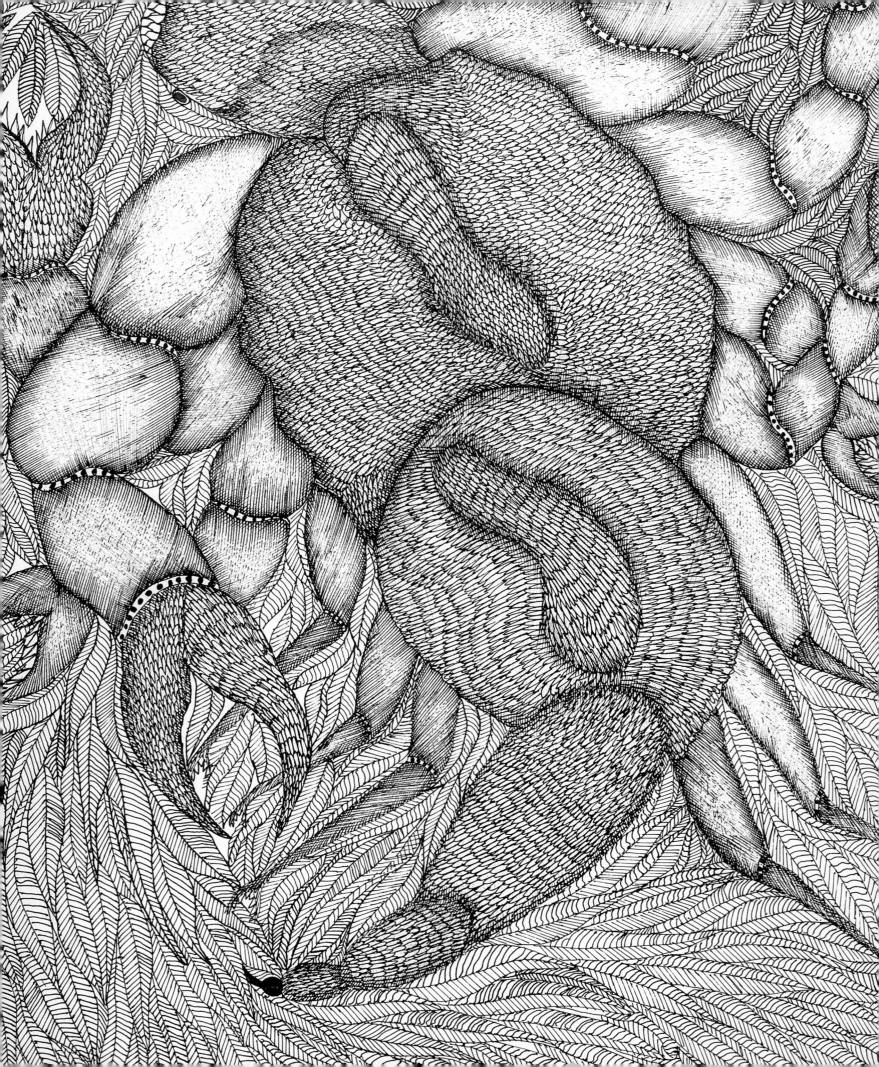

In the relatively short span of his artistic career, Jangarh left behind a formidable body of work, at once original and experimental. There was little in terms of a pre-existing painterly tradition in his community for Jangarh to lean on, except for the simple, geometric clay relief work done by women on their house walls. After his arrival in Bhopal, he evolved a personal idiom of visual expression solely backed by his explosive yearning to draw and paint, his profound curiosity about the mysteries behind the mythologies of his gods, shamans and priests, and his abiding bond with the infinite world of birds, reptiles and other creatures inhabiting the forests and subterranean environment of Patangarh, his native village. Equipped with this cognitive asset, when Jangarh arrived in the warm and welcoming atmosphere of Bharat Bhavan in Bhopal in the early 1980s, his creative outburst seemed to know no limits, especially when he encountered paper and bright pigments there, which led him to say: "The first time I dipped my brush in bright poster colours in Bhopal, tremors went through my body." This quintessential expression of his contained the seed that was to bloom into the enormous body of his unique work, which turned into a movement inspiring a whole generation of young Pardhan artists to paint and branch out into their own spaces of individual expression. Most of them came to Bhopal at Jangarh's instance and belonged to the same cultural background as Jangarh himself. They became a part of the various mediatory processes that were operating in the art world of the city, in which Jangarh's role was pivotal. Some of them initially worked with Jangarh to assist him with his own works, others learnt printmaking with his help, or were initiated into painting while working alongside Jangarh on the mega mural project of the Vidhan Bhavan complex.

Moreover, the presence of such dynamic art and cultural institutions in Bhopal as Bharat Bhavan (and, to some extent, Manav Sangrahalaya), which emerged as a unique composite and egalitarian platform for modernist artists, on the one hand, and contemporary folk and tribal artists, on the other, envisioned by the artist J. Swaminathan and the poet Ashok Vajpeyi, and nurtured by the continuous mutual interaction between them there, played a major role in motivating several Pardhan, Bhil and Bhilala tribal artists, besides Jangarh, to chart out their own individual creative paths. In this context, I must reiterate that it would only be appropriate to use the term 'Jangarh idiom' for the body of his own work but to not subsume the vast outburst of painting that occurred around and after him under

that exclusivist label, as this would subvert the lively, diverse and highly individual-istic forms of Pardhan painting that have emerged in the last two decades.

In fact, it must be noted here that Jangarh himself regularly discouraged other artists from imitating his idiom and sometimes even slighted them for doing so. He always advised the Pardhan artists around him to find their own language of expression. In order to encourage individuality and breaking free from Jangarh's shadow, which appeared to loom large over the newcomer Pardhan artists in Bhopal, Swaminathan urged them to sign their works. He understood all too well that signing their works was more than merely a literal step towards dissuading these artists from inadvertently imitating Jangarh. As the seed was sown in many of the artists to explore their inner worlds and to find a commensurate visual language of expression, the surge of individual creativity that occurred turned into a move-ment constituted by the works of such artists as Ram Singh Urveti, Anand Shyam, Bhajju Shyam, Subhash Vyam, Durgabai Vyam, Nankushiya Shyam, Mayank Shyam, Kalabai Shyam, Rajendra Shyam, Venkatraman Singh, Dileep Shyam, Narmada Prasad Tekam and a few others.

On account of the lack of space and in order not to move too far away from the main focus of this monograph, I present below just a few examples of works by select Pardhan artists to provide a glimpse into the vibrant and fertile scene of the genre as it exists today. Some of these artists have charted new and resonant paths for themselves, and have received much critical acclaim. This brief survey of the current scenario of Pardhan art cannot possibly do justice to the full spectrum of their artistic expression but is merely meant as a small window into the rich land-scape of Pardhan painting as a fitting epilogue to this book.

I. Ram Singh Urveti

Ram Singh, born in Patangarh in the mid-1960s, was Jangarh's childhood friend. As teenagers, they worked side by side in their village fields, and as labourers. Jangarh was instrumental in getting Ram Singh to Bhopal. For the first few years, he worked some odd labour jobs in Bhopal but he also leant printmaking from Jangarh during this period. Ram Singh obtained a printer's position in the graph-ics studio at Manav Sangrahalaya in Bhopal, where he works until today.

In a personal conversation with me in Delhi in June 2018, Ram Singh mentioned that he and Jangarh used to participate together in the village Ramleela performances. Jangarh was aware of Ram Singh's painterly talent and used to encourage him to paint. Ram Singh would respond with reluctance. He told me that he was afraid of 'spoiling' paper or a canvas and wasting pigments by failing to produce a result that would meet Jangarh's expectations. Ram Singh told me that in order to help him overcome his self-doubts, Jangarh and other members of his family would make him drink fair amounts of alcohol and give him paper and pigments to paint while under the influence. Ram Singh produced 'brilliant' results and he has continued to paint, draw and make prints ever since — without requiring any form of liquid assistance.

The three of Ram Singh's paintings reproduced here show his individualistic idiom and sensibility to colour, which differs significantly from Jangarh's works or that of the other artists who trained with Jangarh.

Ritual of Lagun Milai

In order to appoint an auspicious couple of *suwasa* and *suwasin* (married man and married woman), who would officiate at numerous weddings, the *guniya* (priest) performs a ritual known as *lagun milai* in a cowshed (*gotha*), for which a *dhigna* chowk, a slightly raised mud platform, is erected, on which a bronze vessel filled with water is placed. The *guniya* drops two grains of rice into the water in the name of each couple aspiring to act as *suwasa* and *suwasin*. When two rice grains come together in the vessel, that couple is appointed as *suwasa* and *suwasin*.

The elaborate ritual procedure is splendidly abstracted in this painting (Fig. 112) using minimalist geometrical forms and patterns. The transformation of the complex ritual into an ideational, almost diagrammatic representation attained by Ram Singh is brilliant and stands apart from the customary Pardhan idiom of painting.

Fig. 112 Ritual of *Lagun Milai*. Ram Singh Urveti, between 2005-2010, acrylic on canvas, 106 x 77 cm. Collection and image courtesy: Museum of Art & Photography (MAP), Bangalore (PTG.0892)

Fig. 113 *Kasangar* Bird Incubating its Eggs. Ram Singh Urveti, between 2005-2010, pigment on paper, 71 x 56 m. Collection and image courtesy: Museum of Art & Photography (MAP), Bangalore (PTG.0911)

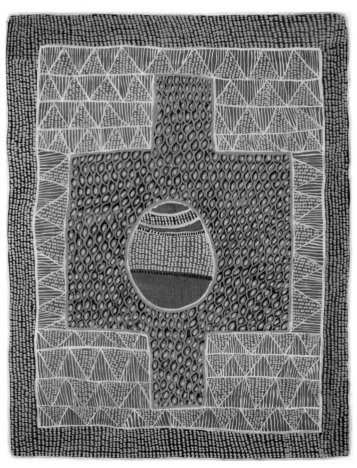

Fig. 112

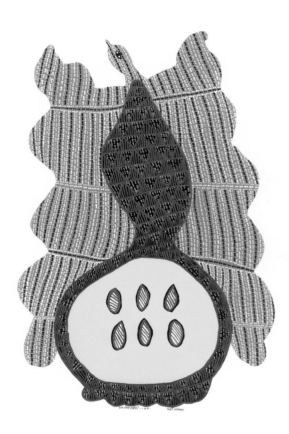

Fig. 113

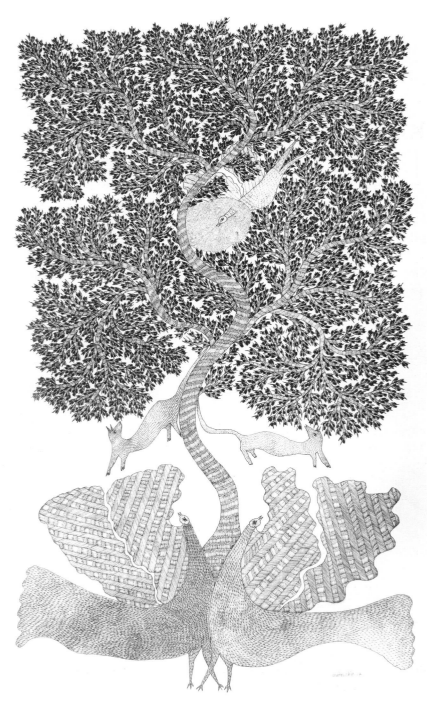

Fig. 114

Fig. 114 *Bamur* tree, Beehive and Eagle. Ram Singh Urveti, 2017-18, ink on canvas, 150 x 90 cm. Collection and image courtesy: the artist

Kasangar Bird Incubating its Eggs

The *kasangar* bird is often seen as Gond, while *bharhi*, another bird of the Patangarh region, is referred to as Pardhan by the people of Mandla. The *bharhi* bird sings beautifully while in flight, which can, at times, last for half an hour. People have observed a parallel between the *bharhi's* song and that of the Pardhan bards:

the *kasangar* is seen sitting still, keenly listening to the *bharhi's* song, just like the Gonds who passionately listen to the Pardhan singers of legends.

The painting (Fig. 113) is, once again, an illustrious example of Ram Singh's immense talent for transfiguration of the commonplace into a metaphoric image — reductive and nominal.

Bamur Tree, Beehive and Eagle

The drawing (Fig. 114) depicts an eagle piercing with its beak a beehive hanging on a *bamur* (*babool*) tree. As the eagle arrives, the squirrels run away and the *myna* birds descend to the ground. Ram Singh has captured that impromptu moment of dramatic action, which he frequently observed in his early years in Patangarh, on his canvas.

II. Anand Shyam

Anand Shyam, born in Patangarh in 1963, is Jangarh's nephew. He stated that before he moved to Bhopal in 1984, he was exposed to ornamental wood carving, which his father Sukh Ram learned at the Shilp Centre, an institution promoting the crafts opened by the anthropologist Verrier Elwin in Patangarh. The father had become adept at carving decorative motifs in low relief on furniture and doors, an exercise Elwin had included in his Crafts Training Centre, to revive the lost art of the Gond Rajas. Later, with Elwin's help, Sukh Ram managed to get a job in the army and was posted in Jabalpur. Anand went along to pursue his studies and began to paint film banners and billboards at the local cinema houses, on the side. Anand's uncle Chhatarpal was skilled at making clay images of Durga, Ganesh and other deities, which kindled a great interest in the young Anand.

In 1984 Anand moved to Bhopal and lived in Jangarh's house, where he began to assist Jangarh in his painterly commissions. As Jangarh worked as an attendant in the graphics studio at Bharat Bhavan, he also learnt printmaking under Jangarh. Eventually, Anand began to do his own painting.

One incident between Jangarh and Anand raises the issue of individual visual languages of expression purposefully evolved by an artist, as against the sterile imitation of another. Anand mentioned to me in a conversation that when he began to do his own individual painting after several years of assisting Jangarh, he unintentionally internalised some of the features of Jangarh's individual idiom, especially his manner of creating dotted patterns. When Jangarh saw this, he advised Anand to evolve his own visual idioms and consciously come out of Jangarh's shadow. After an initial tiff, Anand got Jangarh's well-meaning message and thoughtfully evolved his own pictorial idiom, which at first was a rather literal departure from Jangarh's circular dots to crescent-shaped ones, but in due course Anand went far beyond the issue of a formal stylistic affinity with Jangarh, to create his own locution marked by an untamed surge of lines and joyous lustrous patterning, allowing his scorpions, reptiles and birds to roam playfully in the space of his canvas.

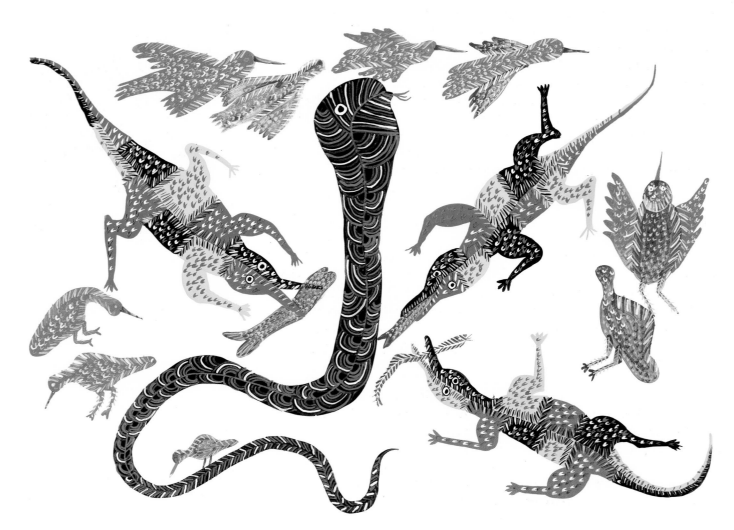

Fig. 115

Fig. 116

This lesson of Jangarh's to his fellow Pardhan artist about developing a sensibility of one's own had crucial artistic repercussions for the growth of the diverse and individualistic Pardhan idioms that arose in Bhopal, around and after Jangarh. The vitality that one sees in the works of some of these artists comes from these subjective explorations and, in a way, calls into question the collective notion of a 'Jangarh idiom.' Anand Shyam's playful spontaneity and fluorescence radiating from contrastingly staggered patterns of graded greens, yellows and reds, compartmentalised so as to give the illusion of dimensionality (see Figs. 115 to 117), also evoke plasmatic formations under the skin of his charming creatures — in the same sense as the word 'plasma' in Greek and Latin stands for 'shape' and 'mould.'

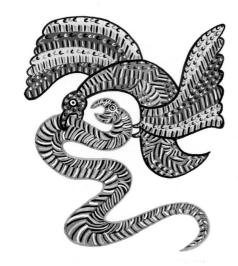

Fig. 117

III. Bhajju Shyam

Bhajju, born in Patangarh in 1971, is also Jangarh's nephew. In a personal conversation in June 2018 at my residence, Bhajju briefly narrated the story of his life. He mentioned that as a child he was sent to a village school, but on account of the family's poverty he could not continue his education. He spent his early teen years working as a farm labourer in and around his village, but later, he moved to Jabalpur in Uttar Pradesh, in search of employment. There, he worked as a construction worker and guard.

On the front of art, Bhajju says that as a young boy he started making figures and motifs while helping his mother with creating *dhigna* and *nahador* clay relief work. He entered the world of new Pardhan painting as an apprentice and assistant to Jangarh, especially to fill up large areas of Jangarh's paintings under the latter's guidance. When Jangarh was commissioned to paint the large-scale murals on the walls of the newly-built Vidhan Bhavan (Legislative Assembly Building), Bhajju was part of Jangarh's team assisting him with the project. This experience became a major asset in Bhajju's training as an artist.

Bhajju's major international break came with the publication of *The London Jungle Book*,[103] in which Bhajju pictorialised his experiences of a visit to London in 2002. Over the last two decades, several Indian folk and tribal artists crossed the margins from their inherited sites of art practices to explore the new possibilities offered by their contemporary predicament. Borders are thinning and formal categories are converging into an expanded field contesting or complementing each other. Bhajju Shyam, in recounting the experience of his stay in London in his paintings, was working in this twilight space. In *The London Jungle Book*, he returns — after a century — Kipling's gaze with an equal sense of wonder, adventure, humour and direct sense of expression. The paintings of this series are a delightful visual narrative focalising the city in terms of the metaphors of his community's life and mythology. Works such as 'When Two Times Meet' and

Fig. 115 *Magar aur Saap*; Crocodiles and Snake. Anand Shyam, 1997, pigment on paper, 56 x 71 cm. Collection and image courtesy: Museum of Art & Photography (MAP), Bangalore (PTG.0733)

Fig. 116 Scorpions in their Nest. Anand Shyam, 1997, pigment on paper, 56 x 71 cm. Collection and image courtesy: Museum of Art & Photography (MAP), Bangalore (PTG.0750)

Fig. 117 Baaj aur Saap; Hawk and Snake. Anand Shyam, 2004, pigment on paper, 35.5 x 27.5 cm. Collection and image courtesy: Museum of Art & Photography (MAP), Bangalore (PTG.0715)

103 Tara Publications, Chennai, 2004

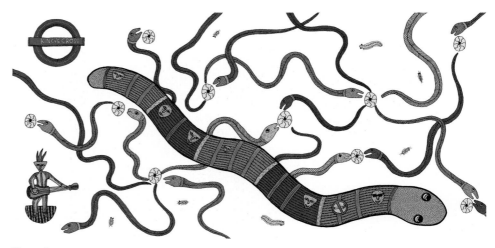

Fig. 118

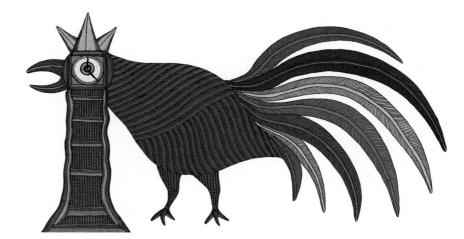

Fig. 119

'The King of the Underworld' are likely to change the viewer's perception of Big Ben or King's Cross station forever. Bhajju has since continued to explore in his work the grey zones between the world of his autochthony and his urban environs.

The underworld inhabited by snakes, earthworms and other creatures forms an important motif in Pardhan belief and painting. In Fig. 118, Bhajju has imaginatively used the Pardhan conception of the underworld as a metaphor for London's tube system. The white medallions represent the tube stations and the street musician in the left bottom corner was perceived by Bhajju as the only peaceful and content person amidst the hustle and bustle of the stations.

In most of the world, as also in India, the call of the rooster is a sign of dawn. In Fig. 119, Bhajju cleverly overlays the eye of the rooster with the clock of Big Ben, so as to conflate the two temporal systems.

Fig. 118 The King of the Underworld. Bhajju Shyam, 2003-4, pigment on paper, 32 x 45 cm. Collection and courtesy line: 'Art by Bhajju Shyam for 'The London Jungle book,' Original Edition ©Tara Books Pvt. Ltd. Chennai, India, www.tarabooks.com

Fig. 119 When Two Times Meet. Bhajju Shyam, 2003-4, pigment on paper, 32 x 45 cm. Collection and courtesy line: 'Art by Bhajju Shyam for 'The London Jungle book,' Original Edition ©Tara Books Pvt. Ltd. Chennai, India, www.tarabooks.com

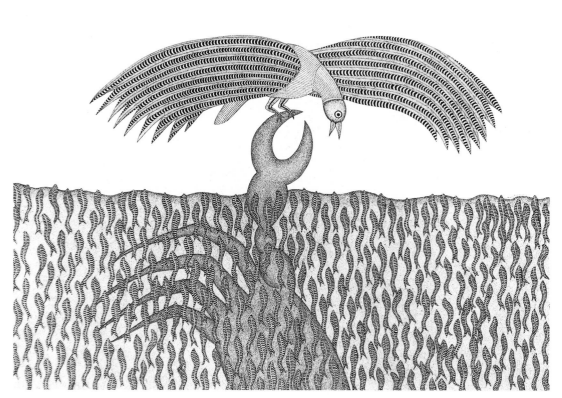

Fig. 120

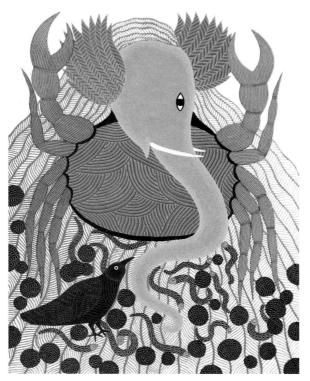

Fig. 121

Fig. 120 Myth of Creation: The Crow and the Crab. Bhajju Shyam, ca. 2016, ink and acrylic on paper, 56 x 76 cm. Collection and image courtesy: Ojas Art Gallery, Delhi

Fig. 121 Myth of Creation: The Elephant-headed Crab. Bhajju Shyam, ca. 2016, ink and acrylic on paper, 76 x 56 cm. Collection and image courtesy: Ojas Art Gallery, Delhi

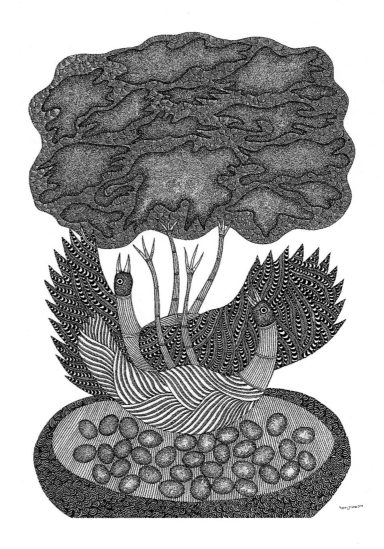

Fig. 122

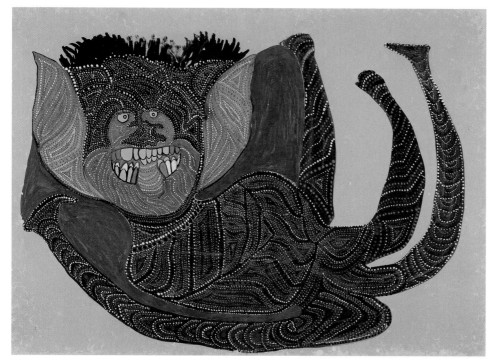

Fig. 123

In a version of the Pardhan myth of creation (Fig. 120), Bhajju depicts the crow, created by Shiva from a speck of dirt on his body to fetch earth from the earth-worm residing in the underworld, being assisted in this task by the crab. In another version of this myth (Fig. 121) Bhajju depicts the elephant-headed crab of the Pardhan myth of creation seated amidst the primordial waters.

Tithi birds are known to lay their eggs in the black earth of the fields without making a nest. In Fig. 122, a *tithi* bird couple is shown protecting their eggs by fanning out their wings with their legs turned upwards, as they do in nature. The clouds above are being pushed away by their legs so that their chicks will not be frightened when they are born, mistaking them for wild beasts. The clouds are therefore shown as abstract forms of beasts.

IV. Narmada Prasad Tekam

Narmada, now 65 years old, is a cousin of Jangarh's. He came to Bhopal and started painting almost at the same time as Jangarh, and his work speaks to an individual mode of expression quite different and independent of the so-called Jangarh *kalam*. The three of his early works reproduced below amply illustrate this (Figs. 123 to 125).

Fig. 124

Fig. 125

Fig. 124 Goddess Banjari Mata. Narmada
Prasad Tekam, 1990, pigment on paper, 71 x
55 cm. Collection and image courtesy: Bharat
Bhavan, Bhopal

Fig. 125 Crocodile. Narmada Prasad Tekam,
early 1990s, pigment on paper, 56 x 71 cm.
Collection and image courtesy: Museum of Art
& Photography (MAP), Bangalore (PTG.0737)

Fig. 126 Cityscape. Mayank Shyam, 2016,
acrylic on canvas, 91 x 168 cm. Collection and
courtesy: Ojas Art Gallery, Delhi

Fig. 127 Metaphor of a Tippler. Dileep Shyam,
2011, acrylic on canvas, 186 x 120 cm. Collection
and courtesy: Museum of Art & Photography
(MAP), Bangalore (PTG.0864)

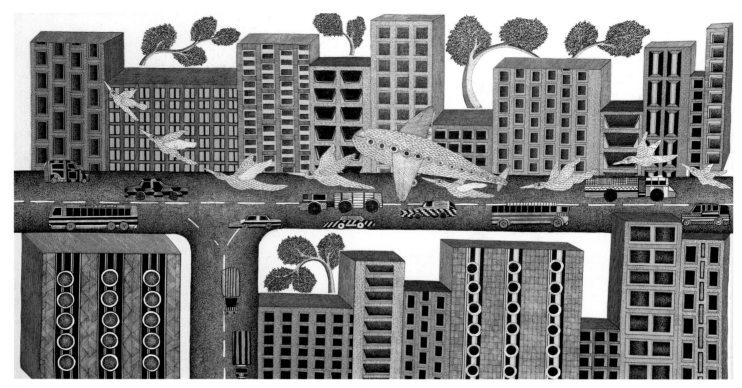

Fig. 126

V. Mayank Shyam

Jangarh's eldest son Mayank was born in Bhopal in 1987. When his father passed away in 2001, Mayank was barely 13 years old. He started to paint soon after his father's death. Born and brought up in Bhopal, Mayank is not rooted in Pardhan culture, myths and religion the way his father was. Initially, he borrowed Pardhan mythological subjects from Jangarh and other Pardhan artists in Bhopal, and rendered them in an exuberant miniature mode, as ink drawings. Seesawing between the artistic legacy of his father and the urban environment of his birth and upbringing, he produced a few cityscapes, which often appeared more prompted than inspired. Yet he retains an unmistakably explorative element in his work (Fig. 126).

VI. Dileep Shyam

Metaphor of a Tippler

The young artist has metaphorically depicted the states of mind of a drinker — from moderate to extreme. The top figure, whose body ends in that of a parrot, represents a moderate drinker. The middle one, a heavy drinker, is depicted as a lion who feels on top of the world after a few pegs, and the bottom one resembles a pig or boar — "all gone." Dileep is the only Pardhan artist who displays a remarkable sense of humour in his work (Fig. 127).

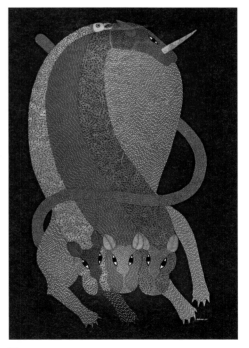

Fig. 127

BIBLIOGRAPHY

Bal, Mieke, *Narratology. Introduction to the Theory of Narrative*, University of Toronto Press, Toronto/Buffalo/London, 2nd edition 1997

Baxandall, Michael, *Patterns of Intention. On the Historical Explanation of Pictures*, Yale University Press, New Haven and London, 1989

Bowles, John H., *Painted Songs and Stories. The Hybrid Flowerings of Contemporary Pardhan Gond Art*, INTACH Bhopal Chapter, Bhopal, 2009

Clifford, James, *The Predicament of Culture. Twentieth-Century Ethnography, Literature, and Art*, Harvard University Press, Cambridge, Mass., and London, 1988

Clifford, James, "Four Northwest Coast Museums: Travel Reflections", in: *Exhibiting Cultures. The Poetics and Politics of Museum Display* (ed. By Ivan Karp and Steven D. Lavine), Smithsonian Institution Press, Washington and London, 1991, pp. 212-254

Clifton, Tony, "The 'Other Masters'. A new show featuring five 'folk' artists proves that India's rich tradition is alive and well", in: *Newsweek*, 27 April, 1998, pp. 54-55

Dalmia, Yashodhara, *The Painted World of the Warlis: Art and Ritual of the Warli Tribes of Maharashtra*, Lalit Kala Akademi, New Delhi, 1988

Das, Aurogeeta, *Jangarh Singh Shyam. The Enchanted Forest. Paintings and Drawings from the Crites Collection*, Showcase Roli Books, 2018

Dutta, Amit, *Invisible Webs. An Art Historical Inquiry into the Life and Death of Jangarh Singh Shyam*, Indian Institute of Advanced Study, Shimla, 2018

Elwin, Verrier, *The Tribal World of Verrier Elwin. An Autobiography*, Oxford University Press, Oxford India Paperbacks, New Delhi, 4th edition, 1998

Elwin, Verrier, *Leaves from the Jungle. Life in a Gond Village*, Oxford University Press, Bombay, 1958

Garimella, Annapurna, *Vernacular, in the Contemporary*, 2 vols., Devi Art Foundation, New Delhi, vol. 1, 2010; vol. 2, 2011

Garimella, Annapurna, "Aboriginalisthan in the Gallery", in: *Sakahan: International Indigenous Art*, ed. Albert Dumont et al., Ottawa, National Gallery of Canada, 2013, pp. 72-84

Groys, Boris, *On the New*, English-language edition published by Verso, London-Brooklyn, 2014, translation G.M. Goshgarian (first published Über das Neue, Carl Hanser Verlag, München-Wien, 1992)

Haekel, Josef, "Der kultische Aspekt des Hauses bei den Bhilala in Zentralindien", in: *Festschrift Paul J. Schebesta*, Studia Instituti Anthropos, vol. 18, Vienna (Mödling), 1963, pp. 357-370

Haekel, Josef, "Beiträge zur Ethnologie der Bhilala in Zentralindien", in: *Folk*, Kobenhavn, vol. 5, 1963, pp. 123-132

Hivale, Shamrao, *The Pardhans of the Upper Narbada Valley*, Oxford University Press, Bombay, 1946

Jain, Jyotindra, *Bavaji und Devi. Bessessenheitskult und Verbrechen in Indien*, Europa Publishing, Vienna, 1973

Jain, Jyotindra, *The Painted Myths of Creation. Art and Ritual of an Indian Tribe*, Lalit Kala Akademi, Loka Kala Series, New Delhi, 1984

Jain, Jyotindra, *Ganga Devi: Tradition and Expression in Mithila Painting*, Mapin Publishing, Middletown, USA, 1997

Jain, Jyotindra (ed.), *Other Masters. Five Contemporary Folk and Tribal Artists of India*, published by Crafts Museum, New Delhi, 1998

Jain, Jyotindra, "Trapped in Crossing", in: *Art India, The Art News Magazine of India*, vol. 6, issue 4, quarter 4, New Delhi, 2001, pp. 22-24

Jain, Jyotindra, *Autres Maîtres de l'Inde* (in French, *Other Masters of India*), Musée de Quai Branly and Somogy Éditions d'Art, Paris, 2010

Kalidas, S., "The Death Visit", in: *India Today*, 23 July 2001, p. 71

Kapur, Geeta, *J. Swaminathan: the artist, the ideologue, the man, his persona*, in: *The India Magazine*, vol. 14, June 1994, pp. 16-17

Kramrisch, Stella, *Unknown India: Ritual Art in Tribe and Village,* Published by Museum of Art, 1968

Martin, Jean-Hubert, *Magiciens de la Terre* (in French, *Magicians of the Earth*), Éditions du Centre Pompidou, Paris, 1989

Narayanan, Renuka, "Tribal Painter's Suicide in Japan: artists sketch a mystery", in: *Indian Express,* Saturday, 7 July 2001, pp. 1-2

Nath, Anubhav, *The Art of Bhajju Shyam. Master Gond Artist,* Ojas Art, New Delhi, 2016

Price, Sally, "Others Art – Our Art", in: *Third Text, Third World Perspectives on Contemporary Art and Culture,* special issue vol. 6, spring 1989, pp. 65-77

Price, Sally, *Primitive Art in Civilized Places,* second edition, The University of Chicago Press, 2001 (originally published 1989)

Pradhan S.V., *The Elusive Aryans: Archaeological Search and Vedic Research. The Origin of the Hindus,* Cambridge Scholars Publishing, Newcastle upon Tyne, 2014

Sathyu, Seema, "Jangarh Singh Shyam", unpublished essay, 1989

Sen, Geeti, "Fourth Triennale: Trial and Tribulations", in: *The Times of India,* New Delhi, February 1978,

Shah, Shampa (ed.), *Tribal Arts and Crafts of Madhya Pradesh,* Mapin Publishing, Ahmedabad, in association with Vanya Prakashan, Bhopal, 1996

Sheikh, Gulammohammed, "The World of Jangarh Singh Shyam", in: *Other Masters. Five Contemporary Folk and Tribal Artists of India* (ed. Jyotindra Jain), Crafts Museum, New Delhi, 1998, pp.17-33

Shyam, Bhajju, with Sirish Rao and Gita Wolf, *The London Jungle Book,* Tara Publishing in association with The Museum of London, Chennai/London, 2004

Singh, Kishore, "In Search of the 'modern'", in: *Business Standard,* 15-16 October 2005

Singh, Madan Gopal, "Swami: Of His Times", in: *The India Magazine,* vol. 14, June 1994, pp. 6-15

Singh, Kavita, "Jangarh Singh Shyam and the Great Machine", in: *Marg Magazine,* vol. 53, no. 2, 2011, pp. 61-64

Swaminathan, J., *The Perceiving Fingers. Catalogue of Roopankar Collection of Folk and Adivasi Art from Madhya Pradesh, India,* Bharat Bhavan, Bhopal, 1987

Swaminathan, J., Shah, Haku, & Jain, Jyotindra, *Art of the Adivasi (Indian Tribal Art),* The Yomiuri Shimbun and The Japan Association of Art Museums, Tokyo, 1988

Thomas, Nicholas, *Entangled Objects. Exchange, Material Culture, and Colonialism in the Pacific,* Harvard University Press, Cambridge, Mass., and London, 1991

Thomas, Nicholas, *Oceanic Art,* Thames & Hudson World of Art, London, reprint 2005 (originally published 1995)

Tully, Mark, "Return of the Artist", in: *No Full Stops in India,* Viking Penguin India, New Delhi, 1991, pp. 268-297

Vajpeyi, Ashok, "A Furious Purity", in: *The India Magazine,* vol. 14, June 1994, pp. 38-49

Vajpeyi, Udayan and Vajpeyi, Vivek, *Jangarh Kalam* (in Hindi), Vanya Prakashan, Bhopal, 2008

ACKNOWLEDGEMENTS

The author wishes to thank the following people and institutions:

For collections and images, Museum of Art & Photography, (MAP), Bangalore and especially Nathaniel Gaskell and Chithra K.S.; Bharat Bhavan, Bhopal; Vivek and Shalini Gupta, New Delhi; Kavita Sanghi, Indore; Gursharan Singh Sidhu, Palo Alto; National Handicrafts & Handlooms Museum, New Delhi; Ojas Art Gallery, New Delhi; Australian High Commission, and specially Hema Rance, New Delhi; Mark Tully and Gillian Wright, New Delhi; Ashish Swami, Umaria (M.P.); Shama Zaidi, Mumbai; Seema Sathyu, Bangalore, and the Foundation Cartier pour l'art contemporain, Paris.

For photographs, Jyoti Bhatt, Vadodara; Asia Art Archive, Hong Kong; Harchandan Singh Bhatty, Bhopal; Prakash Hatvalne, Bhopal; Shajahan Art Gallery, New Delhi; Laxman Das Arya, New Delhi.

For research, Shampa Shah, Bhopal.

For information, special thanks are due to Ashish Swami, Umaria (M.P.), for his continuous discussions and inputs; Ram Singh Urveti, Bhajju Shyam, Anand and Kalavati Shyam, Nankushiya Shyam, Mayank Shyam, Narmada Prasad Tekam, Venkat Shyam, Rajendra Shyam, all in Bhopal; and Anubhav Nath, New Delhi; Erica Izett, Ian McLean, Kade Mcdonald and Henry Skeritt, and Helen Rayment, all in Australia; and special thanks are also due to Monika Correa, Mumbai, and the Charles Correa Foundation, Goa.

For editing, Saskya Jain.

The author is deeply grateful to Jutta Jain-Neubauer for her continuous insights, suggestions, assistance and patience throughout the process of writing over nearly two years, and to Abhishek Poddar for encouraging him to write this book and opening up the MAP archives to him.